PERFORMANCE ART
From Futurism to the Present

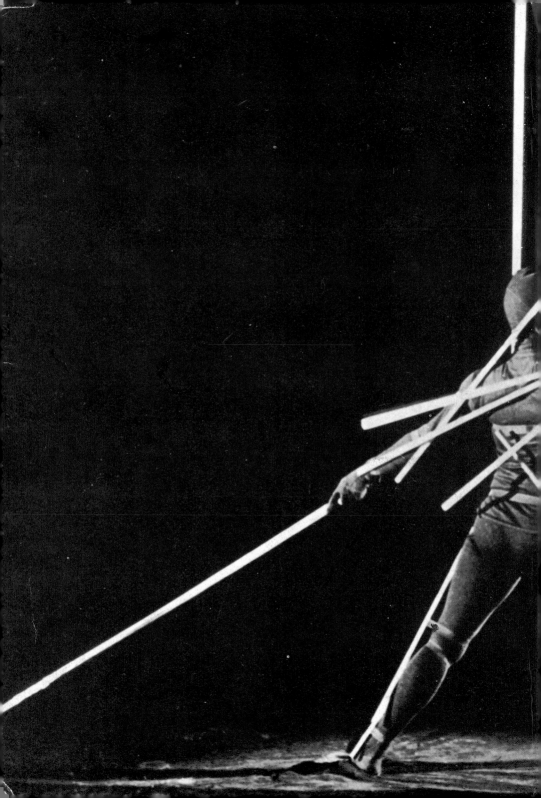

RoseLee Goldberg

PERFORMANCE ART
From Futurism to the Present

Revised and enlarged edition

Harry N. Abrams, Inc., Publishers, New York

For Pauline and Allan

1 *Title page*: **Schlemmer, *Slat Dance*, 1927. The figure, performing in semi-darkness, outlined the geometrical division of the space and emphasized the perspective view for the audience**

The author wishes to thank all those who have contributed to the preparation of the material, especially the artists, Mel Gordon, John Golding, Lillian Kiesler, Andreas and Eva Weininger, and Tony Stokes. Special thanks also to Dakota Jackson for his untiring support and patience.

Revised and enlarged edition 1988

ISBN 0–8109–2371–8

Published in 1988 by Harry N. Abrams, Incorporated, New York
All rights reserved. No part of the contents of this book may
be reproduced without the written permission of the publisher

Times Mirror Books

Printed and bound in Yugoslavia

Contents

2 Raymond O'Daly's fascination with drawing is seen in *The Conversion of Post-Modernism*, 1986

Foreword

Performance became accepted as a medium of artistic expression in its own right in the 1970s. At that time, conceptual art – which insisted on an art of ideas over product, and on an art that could not be bought and sold – was in its heyday and performance was often a demonstration, or an execution, of those ideas. Performance thus became the most tangible art form of the period. Art spaces devoted to performance sprang up in the major international art centres, museums sponsored festivals, art colleges introduced performance courses, and specialist magazines appeared.

It was during that period that this first history of performance was published (1979), demonstrating that there was a long tradition of artists turning to live performance as one means among many of expressing their ideas, and that such events had played an important part in the history of art. It is interesting that performance, until that time, had been consistently left out in the process of evaluating artistic development, especially in the modern period, more on account of the difficulty of placing it in the history of art than of any deliberate omission.

The extent and richness of this history made the question of omission an even more insistent one. For artists did not merely use performance as a means to attract publicity to themselves. Performance has been considered as a way of bringing to life the many formal and conceptual ideas on which the making of art is based. Live gestures have constantly been used as a weapon against the conventions of established art.

Such a radical stance has made performance a catalyst in the history of twentieth-century art; whenever a certain school, be it Cubism, Minimalism or conceptual art, seemed to have reached an impasse, artists have turned to performance as a way of breaking down categories and indicating new directions. Moreover, within the history of the avant garde – meaning those artists who led the field in breaking with each successive tradition – performance in the twentieth century has been at the forefront of such an activity: an avant avant garde. Despite the fact that most of what is written today about the work of the Futurists, Constructivists, Dadaists and Surrealists continues to concentrate on the art objects produced by each period, it was more often than not the case that these movements found their

7

roots and attempted to resolve problematic issues in performance. When the members of such groups were still in their twenties or early thirties, it was in performance that they tested their ideas, only later expressing them in objects. Most of the original Zurich Dadaists, for example, were poets, cabaret artistes and performers who, before actually creating Dada objects themselves, exhibited works from immediately preceding movements, such as the Expressionists. Similarly, most of the Parisian Dadaists and Surrealists were poets, writers and agitators before they made Surrealist objects and paintings. Breton's text *Surrealism and Painting* (1928) was a belated attempt to find a painterly outlet for the Surrealist idea, and as such it continued to raise the question: 'What is Surrealist painting?' for some years after its publication. For was it not Breton who, four years earlier, had stated that the ultimate Surrealist *acte gratuit* would be to fire a revolver at random into a crowd on the street?

Performance manifestos, from the Futurists to the present, have been the expression of dissidents who have attempted to find other means to evaluate art experience in everyday life. Performance has been a way of appealing directly to a large public, as well as shocking audiences into reassessing their own notions of art and its relation to culture. Conversely, public interest in the medium, especially in the 1980s, stems from an apparent desire of that public to gain access to the art world, to be a spectator of its ritual and its distinct community, and to be surprised by the unexpected, always unorthodox presentations that the artists devise. The work may be presented solo or with a group, with lighting, music or visuals made by the performance artist him or herself, or in collaboration, and performed in places ranging from an art gallery or museum to an 'alternative space', a theatre, café, bar or street corner. Unlike theatre, the performer *is* the artist, seldom a character like an actor, and the content rarely follows a traditional plot or narrative. The performance might be a series of intimate gestures or large-scale visual theatre, lasting from a few minutes to many hours; it might be performed only once or repeated several times, with or without a prepared script, spontaneously improvised, or rehearsed over many months.

Whether tribal ritual, medieval passion play, Renaissance spectacle or the 'soirées' arranged by artists in the 1920s in their Paris studios, performance has provided a presence for the artist in society. This presence, depending on the nature of the performance, can be esoteric, shamanistic, instructive, provocative or entertaining. Renaissance examples even show the artist in the role of creator and director of public spectacles, fantastic triumphal parades that often required the construction of elaborate temporary architecture, or allegorical events that utilized the multi-media abilities attributed to Renaissance Man. A mock naval battle, designed by Polidoro da Caravaggio in 1589, took place in the specially flooded courtyard of the Pitti Palace in

Florence; Leonardo da Vinci dressed his performers as planets and had them recite verses about the Golden Age in a pageant entitled *Paradiso* (1490); and the Baroque artist Gian Lorenzo Bernini staged spectacles for which he wrote scripts, designed scenes and costumes, built architectural elements and even constructed realistic flood scenes, as in *L'Inondazione* ('The Inundation of the Tiber', 1638).

The history of performance art in the twentieth century is the history of a permissive, open-ended medium with endless variables, executed by artists impatient with the limitations of more established art forms, and determined to take their art directly to the public. For this reason its base has always been anarchic. By its very nature, performance defies precise or easy definition beyond the simple declaration that it is live art by artists. Any stricter definition would immediately negate the possibility of performance itself. For it draws freely on any number of disciplines and media – literature, poetry, theatre, music, dance, architecture and painting, as well as video, film, slides and narrative – for material, deploying them in any combination. Indeed, no other artistic form of expression has such a boundless manifesto, since each performer makes his or her own definition in the very process and manner of execution.

This book is a record of those artists who use performance in trying to live, and who create work which takes life as its subject. It is also a record of the effort to assimilate more and more the realm of play and pleasure in an art which observes less and less the traditional limitations of making art objects, so that in the end the artist can take delight in almost any activity. It is, finally, about the desire of many artists to make art that functions outside the confines of museums and galleries.

In tracing an untold story, this first history inevitably works itself free of its material, because that material continues to raise questions about the very nature of art. It does not pretend to be a record of every performer in the twentieth century; rather, it pursues the development of a sensibility. The goal of this book is to raise questions and to gain new insights. It can only hint at life off the pages.

New York, February 1978 and January 1987

Gaston CALMETTE
Directeur-Gérant

RÉDACTION — ADMINISTRATION
26, rue Drouot, Paris (9e Arr¹)

POUR LA PUBLICITÉ
D'ADRESSER, 26, RUE DROUOT
A L'HÔTEL DU « FIGARO »
ET POUR LES ANNONCES ET RÉCLAMES
Chez MM. LAGRANGE, CERF & Cᵉ
8, place de la Bourse

LE FIGARO

« Loué par ceux-ci, blâmé par ceux-là, me moquant des sots, bravant les méchants, je me hâte de rire de tout... de peur d'être obligé d'en pleurer. » (BEAUMARCHAIS.)

Le Futurisme

M. Marinetti, le jeune poète italien et à talent remarquable et fougueux, qui de retentissantes manifestations ont fait connaître dans tous les pays latins, vient de fonder l'École du « Futurisme » dont les théories dépassent en hardiesse toutes celles des écoles antérieures du contenu positif. Le « Figaro » qui a déjà servi de tribune à plusieurs d'entre elles, et non des moindres, offre aujourd'hui à ses lecteurs la manifeste des « Futuristes ». Est-il besoin de dire que nous laissons au signataire toute la responsabilité de ses idées singulièrement audacieuses et d'une outrance souvent injuste pour des choses éminemment respectables et, le respectant, partout respectées ? Mais il était intéressant de réserver à nos lecteurs la primeur de cette manifestation, quel que soit le jugement qu'on porte sur elle.

Nous avions veillé toute la nuit, mes amis et moi, sous les lampes de mosquée dont les coupoles de cuivre aussi ajourées que notre âme avaient pourtant des cœurs électriques. Et tout en piétinant notre native paresse sur d'opulents tapis persans, nous avions discuté aux frontières extrêmes de la logique et griffé le papier de démentes écritures.

Un immense orgueil gonflait nos poitrines à nous sentir debout tout seuls, comme des phares ou comme des sentinelles avancées, face à l'armée des étoiles ennemies, qui campent dans leurs bivouacs célestes. Seuls avec les mécaniciens dans les infernales chaufferies des grands navires, seuls avec les noirs fantômes qui fourragent dans le ventre rouge des locomotives affolées, seuls avec les ivrognes battant des ailes contre les murs...

Et nous voilà brusquement distraits par le roulement des énormes tramways à double étage, qui passent sursautants, bariolés de lumières, tels les hameaux en fête que le Pô débordé ébranle tout à coup et déracine, pour les entraîner, sur les cascades et les remous d'un déluge, jusqu'à la mer.

Puis le silence s'aggrava. Comme nous écoutions la prière exténuée du vieux canal et crisser les os des palais moribonds dans leur barbe de verdure, soudain rugirent sous nos fenêtres les automobiles affamées.

— Allons, dis-je, mes amis ! Partons ! Enfin, la Mythologie et l'Idéal mystique sont surpassés. Nous allons assister à la naissance du Centaure et nous verrons bientôt voler les premiers anges ! Il faudra ébranler les portes de la vie pour en essayer les gonds et les verrous ! Partons ! Voilà bien le premier soleil levant sur la terre !... Rien n'égale la splendeur de son épée rouge qui s'escrime pour la première fois dans nos ténèbres millénaires.

Nous nous approchâmes des trois machines renâclantes pour flatter leur poitrail. Je m'allongeai sur la mienne, comme un cadavre dans sa bière, mais je ressuscitai soudain sous le volant, lame de guillotine qui menaçait mon estomac.

Le grand balai de la folie nous arracha à nous-mêmes et nous poussa à travers les rues escarpées et profondes comme des torrents desséchés. Çà et là, des lampes malheureuses, aux fenêtres, nous enseignaient à mépriser nos mathématiques.

— Le flair, criai-je, le flair suffit aux fauves !...

Sortons de la Sagesse comme d'une gangue hideuse et entrons, comme des fruits pimentés d'orgueil, dans la bouche immense et tordue du vent !... Donnons-nous à manger à l'Inconnu, non par désespoir, mais simplement pour enrichir les insondables réservoirs de l'Absurde !

Comme j'avais dit ces mots, je virai

[Colonne 2]

nos bras foulés en écharpe, parmi la complainte des sages pêcheurs à la ligne et des naturalistes navrés, nous dictèrent nos premières volontés à tous les hommes *vivants* de la terre :

Manifeste du Futurisme

1. Nous voulons chanter l'amour du danger, l'habitude de l'énergie et de la témérité.

2. Les éléments essentiels de notre poésie seront le courage, l'audace et la révolte.

3. La littérature ayant jusqu'ici magnifié l'immobilité pensive, l'extase et le sommeil, nous voulons exalter le mouvement agressif, l'insomnie fiévreuse, le pas gymnastique, le saut périlleux, la gifle et le coup de poing.

4. Nous déclarons que la splendeur du monde s'est enrichie d'une beauté nouvelle : la beauté de la vitesse. Une automobile de course avec son coffre orné de gros tuyaux, tels des serpents à l'haleine explosive... une automobile rugissante, qui a l'air de courir sur de la mitraille, est plus belle que la *Victoire de Samothrace*.

5. Nous voulons chanter l'homme qui tient le volant, dont la tige idéale traverse la terre, lancée elle-même sur le circuit de son orbite.

6. Il faut que le poète se dépense avec chaleur, éclat et prodigalité, pour augmenter la ferveur enthousiaste des éléments primordiaux.

7. Il n'y a plus de beauté que dans la lutte. Pas de chef-d'œuvre sans un caractère agressif. La poésie doit être un assaut violent contre les forces inconnues, pour les sommer de se coucher devant l'homme.

8. Nous sommes sur le promontoire extrême des siècles !... A quoi bon regarder derrière nous, du moment qu'il nous faut défoncer les battants mystérieux de l'impossible ? Le Temps et l'Espace sont morts hier. Nous vivons déjà dans l'absolu, puisque nous avons déjà créé l'éternelle vitesse omniprésente.

9. Nous voulons glorifier la guerre, — seule hygiène du monde, — le militarisme, le patriotisme, le geste destructeur des anarchistes, les belles Idées qui tuent et le mépris de la femme.

10. Nous voulons démolir les musées, les bibliothèques, combattre le moralisme, le féminisme et toutes les lâchetés opportunistes et utilitaires.

11. Nous chanterons les grandes foules agitées par le travail, le plaisir ou la révolte ; les ressacs multicolores et polyphoniques des révolutions dans les capitales modernes ; la vibration nocturne des arsenaux et des chantiers sous leurs violentes lunes électriques ; les gares gloutonnes avaleuses de serpents qui fument ; les usines suspendues aux nuages par les ficelles de leurs fumées ; les ponts aux bonds de gymnastes lancés sur la coutellerie diabolique des fleuves ensoleillés ; les paquebots aventureux flairant l'horizon ; les locomotives au grand poitrail qui piaffent sur les rails, tels d'énormes chevaux d'acier bridés de longs tuyaux, et le vol glissant des aéroplanes, dont l'hélice a des claquements de drapeaux et des applaudissements de foule enthousiaste.

C'est en Italie que nous lançons ce manifeste de violence culbutante et incendiaire, par lequel nous fondons aujourd'hui le *Futurisme*, parce que nous voulons délivrer l'Italie de sa gangrène de professeurs, d'archéologues, de cicérones et d'antiquaires.

L'Italie a été trop longtemps le marché des brocanteurs qui fournissaient au monde du mobilier de nos ancêtres, sans cesse renouvelé et soigneusement mutilé pour mutiler le travail des tarcs vénérables. Nous voulons débarrasser l'Italie de ses musées innombrables qui la couvrent d'innombrables cimetières.

Musées, cimetières !... Identiques vraiment dans leur sinistre coudoiement de corps qui ne se connaissent pas. Dortoirs publics où l'on dort à jamais côte à côte avec des êtres haïs ou inconnus. Férocité réciproque des peintres et des sculpteurs s'entre-tuant à coups de lignes et de couleurs dans le même musée.

Qu'on y fasse une visite chaque année comme on va voir ses morts une fois par an !... Nous pouvons bien l'admettre !... Qu'on dépose une fois des fleurs une fois par an aux pieds de la *Joconde*, nous le concevons !... Mais que l'on aille promener quotidiennement nos tristesses, nos courages fragiles et notre inquiétude, non, nous ne l'admettons pas !...

Admirer un vieux tableau, c'est verser notre sensibilité dans une urne funéraire au lieu de la lancer en avant par jets violents de création et d'action. Voulez-vous donc gâcher ainsi vos meilleures forces dans une admiration inutile du passé, dont vous sortez forcément épuisés, amoindris, piétinés ?

En vérité, la fréquentation quotidienne des musées, des bibliothèques et des académies (ces cimetières d'efforts perdus, ces calvaires de rêves crucifiés, ces registres d'élans brisés !...) est pour les artistes ce que est la tutelle prolongée des parents pour de jeunes gens intelligents, ivres de leur talent et de leur volonté ambitieuse.

Pour les moribonds, des invalides et

[Colonne 3]

pour accomplir notre tâche. Quand nous aurons quarante ans, que de plus jeunes et plus vaillants que nous nous veuillent bien nous jeter au panier comme des manuscrits inutiles !... Ils viendront contre nous de très loin, de partout, en bondissant sur la cadence légère de leurs premiers poèmes, griffant l'air de leurs doigts crochus, et humant, aux portes des académies, la bonne odeur de nos esprits pourrissants déjà promis aux catacombes des bibliothèques.

Mais nous ne serons pas là. Ils nous trouveront enfin, par une nuit d'hiver, en pleine campagne, sous un triste hangar pianoté par la pluie monotone, accroupis près de nos aéroplanes trépidants, en train de chauffer nos mains sur le misérable feu que feront nos livres d'aujourd'hui flambant gaiement sous le vol étincelant de leurs images.

Ils s'ameuteront autour de nous, haletants d'angoisse et de dépit, et, tous exaspérés par notre courage infatigable, s'élanceront pour nous tuer, avec d'autant plus de haine que leur cœur sera ivre d'amour et d'admiration pour nous. Et la forte et la saine Injustice éclatera radieusement dans leurs yeux. Car l'art ne peut être que violence, cruauté et injustice.

Les plus âgés d'entre nous n'ont pas encore trente ans, et pourtant nous avons déjà gaspillé des trésors, des trésors de force, d'amour, de courage et d'âpre volonté, à la hâte, en délirant, démesurément, à tour de bras, à perdre haleine.

Regardez-nous ! Nous ne sommes pas essoufflés... Notre cœur n'a pas la moindre fatigue ! Car il s'est nourri de feu, de haine et de vitesse ! Cela vous étonne ? C'est que vous ne vous souvenez même pas d'avoir vécu ! — Debout sur la cime du monde, nous lançons encore une fois le défi aux étoiles !

Vos objections ? Assez ! assez ! Je les connais ! C'est entendu ! Nous savons ce que notre belle et fausse intelligence nous affirme. — Nous ne sommes, dit-elle, que le résumé et le prolongement de nos ancêtres. — Peut-être ! soit !... Qu'importe ?... Mais nous ne voulons pas entendre ! Gardez-vous de répéter ces mots infâmes ! Levez plutôt la tête !

Debout sur la cime du monde, nous lançons encore une fois le défi insolent aux étoiles !

F.-T. MARINETTI

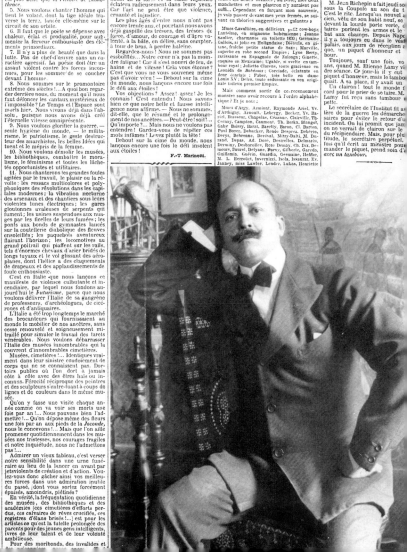

[Colonne 4]

en poussant des vivats et des clameurs, gagna les vastes salles à manger s'éparpilla en groupements sympathiques autour d'une multitude de tables luxueusement dressées.

Sur ces tables chacun trouva un très joli menu orné d'un dessin de de Losques et représentant spirituellement le Roi embrassant Mlle Lavallière et Mlle Lantelme, qui faisant exactement cette fois de suite l'espiègle et délurée petite You-You de la comédie de MM. de Caillavet, Robert de Flers et Emmanuel Arène.

Je renonce à vous donner une idée de l'aspect féerique que présentait alors cette foule de jolies actrices aux parures brillantes et chatoyantes encadrées de dominos et de costumes masculins variés à l'infini, et échangeant d'une table à l'autre des propos joyeux et des répliques — je vous jure — je vous assure spirituelles !

A la table d'honneur présidait Samuel le Magnifique — le Doge de face, — ayant à ses côtés Mmes Lender, Séverine, Yvette Guilbert et Mily Meyer. Beaucoup plus préoccupé de savourer l'excellent menu que de faire du reportage, j'avoue à ma honte de soiriste n'avoir pas songé à noter exactement le nom de toutes les belles invitées ; au reste, mes deux manchettes et mon plastron n'y auraient pas suffi... Cependant en forçant mon souvenir, je vais passer devant mes yeux fermés, se suivant ou s'étreignant suggestives et galantes :

Mais comment sortir de ce recensement monstre sans avoir recours à l'ordre alphabétique ? Et je note :

Mmes d'Arzy, Azmiont, Raymonde Ariel, Yv. d'Artigny, Arneult, Lebergy, Becker, Yv. Barioli, Brasseur, Chaplus, Cézanne, Chavrille, Th. Cernay, Campton, Caumont, Th. Berka, Blanquet, Gaby Buissy, Barat, Baretty, Baron, Cl. Barton, Paul Borey, Debacker, Renée Desprez, Debério, Desys, Debrenne, Dertval, Mitzy-Dalti, M. Durenard, Depas, and Dore, Destrelles, Delmasio, Demainy, Deshuroliez, Rose Demay, Ch. Dix, Demandy, Daurel, Delyane, Fucy, Gilberte, Gareda, Guillemin, Guérin, Guardia, Germaine, Heffter, M. L. Herroüet, Invernizzi, Isola, Issaurat, Ev. Janney, miss Lawler, Lender, Lukas, Henriette

maxima, 8° ; minima, 0°. Vent assez faible. Baromètre : 765mm.
A Berlin : Temps beau.

Les Courses

Aujourd'hui, à 2 heures, C Vincennes. — Gagnants du *Figaro*

Prix Michelet : Frivole ; Fringant.
Prix de Mayenne : Fada ; Bourgos.
Prix Léda : Farnèse ; Fregoli.
Prix Hambrino : Fresnay ; Fetar.
Prix de Maisons-Laffitte (haies) : F...
Prix du Plateau : Fred Leybur... ;
Prix de La Varenne : Elysse ; Ève

A Travers Paris

Le roi des Bulgares a chargé M. ...cioff, ministre de Bulgarie à P... de déposer sur une tombe une couronne, un cercueil du marquis Costa de gard et d'offrir ses condoléances mille du défunt.

M. Jean Richepin a fait jeudi son sous la Coupole où s'est fait son ... C'est le rite. Lorsqu'un nouvel a... cien, vêtu de son habit neuf, se devant la lourde porte verte, ... taires portent les armes et le ... bat aux champs. Depuis Napo... il y a toujours eu dans le vest... palais, aux jours de réception a... vien, un piquet d'honneur et ...

Toujours, sauf une fois, ou ... ans, quand M. Etienne Lamy vi... tère de la guerre les démarche... saires pour éviter le retour d'... cien. On lui promit que rie... on ne verrait de clairon sur ... de son récipiendaire. Mais, po... titude, le secrétaire perpétuel ... fois qu'il écrit au ministre pou... mander le piquet, prend soin d'a... *avec un tambour*.

Un clairon ! tout le monde f... cord pour le genre de glace. M. ... Lamy fut reçu sans tambour ... pette.

Le secrétaire de l'Institut fi... tère de la guerre les démarche... saires pour éviter le retour d'...

Futurism

Early Futurist performance was more manifesto than practice, more propaganda than actual production. Its history begins on 20 February 1909 in Paris with the publication of the first Futurist manifesto in the large-circulation daily, *Le Figaro*. Its author, the wealthy Italian poet, Filippo 3 Tommaso Marinetti, writing from his luxurious Villa Rosa in Milan, had 4 selected the Parisian public as the target of his manifesto of 'incendiary violence'. Such attacks on the establishment values of the painting and literary academies were not infrequent in a city enjoying its reputation as the 'cultural capital of the world'. And nor was it the first time that an Italian poet had indulged in such blatant personal publicity: Marinetti's compatriot, D'Annunzio, dubbed 'Divine Imaginifico', had resorted to similarly flamboyant actions in Italy at the turn of the century.

'Ubu Roi' and 'Roi Bombance'

Marinetti had lived in Paris from 1893 to 1896. At the cafés, salons, literary banquets and dance-halls frequented by eccentric artists, writers and poets, the seventeen-year-old Marinetti was soon drawn into the circle around the literary magazine *La Plume* – Léon Deschamps, Remy de Gourmont, Alfred Jarry and others. They introduced Marinetti to the principles of 'free verse', which he immediately adopted in his own writing. On 11 December 1896, the year Marinetti left Paris for Italy, an inventive and remarkable performance was presented by the twenty-three-year-old poet and cyclist fanatic, Alfred Jarry, when he opened his slapstick and absurd production of *Ubu Roi* at Lugné-Poë's Théâtre de l'Oeuvre. The play was modelled on 5 schoolboy farces from Jarry's earlier days at Rennes and on the puppet shows he had produced in 1888 in the attic of his childhood home under the title of *Théâtre des Phynances*. Jarry explained the main features of the production in a letter to Lugné-Poë, also published as the preface to the play. A mask would distinguish the principal character Ubu, who would wear a horse's head of cardboard around his neck, 'as in the old English theatre'. There would be only one set, eliminating the raising and lowering of the curtain, and throughout the performance a gentleman in evening dress would hang up

3 Page showing Futurist manifesto published in *Le Figaro*, February 1909

4 F.T. Marinetti

signs indicating the scene, as in puppet shows. The principal character would adopt 'a special tone of voice' and the costumes would have as 'little colour and historical accuracy as possible'. These, Jarry added, would be modern, 'since satire is modern', and sordid, 'because they make the action more wretched and repugnant . . .'.

All literary Paris was primed for opening night. Before the curtain went up a crude table was brought out, covered with a piece of 'sordid' sacking. Jarry himself appeared white-faced, sipping from a glass, and for ten minutes prepared the audience for what they should expect. 'The action which is about to begin', he announced, 'takes place in Poland, that is to say: nowhere.' And the curtain rose on the one set – executed by Jarry himself, aided by Pierre Bonnard, Vuillard, Toulouse-Lautrec and Paul Sérusier – painted to represent, in the words of an English observer, 'indoors and out of doors, even the torrid, temperate and arctic zones at once'. Then pear-shaped Ubu (the actor Firmin Gémier) announced the opening line, a single word: 'Merdre'. Pandemonium broke out. Even with an added 'r', 'shit' was strictly taboo in the public domain; whenever Ubu persisted in using the word, response was violent. As Père Ubu, the exponent of Jarry's pataphysics, 'the science of imaginary solutions', slaughtered his way to the throne of Poland, fist fights broke out in the orchestra, and demonstrators clapped and whistled their divided support and antagonism. With only two performances of *Ubu Roi*, the Théâtre de l'Oeuvre had become famous.

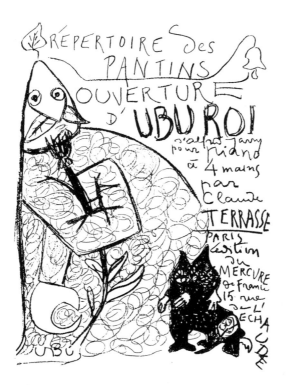

5 Drawing by Alfred Jarry
for poster of *Ubu Roi*, 1896

So it was not surprising that Marinetti, in April 1909, two months after publication of the Futurist manifesto in *Le Figaro*, should present his own play *Roi Bombance* at the same theatre. Not entirely without reference to Marinetti's predecessor-in-provocation, Jarry, *Roi Bombance* was a satire of revolution and democracy. It made a parable of the digestive system, and the poet-hero l'Idiot, who alone recognised the warfare between the 'eaters and eaten', despairingly committed suicide. *Roi Bombance* caused no less of a scandal than Jarry's pataphysician. Crowds stormed the theatre to see how the self-proclaimed Futurist author put into practice the ideals of his manifesto. In fact the style of presentation was not that revolutionary; the play had already been published some years earlier, in 1905. Although it contained many ideas echoed in the manifesto, it only hinted at the kind of performances for which Futurism would become notorious.

First Futurist Evening

On his return to Italy, Marinetti went into action with the production of his play *Poupées électriques* at the Teatro Alfieri in Turin. Prefaced, Jarry-style, by an energetic introduction, mostly based on the same 1909 manifesto, it firmly established Marinetti as a curiosity in the Italian art world and the 'declamation' as a new form of theatre that was to become a trademark of the young Futurists in the following years. But Italy was in the throes of political turmoil and Marinetti recognised the possibilities of utilizing the public unrest and of marrying Futurist ideas for reform in the arts with the current stirrings of nationalism and colonialism. In Rome, Milan, Naples and Florence, artists were campaigning in favour of an intervention against Austria. So Marinetti and his companions headed for Trieste, the pivotal border city in the Austro-Italian conflict, and presented the first Futurist Evening (*serata*) in that city on 12 January 1910 at the Teatro Rosetti. Marinetti raged against the cult of tradition and commercialization of art, singing the praises of patriotic militarism and war, while the heavily-built Armando Mazza introduced the provincial audience to the Futurist 7 manifesto. The Austrian police, or 'walking pissoirs' as they were abusively called, took note of the proceedings and the Futurists' reputation as troublemakers was made. An official complaint by the Austrian consulate was delivered to the Italian government, and subsequent Futurist Evenings were closely watched by large battalions of police.

Futurist painters become performers

Undaunted, Marinetti gathered together painters from in and around Milan to join the cause of Futurism; they organized another Evening at Turin's

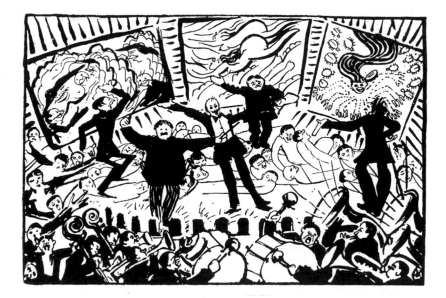

Teatro Chiarella on 8 March 1910. One month later, the painters Umberto
10 Boccioni, Carlo Carrà, Luigi Russolo, Gino Severini and Giacomo Balla,
with the ever present Marinetti, published the *Technical Manifesto of Futurist
Painting*. Having already used Cubism and Orphism to modernize the
appearance of their paintings, the young Futurists translated some of the
original manifesto ideas of 'speed and love of danger' into a blueprint for
Futurist painting. On 30 April 1911, one year after publication of their joint
manifesto, the first group showing of paintings under the Futurist umbrella
opened in Milan with works by Carrà, Boccioni and Russolo among others.
These illustrated how a theoretical manifesto could actually be applied to
painting.

'The gesture for us will no longer be a *fixed moment* of universal
dynamism: it will be decisively the *dynamic sensation* made eternal', they had
declared. With equally ill-defined insistence on 'activity' and 'change' and an
art 'which finds its components in its surroundings', the Futurist painters
turned to performance as the most direct means of forcing an audience to take
note of their ideas. Boccioni for example had written 'that painting was no
longer an exterior scene, the setting of a theatrical spectacle'. Similarly,
Soffici had written 'that the spectator [must] live at the centre of the painted
action'. So it was this prescription for Futurist painting that also justified the
painters' activities as performers.

Performance was the surest means of disrupting a complacent public. It
gave artists licence to be both 'creators' in developing a new form of artists'
theatre, and 'art objects' in that they made no separation between their art as

14

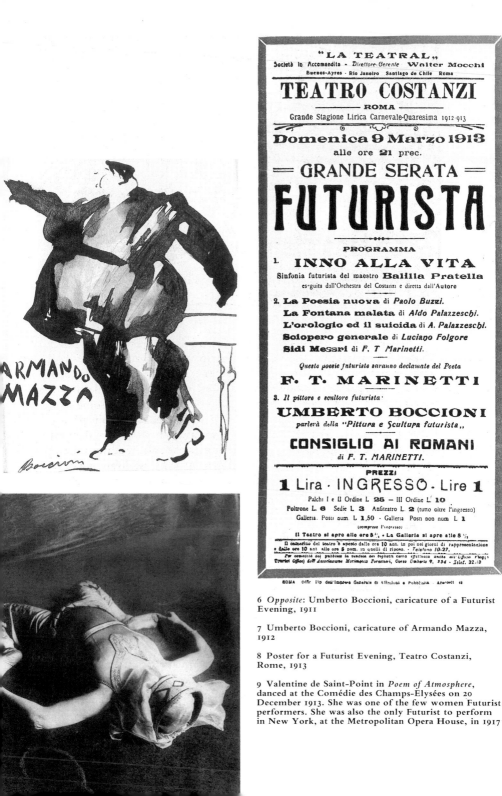

6 *Opposite*: Umberto Boccioni, caricature of a Futurist Evening, 1911

7 Umberto Boccioni, caricature of Armando Mazza, 1912

8 Poster for a Futurist Evening, Teatro Costanzi, Rome, 1913

9 Valentine de Saint-Point in *Poem of Atmosphere*, danced at the Comédie des Champs-Elysées on 20 December 1913. She was one of the few women Futurist performers. She was also the only Futurist to perform in New York, at the Metropolitan Opera House, in 1917

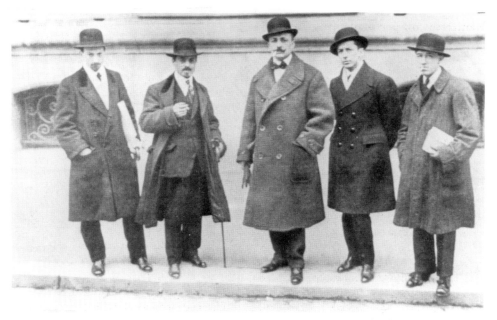

10 Luigi Russolo, Carlo Carrà, F.T. Marinetti, Umberto Boccioni, Gino Severini, in Paris, 1912

poets, as painters or as performers. Subsequent manifestos made these intentions very clear: they instructed painters to 'go out into the street, launch assaults from theatres and introduce the fisticuff into the artistic battle'. And true to form, this is what they did. Audience response was no less hectic – missiles of potatoes, oranges, and whatever else the enthusiastic public could lay their hands on from nearby markets, flew at the performers. Carrà, on one such occasion, retaliated with: 'Throw an idea instead of potatoes, idiots!'

Arrests, convictions, a day or two in jail and free publicity in the next days followed many Evenings. But this was precisely the effect they aimed for: Marinetti even wrote a manifesto on the 'Pleasure of Being Booed' as part of his *War, the Only Hygiene* (1911–15). Futurists must teach all authors and performers to despise the audience, he insisted. Applause merely indicated 'something mediocre, dull, regurgitated or too well digested'. Booing assured the actor that the audience was alive, not simply blinded by 'intellectual intoxication'. He suggested various tricks designed to infuriate the audience: double booking the auditorium, coating the seats with glue. And he encouraged his friends to do whatever came to mind on stage.

So at the Teatro dal Verme in Milan in 1914, the Futurists tore to shreds and then set alight an Austrian flag, before taking the scuffle out onto the streets where more Austrian flags were burnt for 'the fat families lapping their ice cream'.

Manifestos on performance

Manifestos by Pratella on Futurist music had appeared in 1910 and 1911 and one on Futurist playwrights (by thirteen poets, five painters and one musician) in January 1911. The manifestos encouraged the artists to present more elaborate performances and in turn experiments in performance led to more detailed manifestos. For example, months of improvised Evenings with their wide range of performance tactics had led to the *Variety Theatre Manifesto*, when it became appropriate to formulate an official theory of Futurist theatre. Published in October 1913 and a month later in the London *Daily Mail*, it made no mention of the earlier Evenings, but it did explain the intentions behind many of those eventful occasions. By 1913 also, the magazine *Lacerba*, based in Florence and formerly produced by rivals of the Futurists, had become, after much debate, the official organ of the Futurists.

Marinetti admired variety theatre for one reason above all others: because it 'is lucky in having no tradition, no masters, no dogma'. In fact variety theatre did have its traditions and its masters, but it was precisely its *variety* – its mixture of film and acrobatics, song and dance, clowning and 'the whole gamut of stupidity, imbecility, doltishness, and absurdity, insensibly pushing the intelligence to the very border of madness' – that made it an ideal model for Futurist performances.

There were other factors that warranted its celebration. In the first place variety theatre had no story-line (which Marinetti found to be utterly gratuitous). The authors, actors and technicians of variety theatre had only one reason for existing, he said. That was 'incessantly to invent new elements of astonishment'. In addition, variety theatre coerced the audience into collaboration, liberating them from their passive roles as 'stupid voyeurs'. And because the audience 'cooperates in this way with the actors' fantasy, the action develops simultaneously on the stage, in the boxes and in the orchestra'. Moreover, it explained 'quickly and incisively', to adults and children alike, the 'most abstruse problems and most complicated political events'.

Naturally, another aspect of this cabaret form which appealed to Marinetti was the fact that it was 'anti-academic, primitive and naive, hence the more significant for the unexpectedness of its discoveries and the simplicity of its means'. Consequently, in the flow of Marinetti's logic, variety theatre 'destroys the Solemn, the Sacred, the Serious, and the Sublime in Art with a capital A'. And finally, as an added bonus, he offered variety theatre 'to every country (like Italy) that has no single capital city [as] a brilliant résumé of Paris, considered the one magnetic centre of luxury and ultra-refined pleasure'.

One performer was to embody the ultimate destruction of the Solemn and the Sublime and offer a performance of pleasure. Valentine de Saint-

Point, the author of the *Manifesto of Lust* (1913), performed on 20 December 1913 at the Comédie des Champs-Elysées in Paris, a curious dance – poems of love, poems of war, poems of atmosphere – in front of large cloth sheets onto which coloured lights were projected. Mathematical equations were projected onto other walls, while a background of music by Satie and Debussy accompanied her elaborate dance. She was later to perform in 1917 at the Metropolitan Opera House in New York.

Instructions on how to perform

A more carefully designed and elaborate version of earlier Evenings, illustrating some of the new ideas set out in the *Variety Theatre Manifesto*, was *Piedigrotta*, written by Francesco Cangiullo as a 'words-in-freedom' (*parole in libertà*) drama, and performed by Marinetti, Balla and Cangiullo at the Sprovieri Gallery, Rome, on 29 March and 5 April 1914. For this, the gallery, lit by red lights, was hung with paintings by Carrà, Balla, Boccioni, Russolo and Severini. The company – 'a dwarf troupe bristling with fantastic hats of tissue paper' (actually Sprovieri, Balla, Depero, Radiante and Sironi) assisted Marinetti and Balla. They 'declaimed the "words-in-freedom" by the free working Futurist Cangiullo' while the author himself played the piano. Each was responsible for various 'home-made' noise instruments – large sea shells, a fiddle bow (actually a saw with attached rattles of tin) and a small terracotta box covered with skin. Into this box a reed was fitted which vibrated when 'stroked by a wet hand'. According to Marinetti's typical 'non-sense' prose it represented a 'violent irony with which a young and sane race corrects and combats all the nostalgic poisons of Moonshine'.

Typically this performance led to another manifesto, that of *Dynamic and Synoptic Declamation*. Basically it instructed potential performers how to perform, or 'declaim' as Marinetti put it. The purpose of this 'declaiming' technique, he emphasized, was to 'liberate intellectual circles from the old, static, pacifist and nostalgic declamation'. A new dynamic and warlike declamation was desired for these ends. Marinetti proclaimed for himself the 'indisputable world primacy as a declaimer of free verse and words-in-freedom'. This he said equipped him to notice the deficiencies of declamation as it had been understood up until then. The Futurist declaimer, he insisted, should declaim as much with his legs as with his arms. The declaimer's hands should, in addition, wield different noise-making instruments.

The first example of a Dynamic and Synoptic Declamation had been *Piedigrotta*. The second took place at the Doré Gallery in London towards the end of April 1914, shortly after Marinetti's return from a tour of Moscow and St Petersburg. According to the *Times* review the room was 'hung with many specimens of the ultra-modern school of art' and 'Mademoiselle flicflic

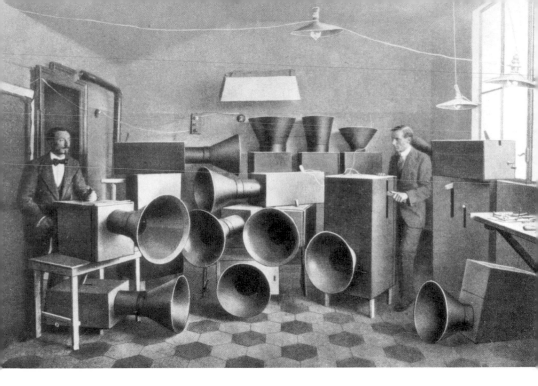

11 Russolo and his assistant Piatti with *intonarumori*, or noise instruments, 1913

12 Marinetti speaking in a Futurist Evening with Cangiullo

13 Title-page of Marinetti's *Zang Tumb Tumb*, 1914

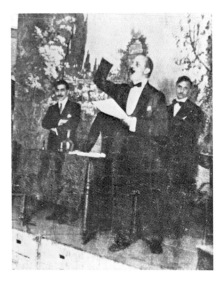

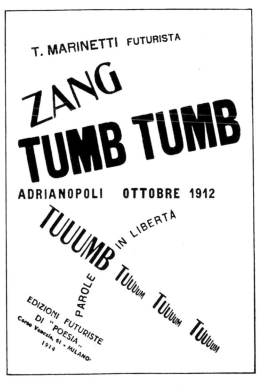

T. MARINETTI FUTURISTA

ZANG

TUMB TUMB

ADRIANOPOLI OTTOBRE 1912

TUUUMB IN LIBERTÀ

PAROLE

TUUUMB TUUUUM TUUUUM TUUUUM

EDIZIONI FUTURISTE
DI "POESIA"
Corso Venezia, 61 - MILANO.
1914

chapchap' – a ballet dancer with cigar holders for legs and cigarettes for neck
– was in attendance. Dynamically and synoptically, Marinetti declaimed
13 several passages from his performance *Zang tumb tumb* (on the siege of
Adrianople): 'On the table in front of me I had a telephone, some boards, and
matching hammers that permitted me to imitate the Turkish general's orders
and the sounds of artillery and machine-gun fire', he wrote. Blackboards had
been set up in three parts of the hall, to which in succession he 'either ran or
walked, to sketch rapidly an analogy with chalk. My listeners, as they turned
to follow me in all my evolutions, participated, their entire bodies inflamed
with emotion, in the violent effects of the battle described by my words-in-
freedom.' In an adjoining room, the painter Nevinson banged two enormous
drums when instructed to do so by Marinetti over the telephone.

Noise music

Zang tumb tumb, Marinetti's 'onomatopoetic artillery' as he called it, was
originally written in a letter from the Bulgarian trenches to the painter
Russolo in 1912. Inspired by Marinetti's description of the 'orchestra of the
great battle' – 'every five seconds siege cannons disembowel space by a chord

– TAM TUUUMB mutiny of five hundred echoes to gore it, mince it, scatter it to infinity' – Russolo began an investigation of the art of noise.

Following a concert by Balilla Pratella in Rome in March 1913, at the crowded Teatro Costanzi, Russolo wrote his manifesto *The Art of Noises*. Pratella's music had confirmed for Russolo the idea that machine sounds were a viable form of music. Addressing himself to Pratella, Russolo explained that while listening to the orchestral execution of that composer's 'forcible Futurist Music', he had conceived of a new art, the Art of Noises, which was a logical consequence to Pratella's innovations. Russolo argued for a more precise definition of noise: in antiquity there was only silence, he explained, but, with the invention of the machine in the nineteenth century, 'Noise was born'. Now, he said, noise had come to reign 'supreme over the sensibility of men'. In addition, the evolution of music paralleled the 'multiplication of machines', providing a competition of noises, 'not only in the noisy atmosphere of the large cities, but also in the country that until yesterday was normally silent', so that 'pure sound, in its exiguity and monotony, no longer arouses emotion'.

Russolo's Art of Noises aimed to combine the noise of trams, explosions of motors, trains and shouting crowds. Special instruments were built which at the turn of a handle would produce such effects. Rectangular wooden boxes, about three feet tall with funnel-shaped amplifiers, contained various motors making up a 'family of noises': the Futurist orchesta. According to Russolo, at least thirty thousand diverse noises were possible.

Performances of noise music were given first at Marinetti's luxurious mansion, Villa Rosa in Milan, on 11 August 1913, and the following June in London at the Coliseum. The concert was reviewed by the London *Times*: 'Weird funnel shaped instruments . . . resembled the sounds heard in the rigging of a channel-steamer during a bad crossing, and it was perhaps unwise of the players – or should we call them the "noisicians"? – to proceed with their second piece . . . after the pathetic cries of "no more" which greeted them from all the excited quarters of the auditorium.' 11

Mechanical movements

Noise music was incorporated into performances, mostly as background music. But just as the *Art of Noises* manifesto had suggested means to mechanize music, that of *Dynamic and Synoptic Declamation* outlined rules for body actions based on the staccato movements of machines. 'Gesticulate geometrically', the manifesto had advised, 'in a draughtsmanlike topological manner, synthetically creating in mid-air, cubes, cones, spirals and ellipses.'

Giacomo Balla's *Macchina tipografica* ('Printing Press') of 1914 realised 15,16
these instructions in a private performance given for Diaghilev. Twelve

people, each part of a machine, performed in front of a backdrop painted with the single word 'Tipografica'. Standing one behind the other, six performers, arms extended, simulated a piston, while six created a 'wheel' driven by the pistons. The performances were rehearsed to ensure mechanical accuracy. One participant, the architect Virgilio Marchi, described how Balla had arranged the performers in geometrical patterns, directing each person to 'represent the soul of the individual pieces of a rotary printing press'. Each performer was allocated an onomatopoeic sound to accompany his or her specific movement. 'I was told to repeat with violence the syllable "STA"', Marchi wrote.

This mechanization of the performer echoed similar ideas by the English theatre director and theoretician Edward Gordon Craig, whose influential magazine *The Mask* (which had reprinted the *Variety Theatre Manifesto* in 1914) was published in Florence. Enrico Prampolini, in his manifestos on *Futurist Scenography* and *Futurist Scenic Atmosphere* (both 1915), called, as Craig had in 1908, for the abolition of the performer. Craig had suggested that the performer be replaced by an *Übermarionette*, but he never actually realised this theory in production. Prampolini, in a disguised attack on Craig, talked of eliminating 'today's supermarionette recommended by recent performers'. Nevertheless the Futurists actually built and 'performed' with those inhuman creatures.

Gilbert Clavel and Fortunato Depero, for instance, presented in 1918 a programme of five short performances at the marionette theatre, Teatro dei Piccoli, at the Palazzo Odescalchi, in Rome. *Plastic Dances* was conceived for less than life-size marionettes. One figure, Depero's 'Great Savage', was taller than a man; its special feature was a small stage which dropped from the belly of the Savage, revealing tiny 'savages' dancing their own marionette routine. One of the sequences included a 'rain of cigarettes' and another a 'Dance of Shadows' – 'dynamic constructed shadows – games of light'. Performed eighteen times, *Plastic Dances* was a great success in the Futurist repertory.

18

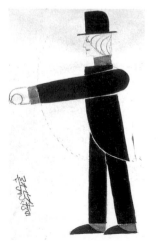

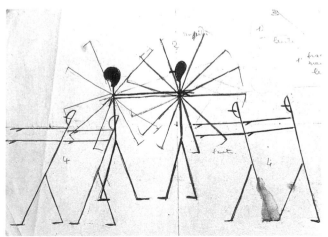

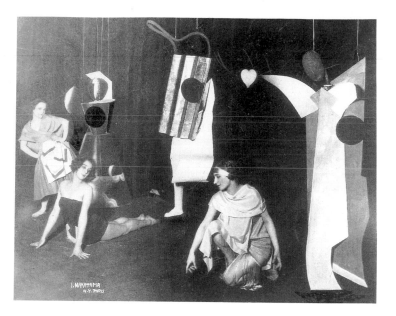

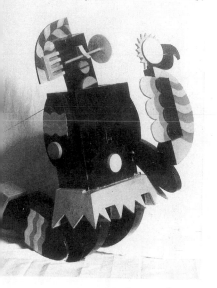

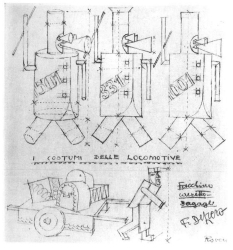

18 'The Great Savage', one of F. Depero's puppets
for his and Clavel's *Plastic Dances*, 1918

19 Depero, costumes for *Macchina del 3000*, a
mechanical ballet with music by Casavola, 1924

15 *Opposite*: Mechanical character from G. Balla's
Futurist composition *Macchina tipografica*, 1914

16 *Opposite*: Balla, drawing of movement of
actors for *Macchina tipografica*, 1914

23

17 *The Merchant of Hearts* by Prampolini and Casavola, presented in 1927, combined marionettes and human figures. Life-size puppets were suspended from the ceiling. More abstract in design, and less mobile than the traditional marionette, these figurines 'performed' together with the live actors.

Futurist ballets

An essential motive behind these mechanical puppets and moving décor was
21 the Futurists' commitment to integrate figures and scenery in one continuous environment. For instance, Ivo Pannaggi had in 1919 designed mechanical costumes for the *Balli Meccanichi*, blending figurines into the painted Futurist setting, while Balla, in a performance of 1917 based on Stravinsky's
20 *Fireworks*, had experimented with the 'choreography' of the setting itself. Presented as part of Diaghilev's Ballets Russes programme at the Teatro Costanzi in Rome, the only 'performers' in *Fireworks* were the moving sets and lights. The set itself was a blown-up three-dimensional version of one of Balla's paintings and Balla himself conducted the 'light ballet' at a keyboard of light controls. Not only the stage, but also the auditorium, was alternately illuminated and darkened in this actor-less performance. In total, the performance lasted just five minutes, by which time, according to Balla's notes, the audience had witnessed no less than forty-nine different settings.

For those 'ballets' by live performers, Marinetti outlined further instructions on 'how to move' in his manifesto on *Futurist Dance* of 1917. There he untypically acknowledged the admirable qualities of certain contemporary dancers, for example Nijinsky, 'with whom the pure geometry of the dance, free of mimicry and without sexual stimulation, appears for the first time', Isadora Duncan and Loie Fuller. But, he warned, one must go beyond 'muscular possibilities' and aim in the dance for 'that ideal multiplied body of the motor that we have so long dreamed of'. How this was to be done, Marinetti explained in great detail. He proposed a Dance of the Shrapnel including such instructions as 'with the feet mark the *boom – boom* of the projectile coming from the cannon's mouth'. And for the Dance of the Aviatrix, he recommended that the danseuse 'simulate with jerks and weavings of her body the successive efforts of a plane trying to take off'!

But whatever the nature of the 'metallicity of the Futurist dance', the figures remained only one component of the overall performance. Obsessively, the numerous manifestos on scenography, pantomime, dance or theatre, insisted on merging actor and scenography in a specially designed space. Sound, scene and gesture, Prampolini had written in his manifesto of *Futurist Pantomime*, 'must create a psychological synchronism in the soul of the spectator'. This synchronism, he explained, answered to the laws of simultaneity that already regulated 'the world-wide Futurist sensibility'.

24

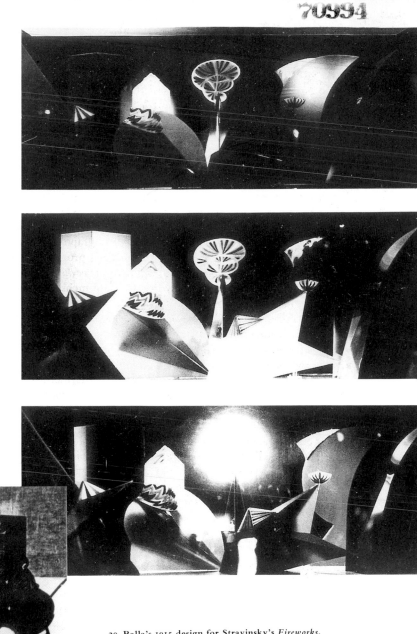

20 Balla's 1915 design for Stravinsky's *Fireworks*, 1917

21 Pannaggi, costume for a ballet by M. Michailov, *c.* 1919. The costumes 'deformed the entire figure bringing about machine-like movements'

25

22 Exit of chairs from
Marinetti's *They're
Coming*, 1915

Synthetic theatre

Such 'synchronism' had been outlined in detail in the manifesto of *Futurist Synthetic Theatre* of 1915. This notion was easily explained: '*Synthetic*. That is, very brief. To compress into a few minutes, into a few words and gestures, innumerable situations, sensibilities, ideas, sensations, facts and symbols.' The variety theatre had recommended representing in a single evening all the Greek, French and Italian tragedies condensed and comically mixed up. It had also suggested reducing the whole of Shakespeare into a single act. Similarly, the Futurist Synthesis (*sintesi*) deliberately consisted of brief, 'one idea' performances. For instance, the single idea in Bruno Corra's and Emilio Settimelli's *Negative Act* was precisely that – negative. A man enters the stage: he is 'busy, preoccupied . . . and walks furiously'. Taking off his overcoat he notices the audience. 'I have absolutely nothing to tell you. . . . Bring down the curtain!', he shouts.

The manifesto condemned 'passéist theatre' for its attempts to present space and time realistically: 'it stuffs many city squares, landscapes, streets, into the sausage of a single room', it complained. Rather, Futurist Synthetic theatre would mechanically, 'by force of brevity, . . . achieve an entirely new theatre perfectly in tune with our swift and laconic Futurist sensibility'. So settings were reduced to a bare minimum. For example, Marinetti's Synthesis 23 *Feet* consisted of the feet of the performers only. 'A curtain edged in black should be raised to about the height of a man's stomach', the script explained. 'The public sees only legs in action. The actors must try to give the greatest expression to the attitudes and movements of their lower extremities.' Seven unrelated scenes revolved around the 'feet' of objects, including two armchairs, a couch, a table and a pedal-operated sewing machine. The brief sequence ended with a foot kicking the shin of another disembodied figure.

22 In *They're Coming*, Marinetti's Synthesis of 1915, the props themselves became the main 'characters'. In a luxurious room lit by a large chandelier, a majordomo simply announced: 'They're coming.' At this point two servants hurriedly arranged eight chairs in a horseshoe beside the armchair. The

23 Marinetti's *Feet*, 1915, a *sintesi* that consisted of only the feet of performers and objects

majordomo ran through the room, crying 'Briccatirakamekame', and exited. He repeated this curious action a second time. Then the servants rearranged the furniture, turned off the lights of the chandelier, and the set remained faintly lit 'by moonlight coming through the French window'. Then the servants, 'wedged into a corner, wait trembling with evident agony, while the chairs leave the room'.

The Futurists refused to explain the meaning of these Syntheses. It was 'stupid to pander to the primitivism of the crowd', they wrote, 'which in the last analysis wants to see the bad guy lose and the good guy win'. There was no reason, the manifesto went on, that the public should always completely understand the whys and wherefores of every scenic action. Despite this refusal to give 'content' or 'meaning' to the Syntheses, many of them revolved around recognisable gags on artistic life. They were timed very much like brief variety theatre sequences, with introductory scene, punch-line and quick exit.

Boccioni's *Genius and Culture* was a short story of a despairing artist, clumsily committing suicide while the ever-present critic, who 'for twenty years had profoundly studied this marvellous phenomenon (the artist)', watched over his quick death. At that point he exclaimed, 'Good, now I'll write a monograph.' Then, hovering over the artist's body 'like a raven near the dead', he began writing, thinking out loud: 'Toward 1915, a marvellous artist blossomed . . . like all great ones, he was 1.68 metres tall, and his width . . .' And the curtain fell.

Simultaneity

A section of the Synthetic theatre manifesto was devoted to explaining the idea of simultaneity. Simultaneity 'is born of improvisation, lightning-like intuition, from suggestive and revealing actuality', it explained. They believed that a work was valuable only 'to the extent that it was improvised

27

(hours, minutes, seconds), not extensively prepared (months, years, centuries)'. This was the only way to capture the confused 'fragments of interconnected events' encountered in everyday life, which to them were far superior to any attempts at realistic theatre.

Marinetti's play *Simultaneity* was the first to give form to this section of the manifesto. Published in 1915, it consisted of two different spaces, with performers in both, occupying the stage at the same time. For most of the play, the various actions took place in separate worlds, quite unaware of each other. At one point, however, the 'life of the beautiful cocotte' penetrated that of the bourgeois family in the adjacent scene. The following year, this concept was elaborated by Marinetti in *Communicating Vases*. There the action took place in three locations simultaneously. As in the earlier play, the action broke through the partitions, and scenes followed in quick succession in and out of the adjacent sets.

The logic of simultaneity led also to scripts written in two columns, as with Mario Dessy's 'Waiting', printed in his book *Your Husband Doesn't Work? . . . Change Him!* Each column described the scene of a young man pacing nervously back and forth, keeping a close eye on their various clocks. Both were awaiting the arrival of their lovers. Both were disappointed.

Some Syntheses could be described as 'play-as-image'. For instance in *There is no Dog*, the only 'image' was the brief walk of a dog across the stage. Others described sensations, as in Balla's *Disconcerted States of Mind*. In this work four people differently dressed recited together various sequences of numbers, followed by vowels and consonants; then simultaneously performed the actions of raising a hat, looking at a watch, blowing a nose, and reading a newspaper ('always seriously'); and finally enunciated together, very expressively, the words 'sadness', 'quickness', 'pleasure', 'denial'. Dessy's *Madness* attempted to instil that very sensation in the audience. 'The protagonist goes mad, the public becomes uneasy, and other characters go mad.' As the script explained, 'little by little everyone is disturbed, obsessed by the idea of madness that overcomes them all. Suddenly the (planted) spectators get up screaming . . . fleeing . . . confusion . . . MADNESS.'

Yet another Synthesis dealt with colours. In Depero's work, actually called *Colours*, the 'characters' were four cardboard objects – Gray (plastic, ovoid), Red (triangular, dynamic), White (long-lined, sharp-pointed) and Black (multiglobed) – and were moved by invisible strings in an empty blue cubic space. Off stage, performers provided sound effects or 'parolibero' such as 'bulubu bulu bulu bulu bulu bulu' which supposedly corresponded to the various colours.

Light, by Cangiullo, began with a stage and auditorium completely in darkness, for 'three BLACK minutes'. The script warned that 'the obsession for lights must be provoked by various actors scattered in the auditorium, so

that it becomes wild, crazy, until the entire space is illuminated in an EXAGGERATED WAY!'

Later Futurist activities

By the mid-twenties the Futurists had fully established performance as an art medium in its own right. In Moscow and Petrograd, Paris, Zurich, New York and London, artists used it as a means to break through the boundaries of the various art genres, applying, to a greater or lesser extent, the provocative and alogical tactics suggested by the various Futurist manifestos. Although in its formative years Futurism had seemed to consist mostly of theoretical treatises, ten years later the total number of performances in these various centres was considerable.

In Paris, the publication of the Surrealist manifesto in 1924 introduced an entirely new sensibility. Meanwhile the Futurists were writing fewer and fewer manifestos of their own. One late one, *The Theatre of Surprise*, written in October 1921 by Marinetti and Cangiullo, did not go far beyond the earlier seminal writings; rather it attempted to place the Futurist activities in historical perspective, giving credit to their earlier work, which they felt had not yet been acclaimed. 'If today a young Italian theatre exists with a serio-comic-grotesque mixture, unreal persons in real environments, simultaneity and interpenetration of time and space', it declared, 'it owes itself to our *synthetic theatre.*'

Nevertheless their activities did not decrease. In fact companies of Futurist performers toured throughout Italian cities, venturing to Paris on several occasions. The Theatre of Surprise company was headed by the actor-manager Rodolfo DeAngelis. In addition to DeAngelis, Marinetti and Cangiullo, it included four actresses, three actors, a small child, two dancers, an acrobat and a dog. Making their début at the Teatro Mercadante in Naples on 30 September 1921, they then toured Rome and Palermo, Florence, Genoa, Turin and Milan. And in 1924 DeAngelis organized the New Futurist Theatre with a repertory of about forty works. With their limited budgets the companies were forced to bring even more of their genius for improvisation into play, and resort to even more forceful measures to 'provoke absolutely improvised words and acts' from the spectators. Just as in earlier performances actors had been planted in the auditorium, so on these tours Cangiullo scattered instruments of the orchestra throughout the house – a trombone was played from a box, a double bass from an orchestra seat, a violin from the pit.

Neither did they leave any field of art untouched. In 1916 they had produced a Futurist film, *Vita futurista*, which investigated new cinematic techniques: toning the print to indicate, for example, 'States of Mind';

distorting images by use of mirrors; love scenes between Balla and a chair; split-screen techniques; and a brief scene with Marinetti demonstrating the Futurist walk. In other words it was a direct application of many of the qualities of the Synthesis to film, with similarly disjointed imagery.

There was even a manifesto of *Futurist Aerial Theatre*, written in April 1919 by the aviator Fedele Azari. He scattered this text from the sky on his 'first flight of expressive dialogue' in the middle of an aerial ballet, producing at the same time flying *intonarumori* [noise intoners] – controlling the volume and sound of the aeroplane's engine – with the device invented by Luigi Russolo. Prized by the flyer as the best means to reach the largest number of spectators in the shortest period of time, the aerial ballet was scripted for performance by Mario Scaparro in February 1920. Entitled *A Birth*, Scaparro's play depicted two aeroplanes making love behind a cloud, and giving birth to four human performers: completely equipped aviators who would jump out of the plane to end the performance.

So Futurism attacked all possible outlets of art, applying its genius to the technological innovations of the time. It spanned the years between the First and Second World Wars, with its last significant contribution taking place around 1933. Already, by that time, the radio had proved itself to be a formidable instrument of propaganda in the changing political climate in Europe; its usefulness was recognised by Marinetti for his own ends. *The Futurist Radiophonic Theatre* manifesto was published by Marinetti and Pino Masnata in October 1933. Radio became the 'new art that begins where theatre, cinematography, and narration stop'. Using noise music, silent intervals and even 'interference between stations', radio 'performances' focused on the 'delimitation and geometric construction of silence'. Marinetti wrote five radio Syntheses, including *Silences Speak Among Themselves* (with atmospheric sounds broken by between eight and forty seconds of 'pure silence') and *A Landscape Hears*, in which the sound of fire crackling alternated with that of lapping water.

Futurist theories and presentations covered almost every area of performance. This was Marinetti's dream, for he had called for an art that 'must be an alcohol, not a balm' and it was precisely this drunkenness that characterized the rising circles of art groups who were turning to performance as a means of spreading their radical art propositions. 'Thanks to us', Marinetti wrote, 'the time will come when life will no longer be a simple matter of bread and labour, nor a life of idleness either, but a *work of art*.' This was a premise that was to underlie many subsequent performances.

Russian Futurism and Constructivism

Two factors marked the beginnings of performance in Russia: on the one hand the artists' reaction against the old order – both the Tzarist régime and the imported painting styles of Impressionism and early Cubism; on the other, the fact that Italian Futurism – suspiciously foreign but more acceptable since it echoed this call to abandon old art forms – was reinterpreted in the Russian context, providing a general weapon against art of the past. The year 1909 – in which Marinetti's first Futurist manifesto was published in Russia as well as Paris – may be regarded as the significant year in this respect.

Such attacks on previously held art values were now expressed in the quasi-Futurist manifesto of 1912 by the young poets and painters Burlyuk, Mayakovsky, Livshits and Khlebnikov, entitled *A Slap in the Face to Public Taste*. In the same year, the 'Donkey's Tail' exhibition was also organized as a protest against 'Paris and Munich decadence', asserting the younger artists' commitment to developing an essentially Russian art following in the footsteps of the Russian avant garde of the 1890s. For while Russian artists had previously looked to western Europe, the new generation promised to reverse that process, to make their impact on European art from an entirely new Russian vantage-point.

Groups of writers and artists sprang up throughout the major cultural centres of St Petersburg, Moscow, Kiev and Odessa. They began to arrange exhibitions and public debates, confronting audiences with their provocative declarations. The meetings soon gathered momentum and an enthusiastic following. Artists such as David Burlyuk lectured on Raphael's Sistine Madonna with photographs of curly-haired boys, attempting to upset respectful attitudes towards art history with his unconventional juxtaposition of a serious painting and random photographs of local youths. Mayakovsky made speeches and read his Futurist poetry, proposing an art of the future.

The Stray Dog Café

Soon a bar in St Petersburg became the rendezvous of the new artistic élite.
The Stray Dog Café, located in Mikhailovskaya Square, attracted poets like
24 Khlebnikov, Anna Andreyevna, Mayakovsky and Burlyuk (and their circle)
as well as the editors of the up-and-coming literary magazine *Satyricon*. There
they were introduced to the tenets of Futurism: Viktor Shklovsky lectured
on 'The Place of Futurism in the History of Language' and all wrote
manifestos. The scathing comments of the Stray Dog habitués towards past
art resulted in violent scuffles, just as angered Italian crowds had broken up
Futurist meetings a few years earlier.

The Futurists were a guaranteed evening's entertainment, drawing
crowds in St Petersburg and Moscow. Soon tired of the predictable café
audience, they took their 'Futurism' to the public: they walked the streets in
outrageous attire, their faces painted, sporting top hats, velvet jackets,
earrings, and radishes or spoons in their button-holes. 'Why We Paint
Ourselves: A Futurist Manifesto' appeared in the magazine *Argus* in St

24 David Burlyuk and Vladimir Mayakovsky, 1914

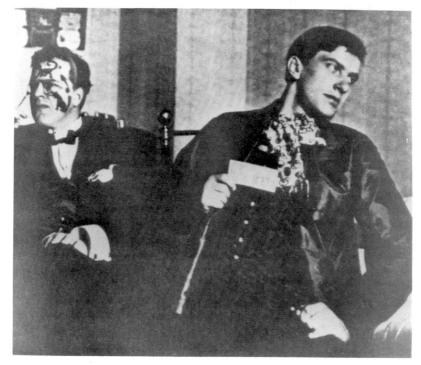

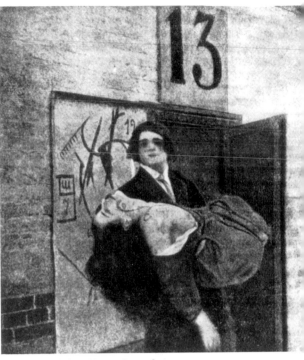

25 The clown Lazarenko, who worked closely with the Futurists in numerous productions

26 *Drama in Cabaret No. 13.* Scene from a Futurist film showing 'everyday' life of the Futurists. The picture shows Larionov, with Goncharova in his arms

Petersburg in 1913; declaring that their self-painting was the first 'speech to have found unknown truths', they explained that they did not aspire to a single form of aesthetics. 'Art is not only a monarch', it read, 'but also a newsman and a decorator. The synthesis of decoration and illustration is the basis of our self-painting. We decorate life and preach – that's why we paint ourselves.' A few months later, they took off on a Futurist tour of seventeen cities, Vladimir Burlyuk carrying with him a twenty-pound pair of dumb-bells in the name of the new art. His brother David wore the notice 'I–Burlyuk' on his forehead, and Mayakovsky routinely appeared in his 'bumble-bee' outfit of black velvet suit and striped yellow jumper. Following the tour, they made a film, *Drama in Cabaret No. 13*, recording 26 their everyday Futurist life, followed by a second film, *I Want to be a Futurist*, with Mayakovsky in the lead and the clown and acrobat from the State Circus, Lazarenko, in the supporting cast. Thus they set the stage for art 25 performance, declaring that life and art were to be freed from conventions, allowing for the limitless application of these ideas to all the realms of culture.

33

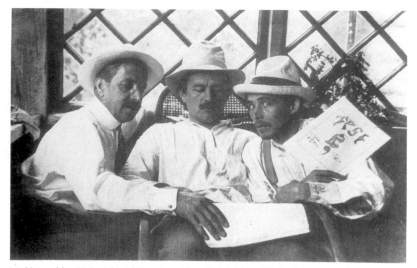

27 Matyushin, Malevich and Kruchenykh at Uuisikirkko, Finland, in 1913. The composer, designer and author of the first Futurist opera, *Victory Over the Sun*, presented in that same year

'Victory Over the Sun'

In October 1913, Russian Futurism moved from the streets and 'home-movies' to St Petersburg's Luna Park. Mayakovsky had been working on his tragedy, *Vladimir Mayakovsky*, and his friend and Futurist poet, Alexei Kruchenykh, was planning an 'opera', *Victory Over the Sun*. A small notice appeared in the journal *Speech* inviting all those wishing to audition for the productions to go to the Troyitsky Theatre; 'Actors do not bother to come, please', it read. On 12 October numerous students showed up at the theatre. One of them, Tomachevsky, wrote: 'None of us had seriously considered the possibility of being hired . . . we had before us the opportunity not only of seeing the Futurists, but of getting to know them, so to speak, in their own creative environment.' And there were a number of Futurists for them to see: twenty-year-old Mayakovsky, dressed in top hat, gloves and black velvet coat; clean-shaven Kruchenykh and mustachioed Mikhail Matyushin who wrote the score of the opera; Filonov, co-designer of the backcloth for Mayakovsky's tragedy, and Vladimir Rappaport, the Futurist author and administrator.

First, Mayakovsky read his work. He made no attempt to disguise the theme of the play, a celebration of his own poetic genius, with obsessive repetition of his own name. Most of the characters, even those who paid respect to Mayakovsky, were 'Mayakovsky': The Man Without a Head, The

34

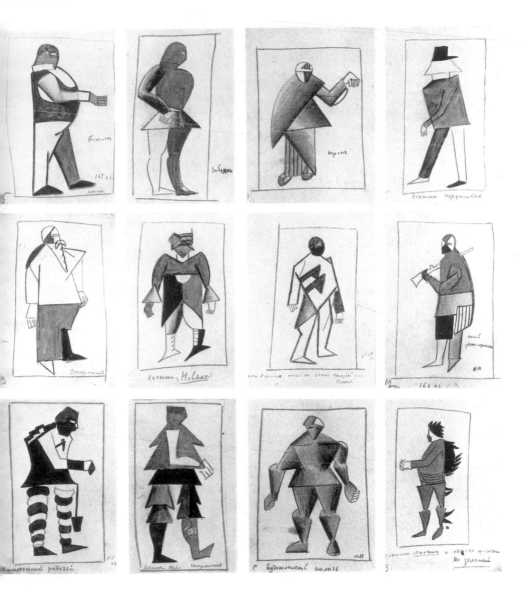

28 Malevich's designs for the costumes of *Victory Over the Sun*

Man With One Ear, The Man With One Eye and One Leg, The Man With Two Kisses, The Man With a Long Drawn-Out Face. Then there were the women: The Woman With a Tear, The Woman With a Great Big Tear, and The Enormous Woman, whose veil was torn off by Mayakovsky. Under the veil was a twenty-foot-tall female doll, hoisted up and carried away. Only then did Mayakovsky choose a few, select 'actors' to feature in the celebration of himself.

Kruchenykh was more liberal. He cast almost everybody left out of the tragedy for his opera. He asked those auditioning to pronounce all words with pauses between each syllable: 'The cam-el-like fac-to-ries al-read-y threat-en us . . .'. According to Tomachevsky, he constantly invented something new and 'was getting on everyone's nerves'.

Victory Over the Sun, essentially a libretto which narrated how a band of 'Futurecountrymen' set out to conquer the sun, drew young Futurists to the rehearsals. 'The theatre at Luna Park became a sort of Futurist salon', Tomachevsky wrote. 'Here one could meet all the Futurists, beginning with the handsome Kublin, and ending with the inexperienced puppies who persistently followed Burlyuk and the other Futurist masters around. Everyone came there: Futurist poets, critics and painters.'

28 Kasimir Malevich designed the scenery and costumes for the opera. 'The painted scenery was Cubist and non-objective: on the backdrops were painted conical and spiral forms similar to those painted on the curtain (that the Futurecountrymen tore apart in the opening scene)', Tomachevsky remembered. 'The costumes were made of cardboard and resembled armour painted in Cubist style.' The actors, wearing papier-mâché heads that were larger than life-size, performed on a narrow strip of stage with puppet-like gestures. Kruchenykh, the author, approved the stage effects: 'They were as I expected and wanted. A blinding light came from the projectors. The scenery was made of big sheets – triangles, circles, bits of machinery. The actors' masks reminded one of modern gas masks. The costumes transformed the human anatomy, and the actors moved, held and directed by the rhythm dictated by the artist and director.' Malevich subsequently described the opening scene: 'The curtain flew up, and the spectator found himself in front of a white calico on which the author himself, the composer and the designer were represented in three different sets of hieroglyphics. The first chord of music sounded, and the second curtain parted in two, and an announcer and troubadour appeared and an I-don't-know-what with bloody hands and a big cigarette.'

The two productions were an enormous success. Police stood in large numbers outside the theatre. Crowds attended the more than forty lectures, discussions and debates organized in the weeks following. Yet the St Petersburg press remained in a state of complete ignorance and perplexity

about the importance of these events. 'Is it possible', asked Mikhail Matyushin, composer of the music for *Victory Over the Sun*, 'that they [the press] are so tightly knit by their herd instinct that it does not allow them to have a close look, to learn and meditate about what is happening in literature, music and the visual arts at the present time?' The changes that many found so indigestible included a complete displacement of visual relationships, the introduction of new concepts of relief and weight, certain new ideas of form and colour, of harmony and melody and a breakaway from the traditional use of words.

The non-sense and non-realism of the libretto had suggested to Malevich the puppet-like figures and geometric stage sets. In turn, the figurines determined the nature of the movements and therefore the entire style of the production. In later performances mechanical figures appeared, developing the ideals of speed and mechanization expressed by the Rayonnists' and Futurists' paintings. The figures were visually broken by blades of lights, alternately deprived of hands, legs and torso, even subjected to total dissolution. The effects of these merely geometric bodies and of abstract spatial representation on Malevich's later work were considerable. It was to *Victory Over the Sun* that Malevich attributed the origins of his Suprematist paintings, with their characteristic features of white and black square and trapezoid forms. *Victory Over the Sun* represented a comprehensive collaboration by the poet, the musician and the artist, setting a precedent for the years to come. Yet its complete breakaway from the traditional theatre or opera did not ultimately define a new genre. According to Matyushin, it presented the 'first performance on a stage of the disintegration of concepts and words, of old staging and of musical harmony'. In retrospect, it was a transitional event: it had succeeded in suggesting new directions.

Foregger and the renaissance of the circus

Victory Over the Sun and *Vladimir Mayakovsky* had clinched the close relationship between painters and poets. Encouraged by their success, writers went on to plan new productions which would incorporate the newly established artists as designers, and the painters organized new exhibitions. The 'First Futurist Exhibition: Tramway V' took place in February 1915 in Petrograd. Financed by Ivan Puni, it brought together the two key figures of the emerging avant garde, Malevich and Tatlin. Malevich showed works from 1911 to 1914 while Tatlin exhibited his 'Painting Reliefs', not previously seen in a group exhibition. There were also the works of many artists who had just a year earlier returned to Moscow at the outbreak of the war in Europe; for unlike other centres where the war separated the various members of art groups, Moscow enjoyed the reunion of Russian artists.

Only ten months later, Puni organized the 'Last Futurist Exhibition of Pictures: o.10'. Malevich's *Black Square on a White Background* and two Suprematist pamphlets marked the event. But more importantly for performance, it was following this exhibition that Alexandra Exter was commissioned by Tairov, the producer and founder of the Moscow Kamerny Theatre, to prepare sets and costumes for his productions. Essentially their theory of 'Synthetic Theatre' integrated set, costume, actor and gesture. Tairov elaborated his study of spectator participation, citing music hall as the only true means of achieving it. Thus the early Revolutionary collaborations saw the gradual adaptation of Futurist and Constructivist ideas to theatre in the name of 'production art'.

Production art was virtually an ethical proclamation by the Constructivists: they believed that in order to oust the reigning academicism, speculative activites such as painting and the 'outmoded tools of brushes and paint' must be put aside. Moreover they insisted that artists use 'real space and real materials'. Circus, music hall and variety theatre, the eurhythmics of Emile Jaques-Dalcroze and eukinetics of Rudolf von Laban, Japanese theatre and the puppet show were all meticulously examined. Each suggested possibilities for arriving at popular entertainment models which would appeal to large and not necessarily educated audiences. Liberally laced with news of social and political events, ideology and the new spirit of Communism, they seemed the perfect vehicles for communicating the new art as much as the new ideology to a wide public.

One artist was to become the catalyst of such a variety of obsessions. Nikolai Foregger had arrived in Moscow from his native Kiev in 1916 and did a brief apprenticeship at the Kamerny Theatre before it closed in February 1917. He was just in time to witness the excitement in the press, stirred by the young Rayonnists, Constructivists and art-activists. Fascinated by the endless discussions held at exhibitions, and by the mechanization and abstraction of art and theatre, he extended these ideas to include dance. In search of physical means by which to mirror the stylized designs of the pre-Revolutionary avant garde, he examined acting gestures and dance movements. After only a year in Moscow, he went to Petrograd, where he set up a workshop in his small studio-cum-theatre to carry out these studies.

To begin with, he broke down the traditional elements of French medieval court farce and of the commedia dell'arte of the seventeenth and eighteenth centuries, in a series of productions, such as Platuz's *The Twins* (1920), under the umbrella title of 'The Theatre of the Four Masks'. These early presentations in the years immediately following the revolution were initially successful, but audiences soon tired of his 'classical' and therefore reactionary reinterpretation of theatre forms. As a result, Foregger tried to find a form of popular theatre more appropriate to the demands of the new

38

socialist attitudes, this time with a playwright, poet and theatre critic, Vladimir Mass. The two joined agit-trains and experimented with political humour before moving to Moscow in 1921 where they continued to develop their idea of a theatre of masks, its characters now directly reflecting current events. For example, Lenin had implemented his New Economic Policy (NEP), intended to stabilize Russia's fluctuating economy: for Foregger, 'Nepman' became the stereotype of the Russian bourgeois taking advantage of the liberal economic policies. Nepman, along with the Intellectual Mystic, the Militant Female Communist with leather brief case and the Imagist Poet, all became the stock characters of Foregger's workshop, the newly formed Mastfor Studio.

Students active in designing productions for Mastfor were the young film makers such as Eisenstein, Yutkevich, Barnet, Fogel and Illinsky. The seventeen-year-old Yutkevich and Eisenstein designed 'The Parody Show', comprising three sketches: 'For Every Wiseman One Operetta is Enough', 'Don't Drink the Water Unless It's Boiled' and 'The Phenomenal Tragedy of Phetra'. Together they introduced elaborate new techniques, referred to as being 'American' for their emphasis on mechanical devices. Yutkevich designed Mass's *Be Kind to Horses* (1922): in it he devised a fully mobile environment with moving steps and treadmill, trampolines, flashing electric signs and cinema posters, rotating décor and flying lights. Eisenstein was responsible for the costumes, one of which dressed a female figure in a spiral of hoops, fastened by multi-coloured ribbons and thin strips of coloured paper.

In *The Kidnapping of Children* (1922), Foregger added to the music hall elements of the earlier productions the process of 'cinefication' – spotlights were projected onto rapidly revolving discs producing cinematic effects. Apart from these mechanistic inventions, Foregger introduced two further theories: one was his 'tafiatrenage' – a training method never explicitly codified but stressing the importance of technique for the physical and psychological development of the performer – and the other, outlined in his lecture of February 1919 at the Union of International Artists of the Circus, was his belief in 'the renaissance of the circus'. Both ideas marked a step in the use of extra-painting and extra-theatrical devices in the search for new performance modes.

Foregger held the circus to be the 'Siamese twin' of the theatre, citing Elizabethan England and seventeenth-century Spain as models of perfect theatre-circus combinations. Insisting on a new system of dance and physical training – 'we view the dancer's body as a machine and the volitional muscles as the machinist' – tafiatrenage was not unlike other body theories such as Meyerhold's bio-mechanics or Laban's eukinetics. Bio-mechanics was a 37–40 system of actor training based on sixteen 'Etudes' or exercises which helped

29 Foregger's dance company, extract from *Mechanical Dances*, 1923. One of the dances imitated a transmission

the actor to develop the necessary skills for scenic movement, for example moving in a square, a circle or a triangle. Tafiatrenage, on the other hand, was seen by Foregger not merely as a pre-performance training system but as an art form in itself.

29 Foregger's *Mechanical Dances* were first performed in February 1923. One of the dances imitated a transmission: two men stood about ten feet apart and several women, holding onto each other's ankles, moved in a chain around them. Another dance represented a saw: two men holding the hands and feet of a woman, swinging her in curved movements. Sound effects, including the smashing of glass and the striking of different metal objects backstage, were provided by a lively noise orchestra.

The *Mechanical Dances* were enthusiastically received, but they were soon to come in for harsh criticism from several workers who wrote to the theatrical trade magazine, threatening to report Foregger's company for its 'anti-Soviet' and 'pornographic' productions. The Russian critic Cherepnin called it 'half-mythical, half-legendary Americanism', for Foregger's mechanical art seemed foreign to Russian sensibilities and appeared as a mere curiosity. He was accused of moving too far towards music hall and entertainment, away from the social and political significance demanded of productions of the time.

Revolutionary performances

While Foregger was developing a purely mechanistic art form, which was appreciated more for its aesthetic than ethical inspiration, other artists,

40

playwrights and actors favoured the propaganda machine, for it made immediate and comprehensible the new policies and the new life styles of the revolution.

For Mayakovsky, for example, 'there was no such question', he wrote. 'It was my revolution.' Along with his colleagues, he believed that propaganda was crucial: 'spoken newspapers', posters, theatre and film were all used to inform a largely illiterate public. Mayakovsky was among the many artists who joined ROSTA, the Russian Telegraph Agency. 'Window ROSTA was 30 a fantastic thing', he recalled. 'It meant telegraphed news immediately translated into posters and decrees into slogans. It was a new form that spontaneously originated in life itself. It meant men of the Red Army looking at posters before a battle and going to fight not with a prayer but a slogan on their lips.'

Soon, the success of the windows and billboard posters led to live events. Posters were projected in sequence in a series of images. Travelling productions began with the filming of a title such as 'All Power to The People!' This was followed by static images demonstrating and elaborating the idea of the slogan. The poster became part of the scenography and performers appeared with a series of posters painted on canvas.

Agit-trains and ships, ROSTA and agit-street theatre were only some of 31,32 the outlets available for the young artists intent on abandoning purely 'speculative activities' for socially utilitarian art. Performances took on a new meaning, far from the art experiments of the earlier years. Artists masterminded May the First pageants depicting the Revolutionary take-over, decorating the streets and involving thousands of citizens in dramatic reconstructions of highlights from 1917.

A mass demonstration was organized by Nathan Altman and other Futurists for the first anniversary of the October Revolution, in 1918. It took place in the street and on the square of the Winter Palace in Petrograd; yards of Futurist paintings covered the buildings and a mobile Futurist construction was attached to the obelisk in the square. This and other extraordinary spectacles culminated two years later, on 7 November 1920, in the third anniversary celebrations. 'The Storming of the Winter Palace' involved a 33,34 partial reconstruction of events preceding the October Revolution and of the actual storming of the palace against the entrenched Provisional Government. Under the chief directorship of Nikolai Yevreinov, three major theatre directors, Petrov, Kugel and Annenkov (who also designed the sets), organized an army battalion and more than 8000 citizens in a re-enactment of the events of that day three years earlier.

The work was staged in three main areas surrounding the palace, and streets leading to the square were filled with army units, armoured cars and army trucks. Two large platforms, each about sixty yards long and eighteen

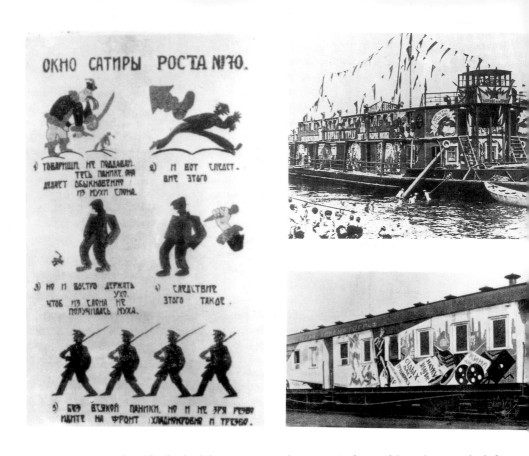

yards wide, flanked the entrance to the square in front of the palace: on the left the 'red' platform, of the Red Army (the proletariat), and on the right the 'white' platform where the Provisional Government presided. The white platform included 2685 participants, among them 125 ballet dancers, 100 circus artistes, and 1750 extras. The red platform was equally large, and included as many of the original workers that had participated in the actual battle as Yevreinov could find. Beginning about 10 pm, the performance opened with a gun shot, and an orchestra of five hundred played a symphony by Varlich, ending with 'La Marseillaise', the music of the Provisional Government. Hundreds of voices shouted 'Lenin! Lenin!' and while 'La Marseillaise' was repeated, slightly out of tune, the crowds roared the 'Internationale'. Finally, trucks filled with workers sped through the arch into the square, and reaching their destination, into the Winter Palace itself. As the revolutionaries converged on the building, the Palace, that had previously been dark, was suddenly illuminated by a flood of lights in the building, fireworks and a parade of the armed forces.

42

30 *Opposite*:
Mayakovsky's Window
ROSTA poster

31, 32 Agit-ship and
train, 1919, popular
features of post-
revolutionary
propaganda activities.
They carried
performers and news
to all parts of Russia

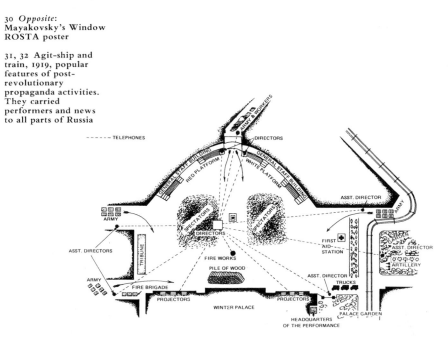

33 Diagram of layout for 'The Storming of the Winter Palace' event, 1920

34 'The Storming of the Winter Palace', on the third anniversary of the Russian
Revolution, 7 November 1920. It was directed by Yevreinov, Petrov, Kugel and
Annenkov and involved more than eight thousand performers

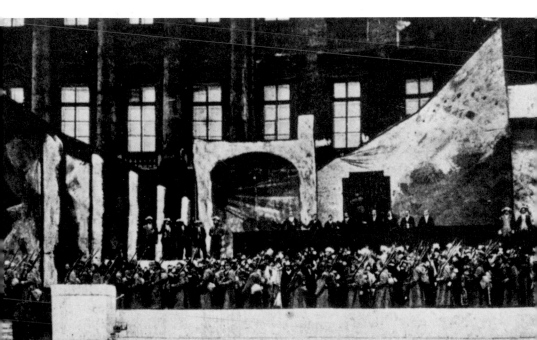

35 Costume by Popova for *The
Magnificent Cuckold*, 1922

36 Drawing for set of *The Magnificent Cuckold*, by Popova

'The Magnificent Cuckold'

The momentum of the anniversary productions had brought just about
every possible technique and style of painting, theatre, circus and film into
play. As such the limits of performance were endless: nowhere was there an
attempt to classify or restrict the different disciplines. Constructivist artists
committed to production art worked continuously on developing their
notions of an art in real space, announcing the death of painting.

By 1919, before he was acquainted with the Constructivists, the theatre
director Vsevolod Meyerhold had written: 'We are right to invite the Cubists
to work with us, because we need settings which resemble those we shall be
performing against tomorrow. We want our setting to be an iron pipe, of the
open sea or something constructed by the new man . . . we'll erect a trapeze
and put our acrobats to work on it, to make their bodies express the very
essence of our revolutionary theatre and remind us that we are enjoying the
struggle we are engaged in.' Meyerhold found in the Constructivists the set
designers he had been longing for. When in 1921 circumstances forced him to
seek a setting which could be erected anywhere, without resort to
conventional stage machinery, Meyerhold saw in the Constructivists' work
the possibility of a utilitarian multi-purpose scaffolding which could easily be
dismantled and reassembled. Popova's catalogue entries to the '5 × 5 = 25'
exhibition that year in Moscow confirmed Meyerhold's belief that he had
found the designer to build his stage set. She had declared: 'All the given
constructions [in the exhibition] are pictorial and must be considered simply
as a series of preparatory experiments towards materialized constructions',
leaving it open to suggestion as to how this end would be attained.

44

Clearly Meyerhold sensed that Constructivism led the way to militating against the worked out aesthetic tradition of theatre, enabling him to realise his dream of extra-theatrical productions removed from the box-like auditorium, to any place: the market, the foundry of a metal plant, the deck of a battleship. He discussed this project with various members of the group, Popova in particular. Yet collaboration was not always as smooth as the final production might suggest. When, by early 1922, Meyerhold suggested a performance based on Popova's spatial theories, she flatly refused: the Constructivist group as a whole was reluctant to enter into production. Too hasty a decision would have meant taking the risk of discrediting the new ideas. Meyerhold, however, was convinced that the Constructivists' work was ideal for his new production, that of Crommelynck's *The Magnificent* 35,36 *Cuckold*. He slyly approached each of the artists individually, asking them to submit preparatory studies, just for a contingency. Each worked in secret, unaware that the others were designing models for the production: the presentation in April 1922 was thus a joint effort with Popova as the coordinator.

The *Magnificent Cuckold* stage set consisted of frames of conventional theatre flats, platforms joined by steps, chutes and catwalks, windmill sails, two wheels and a large disc bearing the letters CR–ML–NCK (standing for Crommelynck). The characters wore loose-fitting overalls, but even with their comfortable dress would need acrobatic skills to 'work' the set. Thus the production became the ideal forum for Meyerhold's system of biomechanics, described earlier, which he had developed shortly before. Having 37–40 studied Taylorism, a method of work efficiency then popular in the United States, he called for a 'Taylorism of the theatre [which] will make it possible to perform in one hour that which requires four at present'.

37–40 A series of poses from Meyerhold's bio-mechanical exercises, made up of sixteen 'Etudes', for the training of actors

The success of *The Magnificent Cuckold* established the Constructivists as the leaders in stage design. This work was the culmination of an exchange between the arts, for in this production, the artist not only responded to the theatrical needs of an innovative director, but actually transformed the nature of acting and the very intent of the play through devising such complex 'acting machines'.

The Blue Blouse and the Factory of the Eccentric Actor

Each year saw innovations in art, architecture and theatre; new groups formed with such regularity that it became impossible to pinpoint the exact sources of each 'manifesto' or even of the originators. Artists constantly moved from one workshop to another: Eisenstein worked with Foregger, then with Meyerhold; Exter with Meyerhold and Tairov; Mayakovsky with ROSTA, Meyerhold and the Blue Blouse Group.

41,43 The Blue Blouse Group was officially formed in October 1923; overtly political, it employed avant-garde as well as popular techniques, specifically intended for a mass audience. At its height, it probably involved more than 100,000 people, with its numerous clubs in cities throughout the country. Using agit-prop, 'living newspapers' and the tradition of the club theatre, their repertory was essentially made up of film, dance and animated posters. In many ways it was the ultimate realisation, on a grand scale, of Marinetti's variety theatre, 'the healthiest of all spectacles in its dynamism of form and colour and the simultaneous movement of jugglers, ballerinas, gymnasts, riding masters, and spiral cyclones'. Another source for these extravaganzas was Eisenstein's staging of Ostrovsky's *Diary of a Scoundrel*, which included a montage of twenty-five different attractions: film, clown acts, sketches, farcical scenes, choral agit-song and circus acts. Mastfor's laboratory no less suggested technical devices and the use of film collage; Meyerhold's bio-mechanics also greatly influenced the overall style of the Blue Blouse performances.

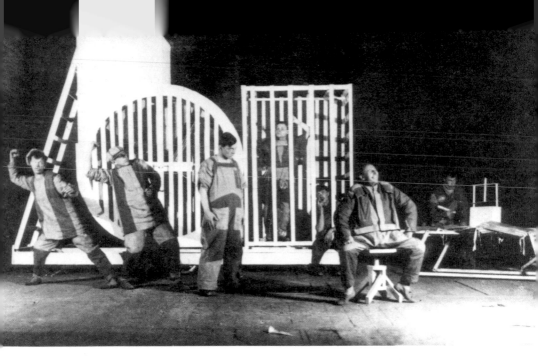

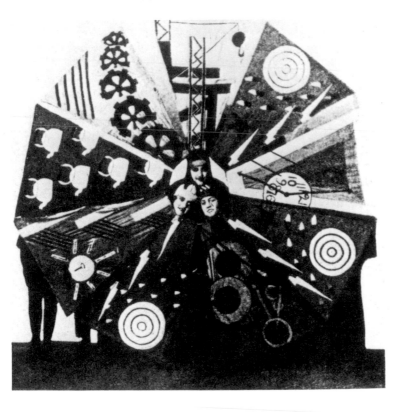

42 (*above*) Scene from Meyerhold's production of *Tarelkin's Death*, designed by Varvara Stepanova, Rodchenko's wife, Moscow, 1922

41 (*opposite*), 43 The Blue Blouse Group, founded in 1923. Huge posters were placed on the stage, with holes cut out for heads, arms and legs of actors who recited texts based on controversial political and social events

The mechanistic devices employed in the group, with its ability to mount large-scale 'industrial productions', also reflected the work of an earlier group, the Factory of the Eccentric Actor, or FEKS. In love with the new industrial society that the United States exemplified, FEKS promoted those aspects most typical of American life: high technology and 'low culture' – jazz, comic books, music hall, advertisements and so on. Specially notable 42 was the production of Sukhovo-Kobylin's play *Tarelkin's Death*, for which Stepanova designed collapsible furniture. Once more, the Russian performance productions had realised some of the tenets set out in the Futurist manifestos of almost a decade earlier, for Fortunato Depero had called for a theatre in which 'everything turns – disappears – reappears, multiplies and breaks, pulverizes and overturns, trembles and transforms into a cosmic machine that is life'. Although FEKS manifestos tried to refute the influence of the Italian Futurists, it was in their productions that those earlier ideas were consistently realised.

'Moscow is Burning'

Theatre had been drawn into art production as much as art production had transformed theatre. Russia was experiencing a cultural riot as violent as the 1905 Revolution; it was as though that energy had never been stopped. And in 1930, the twenty-fifth anniversary of that fateful Bloody Sunday when workers protested outside the Winter Palace and were shot as they fled, a period was nearing its end. Mayakovsky, in a final tragic gesture, was to 44 prepare the commemoration: *Moscow is Burning*. Commissioned by the Soviet Central Agency of State Circuses, the pantomime was presented in the second half of the circus programme. All the possibilities of the circus were used, and *Moscow is Burning* was an entirely new phenomenon in the field of circus pantomime. A sharp political satire, it told the story of the first days of the Revolution, in motion-picture style. Five hundred performers participated in the spectacle: circus artistes, students from the drama and circus schools, and cavalry units. *Moscow is Burning* opened on 21 April 1930 at the First Moscow State Circus. One week earlier, on 14 April, Mayakovsky had shot himself.

Although 1909 marked the beginning of artists' performance, it was 1905, the year of Bloody Sunday, that actually triggered off a theatrical and artistic revolution in Russia. For the increasing energy of the workers in attempting to oust the Tzarist regime led to a working-class theatrical movement which soon attracted the participation of numerous artists. On the other hand, 1934 dramatically marked a second turning-point in theatre and artists' performance, putting a stop to almost thirty years of extraordinary productions. In that year the annual ten-day Soviet Theatre Festival opened with works

revived from the early and mid-twenties: Meyerhold's *The Magnificent Cuckold* of 1922, Tairov's *The Hairy Ape* of 1926 and Vakhtangov's *Princess Turandot* of 1922 brought the curtain down on an experimental era. For, not coincidentally, it was in 1934, at the Writers Congress in Moscow, that Zhdanov, the party spokesman for matters affecting the arts, delivered the first definitive statement on socialist realism, outlining an official and enforceable code for cultural activity.

44 **The pyramid setting from** *Moscow is Burning*, **presented in an actual circus, the First Moscow State Circus, to commemorate the twenty-fifth anniversary of the 1905 Bloody Sunday revolution**

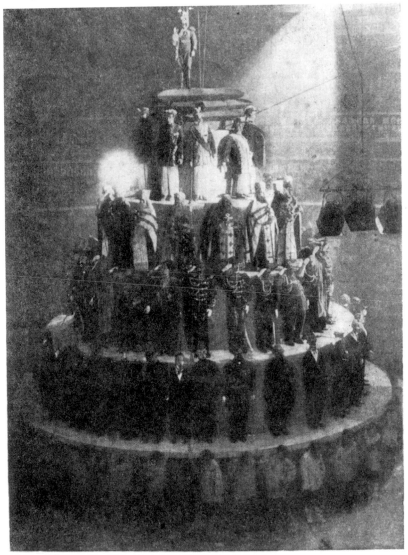

Dada

Wedekind in Munich

Long before Dada's activities began at the Cabaret Voltaire in Zurich in 1916, cabaret theatre was already popular night-life entertainment in German cities. Munich, a thriving art centre before the war, was the city from which came the two key personalities of the Cabaret Voltaire – its founders the night club entertainer Emmy Hennings and her future husband Hugo Ball. Noted for the Blaue Reiter group of Expressionist painters and for its prolific Expressionist theatre performances, Munich was also famous for its bars and cafés, that were the focal point for the city's bohemian artists, poets, writers and actors. It was in cafés like the Simplicissmus (where Ball met Hennings, one of the cabaret stars) that their half-written manifestos and partly edited magazines were discussed in the dim light while, on small platform stages, dancers and singers, poets and magicians played out their satirical sketches based on everyday life in the prewar Bavarian capital. In these so-called 'intimate theatres', eccentric figures flourished, among them Benjamin
45 Franklin Wedekind, better known as Frank Wedekind.

Notorious as a man determined to provoke, especially on sexual topics, his standard first line to young women was inevitably 'Are you still a virgin?', to which he would add a sensual grimace, said to be only partly the result of his ill-fitting dentures. Called 'libertine', 'anti-bourgeois exploiter of sexuality', a 'threat to public morality', Wedekind would perform cabaret when lost for capital to produce his plays or when thwarted by official censorship. He would even urinate and masturbate on stage and according to Hugo Ball, induce convulsions 'in his arms, his legs, his —— and even in his brain', at a time when morality was still chained to Protestant archbishops' gowns. An equally anti-bourgeois arts scene appreciated the scathing criticism built into each of his provocative performances.

His plays were no less controversial. Following temporary exile in Paris and several months in prison for censorship violation, Wedekind wrote his famous satire on Munich life, *Der Marquis von Keith*. Greeted with derision by public and press, he retorted with the play *König Nicolò, oder So Ist das Leben* ('King Nicolo, or Such is Life') in 1901, a vicious tale of the overthrow by his bourgeois subjects of a king who, having failed all else, is forced to play

court jester to his own usurper. It was as though Wedekind sought consolation in each performance, using it as a counter-attack to adverse criticism. In turn, each play was censored by Kaiser Wilhelm's Prussian officials, and often abridged by his publishers. Financially drained by prison sentences and generally ostracized by nervous producers, he was to work again the popular cabaret circuit, at one time joining a famous touring group, The Eleven Executioners, in order to earn a living.

These irreverent performances, bordering on the obscene, endeared Wedekind to the artistic community in Munich, while the censorship trials which inevitably followed guaranteed his prominence in the city. Ball, who frequented the Café Simplicissimus, commented that from 1910 onwards everything in his life revolved around the theatre: 'Life, people, love, morality. To me the theatre meant inconceivable freedom', he wrote. 'My strongest impression was of the poet as a fearful cynical spectacle: Frank Wedekind. I saw him at many rehearsals and in almost all of his plays. In the theatre he was struggling to eliminate both himself and the last remains of a once firmly established civilization.'

Wedekind's *Die Büchse der Pandora* ('Pandora's Box'), the tale of an emancipated woman's career, published in 1904, was considered such an elimination. The play was promptly barred from public performance in

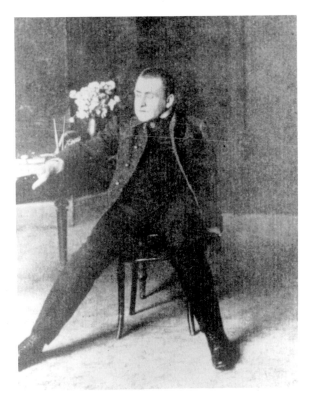

45 Frank Wedekind in his play *Hidalla*, 1905

Germany during the author's lifetime. Angry at the Public Prosecutor, who he felt distorted the evidence in such a way as to suggest indecency, Wedekind replied with an unpublished adaptation of Goethe's famous *Heidenröslein*, parodying court proceedings and legal jargon:

> The tramp says: I will have sexual intercourse with you, female vagrant.
> The female vagrant answers: I will infect you so badly with venereal disease that you will always have cause to remember me.
> Clearly she has no interest in sexual intercourse at that time.

Wedekind's performances revelled in the licence given the artist to be a mad outsider, exempt from society's normal behaviour. But he knew that such licence was given only because the role of the artist was considered utterly insignificant, more tolerated than accepted. Taking up the cause of the artist against the complacent public at large, Wedekind was soon joined by others in Munich and elsewhere who began to use performance as a cutting edge against society.

Kokoschka in Vienna

Wedekind's notoriety travelled beyond Munich. While court proceedings on *Die Büchse der Pandora* continued in Germany, the play was privately presented in Vienna. There Wedekind himself performed Jack the Ripper, while Tilly Newes, his wife-to-be, played the heroine Lulu. Midst the popular wave of Expressionism in Munich, Berlin and Vienna around this time, albeit in written form rather than actual performance, Wedekind viewed with extreme disfavour any attempts to align his works with Expressionism. He had, after all, instinctively used expressionist techniques in his work long before the term and the movement had become popular.

It was in Vienna that the prototypical Expressionist production, Kokoschka's *Mörder, Hoffnung der Frauen* ('Murderer, Hope of Women') was presented. It was to reach Munich, via Berlin, by way of the magazine *Der Sturm*, which published the text and drawings shortly after its presentation in Vienna in 1909. Like Wedekind, the twenty-two-year-old Kokoschka was considered something of an eccentric affront to public morals and to the taste of the conservative Viennese society, and he was threatened with dismissal from his teaching post at the Vienna School of Arts and Crafts by the Minister of Education. 'Degenerate artist', 'Bourgeois-bater', 'common criminal', the critics called him, as well as *Oberwilding* or chief savage, following the exhibition of his clay bust *The Warrior* at the 1908 Vienna Kunstschau.

Angered by such primitive attacks, he threw *Mörder, Hoffnung der Frauen* in the faces of the staid Viennese, at a performance in the garden theatre of the Vienna Kunstschau. The cast, his friends and acting students, had only one

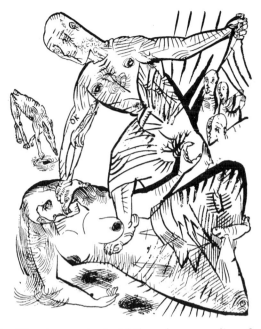

46 Kokoschka, pen and ink drawing for his play *Mörder, Hoffnung der Frauen*, an early Expressionist production, presented in Vienna in 1909

rehearsal before opening night. They improvised with 'key phrases on slips of paper', after Kokoschka had demonstrated the essentials of the play, complete with variations of pitch, rhythm and expression. In the garden they dug a ditch for the musicians, building a stage of boards and planks. Central to the setting was a large tower with a cage door. Around this object, the players crept, flinging their arms, arching their backs, and making exaggerated facial expressions; these actions became the mark of expressionist acting techniques. Midst this eerie atmosphere they played out an aggressive battle between male and female, with a man ripping the dress of the leading woman and branding her symbolically with his sign. In defence she attacked him with a knife, and as theatrical blood oozed from his wounds, he was placed in a coffin by three masked men and raised to the grilled tower. However, the 'New Man', so important to later Expressionist writers, triumphed: by spilling his blood the woman had only spelt her own doom – she died, slowly and dramatically, while the virile and pure New Man survived.

Kokoschka was to reminisce in later years that 'hateful and malicious opposition was shouted forth' against his play. The literary argument would have degenerated into a bloody war, if Adolf Loos, the architect and patron of Kokoschka, 'had not intervened with a group of his faithful and rescued me from the fate of being beaten to death'. Kokoschka continued: 'What irritated people particularly was that the nerves were drawn outside the figures, on the skins as though they could in fact be seen. The Greeks put masks on their actors, to fix character – sad, passionate, angry, etc. I did the

same thing in my own way, by painting on faces, not as decoration but to underline the character. It was all meant to be effective at a distance, like a fresco painting. I treated the members of the cast quite differently. Some of them I gave cross stripes, like a tiger or cat, but I painted the nerves on all of them. Where they were located I knew from my study of anatomy.'

By 1912, the year in which Sorge's *Der Bettler*, generally regarded as the first Expressionist play, was published, Kokoschka's production was the centre of conversation in Munich. Although few explicitly Expressionist plays had actually yet been performed, the new notions of performance were already being seen as a possible means of destroying earlier realistic traditions by such people as the twenty-six-year-old Hugo Ball, who was by then deeply involved in the planning of performances of his own. To Ball, the Munich years meant plans to initiate a collaborative *Künstlertheater*. He teamed up with Kandinsky who 'by his mere presence placed this city far above all other German cities in its modernity', and the periodicals in which they expressed themselves were *Der Sturm, Die Aktion, Die Neue Kunst* and in 1913, *Die Revolution*. It was a period according to Ball when common sense had to be opposed at all times, when 'philosophy had been taken over by the artists', and an 'epoch of the interesting and of gossip'. Within this disturbing milieu Ball imagined that the 'regeneration of society' would come about through the 'union of all artistic media and forces'. Only the theatre was capable of creating the new society, he believed. But his notion of theatre was not a traditional one: on the one hand, he had studied with the innovative director Max Reinhardt, and sought new dramatic techniques; on the other, the concept of a total artwork, or *Gesamtkunstwerk*, put foward over half a century earlier by Wagner, involving artists from all disciplines in large-scale productions, still held a fascination for him. So Ball's theatre would, if he had had his way, have involved all the following artists: Kandinsky, to whom he would have designated the overall direction, Marc, Fokine, Hartmann, Klee, Kokoschka, Yevreinov, Mendelsohn, Kubin and himself. On several counts this programme outline prefigured the enthusiasm with which he brought together different artists two years later in Zurich.

But these plans never materialized in Munich. Ball did not find sponsors, nor did he succeed in his bid for the directorship of the Staatstheater in Dresden. Disheartened, he left Germany via Berlin for Switzerland. Depressed by the war and the German society of the time, he started to see theatre in a new light: 'The importance of the theatre is always inversely proportionate to the importance of social morality and civil freedom.' For him social morality and civil freedom were at odds and in Russia as well as Germany, theatre was crushed by the war. 'Theatre has no sense any more. Who wants to act now, or even see acting? . . . I feel about the theatre as a man must feel who has suddenly been decapitated.'

Ball in Zurich

Hugo Ball and Emmy Hennings arrived in Zurich in the quiet summer of 1915. Hennings was only eight months out of prison for forging foreign passports for those who wished to avoid military service; he himself was carrying forged papers and living under an assumed name.

'It is strange, but occasionally people do not know what my real name is. Then officials come in and make inquiries.' Having to change names to avoid detection by official German spies on the lookout for draft evaders was only the least of their worries. They were poor, unemployed and unregistered aliens. Hennings took part-time menial jobs, Ball tried to continue his studies. When the Swiss police in Zurich discovered he was living under assumed names he fled to Geneva, returning to Zurich to twelve days' imprisonment. Then he was left alone. The Swiss authorities had no interest in turning him over to the Germans for military service. By the autumn their situation was serious – no funds, no place to go. Ball kept a diary in which he hinted at an attempted suicide; the police were called to stop him at Lake Zurich. His coat, which he salvaged from the lake, was no tempting buy at the night-club where he offered it for sale. But somehow his luck turned and he was signed up by the night-club with a touring troupe called the Flamingo. Even while touring with the Flamingo in various Swiss cities, Ball was obsessed with an attempt to understand the German culture that he had fled. He began to draw up plans for a book, later published as *Zur Kritik der deutschen Intelligenz* ('Critique of the German Mentality'), and wrote endless texts on the philosophical and spiritual malaise of the time. He became a confirmed pacifist, experimented with narcotics and mysticism, and began a correspondence with the poet Marinetti, the leader of the Futurists. He wrote for Schickele's journal *Die Weissen Blätter* and the Zurich periodical *Der Revoluzzer*.

However, the cabaret performances and his writings conflicted with each other. Ball was writing about a kind of art that he was increasingly impatient to implement: 'In an age like ours, when people are assaulted daily by the most monstrous things without being able to keep account of their impressions, in such an age aesthetic production becomes a prescribed course. But all living art will be irrational, primitive, complex: it will speak a secret language and leave behind documents not of edification but of paradox.' Ball, after several tiring months with the Flamingo, returned to Zurich.

Cabaret Voltaire

Early in 1916 Ball and Hennings decided to start their own café–cabaret, not 47,48 unlike the ones they had left behind in Munich. Jan Ephraim, the owner of a small bar in Spiegelgasse, agreed to them using his premises for that purpose,

and there followed frantic days of collecting artwork from various friends to decorate the club. A press release was distributed: 'Cabaret Voltaire. Under this name a group of young artists and writers has been formed whose aim is to create a centre for artistic entertainment. The idea of the cabaret will be that guest artists will come and give musical performances and readings at the daily meetings. The young artists of Zurich, whatever their orientation, are invited to come along with suggestions and contributions of all kinds.'

The opening night attracted a large crowd and the place was full to overflowing. Ball recalled: 'At about six in the evening while we were still busy hammering and putting up Futurist posters, an oriental-looking deputation of four little men arrived, with portfolios and pictures under their arms; repeatedly they bowed politely. They introduced themselves: Marcel Janco the painter, Tristan Tzara, Georges Janco and a fourth gentleman whose name I did not quite catch. Arp happened to be there also, and we came to an understanding without many words. Soon Janco's sumptuous *Archangels* was hanging with the other beautiful objects, and on that same evening Tzara read some traditional-style poems, which he fished out of his various coat pockets in a rather charming way. Emmy Hennings and Mme Laconte sang in French and Danish, Tzara read some of his Rumanian poetry, while a balalaika orchestra played popular tunes and Russian dances.'

Thus on 5 February 1916 the Cabaret Voltaire began. It was a nightly affair: on the 6th, with many Russians in the audience, the programme included poems by Kandinsky and Else Lasker, the 'Donnerwetterlied' ('Thundersong') by Wedekind, the 'Totentanz' ('Dance of Death') 'with the assistance of the revolutionary chorus', and Aristide Bruant's 'A la Villette' ('To Villette'). On the following night, the 7th, there were poems by Blaise Cendrars and Jakob van Hoddis and on the 11th, Ball's friend from Munich, Richard Huelsenbeck, arrived. 'He pleads for a stronger rhythm (Negro rhythm)', Ball noted. 'He would prefer to drum literature into the ground.'

The following weeks were filled with works as varied as poems by Werfel, Morgenstern and Lichtenstein. 'Everyone has been seized by an indefinable intoxication. The little cabaret is about to come apart at the seams and is getting to be a playground for crazy emotions.' Ball was caught up in the excitement of arranging programmes and writing material with his various colleagues. They were less concerned about creating new art; indeed Ball warned that 'the artist who works from his freewheeling imagination is deluding himself about his originality. He is using a material that is already formed and so is undertaking only to elaborate on it.' Rather he enjoyed the role of catalyst: '*Producere* means "to produce", "to bring into existence". It does not have to be books. One can produce artists too.'

Material for the cabaret evenings included collaborative contributions by Arp, Huelsenbeck, Tzara, Janco, Hennings and other passing writers and

Als ich das Cabaret Voltaire gründete, war ich der Meinung, es möchten sich in der Schweiz einige junge Leute finden, denen gleich mir daran gelegen wäre, ihre Unabhängigkeit nicht nur zu geniessen, sondern auch zu dokumentieren. Ich ging zu Herrn Ephraim, dem Besitzer der „Meierei" und sagte: „Bitte, Herr Ephraim, geben Sie mir Ihren Saal. Ich möchte ein Cabaret machen." Herr Ephraim war einverstanden und gab mir den Saal. Und ich ging zu einigen Bekannten und bat sie: „Bitte geben Sie mir ein Bild, eine Zeichnung, eine Gravüre. Ich möchte eine kleine Ausstellung mit meinem Cabaret verbinden." Ging zu der freundlichen Züricher Presse und bat sie: „Bringen sie einige Notizen. Es soll ein internationales Cabaret werden. Wir wollen schöne Dinge machen," Und man gab mir Bilder und brachte meine Notizen. Da hatten wir am 5. Februar ein Cabaret. Mde. Hennings und Mde. Leconte sangen französische und dänische Chansons. Herr Tristan Tzara rezitierte rumänische Verse. Ein Balalaika-Orchester spielte entzückende russische Volkslieder und Tänze.

Viel Unterstützung und Sympathie fand ich bei Herrn M. Slodki, der das Plakat des Cabarets entwarf, bei Herrn Hans Arp, der mir neben eigenen Arbeiten einige Picassos zur Verfügung stellte und mir Bilder seiner Freunde O. van Rees und Artur Segall vermittelte. Viel Unterstützung bei den Herren Tristan Tzara, Marcel Janco und Max Oppenheimer, die sich gerne bereit erklärten, im Cabaret auch aufzutreten. Wir veranstalteten eine RUSSISCHE und bald darauf eine FRANZÖSISCHE Soirée (aus Werken von Apollinaire, Max Jacob, André Salmon, A. Jarry, Laforgue und Rimbaud). Am 26.

Februar kam Richard Huelsenbeck aus Berlin und am 30. März führten wir eine wundervolle Negermusik auf (toujours avec la grosse caisse: boum boum boum boum — drabatja mo gere drabatja mo bonooooooooooooo —) Monsieur Laban assistierte der Vorstellung und war begeistert. Und durch die Initiative des Herrn Tristan Tzara führten die Herren Tzara, Huelsenbeck und Janco (zum ersten Mal in Zürich und in der ganzen Welt) simultanistische Verse der Herren Henri Barzun und Fernand Divoire auf, sowie ein Poème simultan eigener Composition, das auf der sechsten und siebenten Seite abgedruckt ist. Das kleine Heft, das wir heute herausgeben, verdanken wir unserer Initiative und der Beihilfe unserer Freunde in Frankreich, ITALIEN und Russland. Es soll die Aktivität und die Interessen des Cabarets bezeichnen, dessen ganze Absicht darauf gerichtet ist, über den Krieg und die Vaterländer hinweg an die wenigen Unabhängigen zu erinnern, die anderen Idealen leben.

Das nächste Ziel der hier vereinigten Künstler ist die Herausgabe einer Revue Internationale. La revue paraîtra à Zurich et portera le nom „DADA". („Dada") Dada Dada Dada Dada.

ZÜRICH, 15. Mai 1916

47 Hugo Ball's press release for the Cabaret Voltaire, Zurich, 1916

48 Hugo Ball and Emmy Hennings in Zurich, 1916

artists. Under pressure to entertain a varied audience, they were forced to 'be incessantly lively, new and naive. It is a race with the expectations of the audience and this race calls on all our forces of invention and debate.' To Ball there was something specially pleasurable in cabaret: 'One cannot exactly say that the art of the last twenty years has been joyful and that the modern poets are very entertaining and popular.' Live reading and performance was the key to rediscovering pleasure in art.

Each evening was constructed around a particular theme: Russian evenings for the Russians; Sundays put patronizingly aside for the Swiss – 'but the young Swiss are too cautious for a cabaret', the Dadaists thought. Huelsenbeck developed an identifiable reading style: 'When he enters, he keeps his cane of Spanish reed in his hand and occasionally swishes it around. That excites the audience. They think he is arrogant, and he certainly looks it. His nostrils quiver, his eyebrows are arched. His mouth with its ironic twitch is tired but composed. He reads, accompanied by the big drum, shouts, whistles, and laughter':

> Slowly the group of houses opened its body.
> Then the swollen throats of the churches screamed to the depths . . .

At a French soirée on 14 March Tzara read poems by Max Jacob, André Salmon and Laforgue; Oser and Rubinstein played the first movement of a Cello Sonata by Saint-Saëns; Arp read from Jarry's *Ubu Roi*, and so on. 'As long as the whole city is not enchanted, the cabaret has failed', Ball wrote.

The evening of 30 March marked a new development: 'On the initiative of Tzara, Huelsenbeck, Janco and Tzara recited (for the first time in Zurich and the whole world) the simultaneous verses of Henri Barzun and Fernand Divoire, and a simultaneous poem of their own composition.' Ball defined the concept of the simultaneous poem thus:

> a contrapuntal recitative in which three or more voices speak, sing, whistle, etc. at the same time, in such a way that the elegiac, humorous, or bizarre content of the piece is brought out by these combinations. In such a simultaneous poem, the wilful quality of an organic work is given powerful expression, and so is its limitation by the accompaniment. Noises (an *rrrr* drawn out for minutes, or crashes, or sirens, etc.) are superior to the human voice in energy.

The cabaret was by now a roaring success. Ball was exhausted: 'The cabaret needs a rest. With all the tension the daily performances are not just exhausting,' he wrote, 'they are crippling. In the middle of the crowds I start to tremble all over.'

Russian Socialist exiles including Lenin and Zinoviev, writers such as Wedekind, the German Expressionists Leonhard Frank and Ludwig Rubiner, and younger German and East European expatriates, all milled

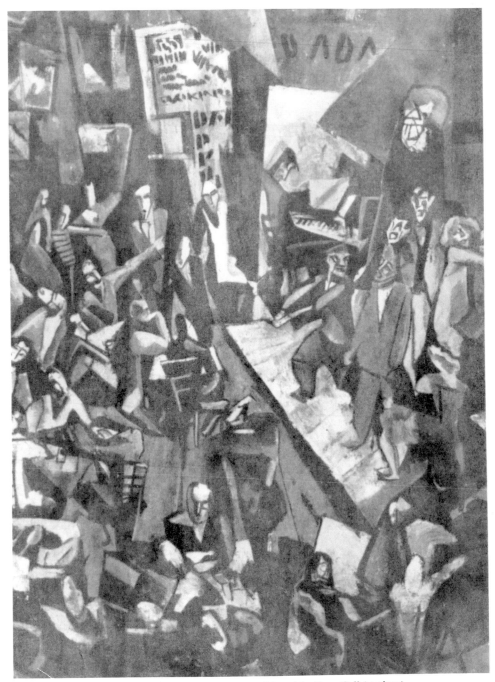

49 Marcel Janco, *Cabaret Voltaire*, 1916. On the podium, *left to right*, Hugo Ball (at piano), Tristan Tzara (wringing hands), Jean Arp, Richard Huelsenbeck (below Arp), Marcel Janco

around the centre of Zurich. Some of them visited the cabaret, some joined in. Rudolf von Laban, the choreographer and dance pioneer, attended while his dancers performed. Janco painted the *Cabaret Voltaire* and Arp explained the cast:

> On the stage of a gaudy, motley, overcrowded tavern there are several weird and peculiar figures representing Tzara, Janco, Ball, Huelsenbeck, Madame Hennings, and your humble servant. Total pandemonium. The people around us are shouting, laughing, and gesticulating. Our replies are sighs of love, volleys of hiccups, poems, moos, and miaowing of medieval *Bruitists*. Tzara is wiggling his behind like the belly of an oriental dancer. Janco is playing an invisible violin and bowing and scraping. Madame Hennings, with a Madonna face, is doing the splits. Huelsenbeck is banging away nonstop on the great drum, with Ball accompanying him on the piano, pale as a chalky ghost. We were given the honarary title of Nihilists.

The cabaret also generated violence and drunkenness in the conservative context of the Swiss city. Huelsenbeck pointed out that 'it was the sons of the Zurich bourgeoisie, the university students, who used to go to the Cabaret Voltaire, a beer parlour. We wanted to make the Cabaret Voltaire a focal point of the "newest art" although we did not neglect from time to time to tell the fat and utterly uncomprehending Zurich philistines that we regarded them as pigs and the German Kaiser as the initiator of the war.'

They each became practised in their specialities: Janco made masks which Ball said 'were not just clever. They were reminiscent of the Japanese or ancient Greek theatre, yet were wholly modern.' Designed to be effective from a distance in the relatively small space of the cabaret, they had a sensational effect. 'We were all there when Janco arrived with his masks, and everyone immediately put one on. Then something strange happened. Not only did the mask immediately call for a costume; it also demanded a quite definite, passionate gesture, bordering on madness.'

Emmy Hennings devised new works daily. Except for her, there were no professional cabaret performers. The press was quick to acknowledge the professional quality of her work: 'The star of the cabaret', wrote the *Zürcher Post*, 'is Emmy Hennings, star of many nights of cabarets and poems. Years ago, she stood by the rustling yellow curtain of a Berlin cabaret, hands on hips, as exuberant as a flowering shrub; today too she presents the same bold front and performs the same songs with a body that has since then been only slightly ravaged by grief.'

Ball invented a new species of 'verse without words' or 'sound poems', in which 'the balancing of the vowels is gauged and distributed only to the value of the initial line'. He described the costume that he had designed for the first reading of one of these poems, which he gave on 23 June 1916 at the Cabaret

Voltaire, in his diary entry of the same day: on his head he wore 'a high, blue- 51
and-white-striped witch doctor's hat'; his legs were covered in blue
cardboard tubes 'which came up to my hips so that I looked like an obelisk';
and he wore a huge cardboard collar, scarlet inside and gold outside, which he
raised and lowered like wings. He had to be carried onto the stage in the dark
and, reading from music stands placed on the three sides of the stage, he began
'slowly and solemnly':

> gadji beri bimba
> glandridi lauli lonni cadori
> gadjama bim beri glassala
> glandridi glassala tuffm i zimbrabim
> blassa galassasa tuffm i zimbrabim

This recitation though was problematic. He said that he soon noticed that
his means of expression was not adequate to the 'pomp of his stage setting'. As
though mystically directed he 'seemed to have no other choice than to assume
the age-old cadence of the sacerdotal lamentation, like the chanting of the
mass that wails through the Catholic churches of both the Occident and the
Orient . . . I don't know what inspired me to use this music, but I began to
sing my vowel lines like a recitative, in the style of the church.' With these
new sound poems, he hoped to renounce 'the language devastated and made
impossible by journalism'.

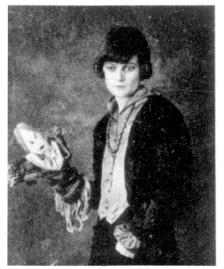

50 Emmy Hennings and doll

51 Hugo Ball reciting the sound poem
Karawane, 1916, one of the last events at the
Cabaret Voltaire. Ball placed his texts on
music stands scattered over the podium, and
turned from one to the other during the
performance, raising and lowering the
cardboard 'wings' of his costume

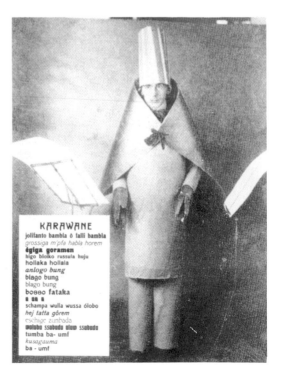

KARAWANE
jolifanto bambla ô falli bambla
grossiga m'pfa habla horem
égiga goramen
higo bloiko russula huju
hollaka hollala
anlogo bung
blago bung
blago bung
bosso fataka
û ûû û
schampa wulla wussa ólobo
hej tatta górem
eschige zunbada
wolubu ssubudu uluw ssubudu
tumba ba- umf
kusagauma
ba - umf

Dada

Tzara had other problems. He kept on worrying about a periodical and had more ambitious plans for the goings-on at the Cabaret Voltaire; he saw its potential – as a movement, as a magazine, as a means of storming Paris. Arp on the other hand, a quiet introspective personality, remained on the outside of the cabaret. 'Arp never performed', Huelsenbeck recalled. 'He never needed any hullabaloo, yet his personality had such a strong effect, that from the very first, Dada would have been impossible without him. He was the spirit in the wind and formative power in the burning bush. His delicate complexion, the balletic slenderness of his bones, his elastic gait, were all indicative of his enormous sensitivity. Arp's greatness lay in his ability to limit himself to art.'

The cabaret evenings continued. They began to find a particular form, but above all, they remained a gesture. Ball explained that 'every word spoken and sung here says at least this one thing: that this humiliating age has not succeeded in winning our respect. What could be respectable and impressive about it? Its cannons? Our big drum drowns them. Its idealism? That has long been a laughing-stock, in its popular and its academic edition. The grandiose slaughters and cannibalistic exploits? Our spontaneous foolishness and enthusiasm for illusion will destroy them.'

In April 1916 there were plans for a 'Voltaire Society' and an international exhibition. The proceeds of the soirées would go toward the publishing of an anthology. Tzara, especially, wanted the anthology; Ball and Huelsenbeck were against it. They were against 'organization': 'People have had enough of it', Huelsenbeck argued. Both he and Ball felt that 'one should not turn a whim into an artistic school'. But Tzara was persistent. It was by this time that Ball and Huelsenbeck had coined the name, which they had found in a German–French dictionary, for the singer Madame le Roy: 'Dada is "yes, yes" in Rumanian, "rocking horse" and "hobby horse" in French.' 'For Germans', Ball said, 'it is a sign of foolish naïveté, joy in procreation and preoccupation with the baby carriage.'

On 18 June 1916, Ball was writing: 'We have now driven the plasticity of the word to the point where it can scarcely be equalled. We achieved this at the expense of the rational, logically constructed sentence, and also by abandoning documentary work . . .' He cited two factors which had made such thinking possible: 'First of all, the special circumstance of these times, which do not allow real talent either to rest or mature and so put its capabilities to the test. Then there was the emphatic energy of our group . . .'. Their starting-point he acknowledged was Marinetti, whose words-in-freedom took the word out of the sentence frame (the world image) 'and nourished the emaciated big-city vocables with light and air, and gave them back their warmth, emotion and their original untroubled freedom'.

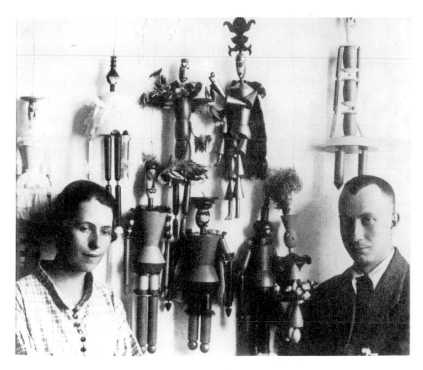

52 Sophie Taeuber and Jean Arp with puppets made by Taeuber used in various performances, Zurich, 1918

Months of nightly rumpus at the cabaret began to disturb the owner, Ephraim. 'The man told us we must either offer better entertainment and draw a larger crowd or else shut down the cabaret', Huelsenbeck wrote. The various Dadaists reacted to this ultimatum characteristically: Ball was 'ready to close shop', while Tzara, Huelsenbeck cynically remarked, 'concentrated on his correspondence with Rome and Paris, remaining the international intellectual playing with the ideas of the world'. Reserved as ever, 'Arp always maintained a certain distance. His programme was clear. He wanted to revolutionize art and do away with objective painting and sculpture.'

Cabaret Voltaire, after only five months, closed its doors.

Dada: magazine and gallery

A new phase began when Dada went public at the Waag Hall in Zurich on 14 July 1916. Ball saw the event as the end of his Dada involvement: 'My manifesto on the first *public* Dada evening was a thinly disguised break with friends.' It was a statement concerned with the absolute primacy of the word in language. But more particularly, it was Ball's declared opposition to the

idea of Dada as a 'tendency in art'. 'To make it an artistic tendency must mean that one is anticipating complications', Ball wrote. Tzara, however, was in his element. In his *Zurich Chronicle*, Tzara described his own role:

> 14 July 1916 – For the first time anywhere. Waag Hall: First Dada Evening
> (Music, dances, theories, manifestos, poems, paintings, costumes, masks)
>
> In the presence of a compact crowd Tzara demonstrates, we demand we demand the right to piss in different colours, Huelsenbeck demonstrates, Ball demonstrates, Arp *Erklärung* [statement], Janco *meine Bilder* [my pictures], Heusser *eigene Kompositionen* [original compositions] the dogs bay and the dissection of Panama on the piano on the piano and dock—shouted Poem—shouting and fighting in the hall, first row approves second row declares itself incompetent to judge the rest shout, who is the strongest, the big drum is brought in, Huelsenbeck against 200, Hoosenlatz accentuated by the very big drum and little bells on his left foot—the people protest shout smash windowpanes kill each each demolish fight here come the police interruption.
>
> Boxing resumed: Cubist dance, costumes by Janco, each man his own big drum on his head, noise, Negro music/trabatgea bonoooooo oo ooooo/5 literary experiments: Tzara in tails stands before the curtain, stone sober for the animals, and explains the new aesthetic: gymnastic poem, concert of vowels, bruitist poem, static poem chemical arrangement of ideas, *Biriboom biriboom saust der Ochs im Kreis herum* [the ox dashes round in a ring] (Huelsenbeck), vowel poem aaò, ieo, aïï, new interpretation the subjective folly of the arteries the dance of the heart on burning buildings and acrobatics in the audience. More outcries, the big drum, piano and impotent cannon, cardboard costumes torn off the audience hurls itself into puerperal fever interrupt. The newspapers dissatisfied simultaneous poem for 4 voices + simultaneous work for 300 hopeless idiots.

The five principals read various manifestos. That same month *Collection Dada* issued its first volume, including Tzara's *La Première Aventure céleste de M. Antipyrine* ('The First Celestial Adventure of Mr Antipyrine'). This was followed in September and October of the same year by two volumes of poetry by Huelsenbeck. While Tzara was creating a literary movement out of the Dada idea, he was slowly alienating Ball. Huelsenbeck collaborated for a while, but he shared Ball's reservations about what Dada was becoming, if for different reasons. Huelsenbeck saw the move as codifying Dada, while Ball merely wanted to get away from it all to concentrate on his own writing.

From the public meeting to the magazine, the next step was a place of their own, a Dada gallery. First it was a rented space: in January 1917 the first public Dada exhibition opened at the Galerie Corray, including work by Arp, Van Rees, Janco and Richter, Negro art and talks by Tzara on 'Cubism', 'Old and New Art', and 'Art of the Present'. Soon Ball and Tzara took over the Galerie Corray and opened it on 17 March as the Galerie Dada with an

53 Arp, Tzara and Hans Richter, Zurich, 1917 or 1918

exhibition of *Der Sturm* paintings. Ball wrote that it was 'a continuation of the cabaret idea of last year'. It was a hurried affair with only three days between the proposal and the opening day. Ball remembered that about forty people arrived for the opening where he announced the plan 'to form a small group of people who would support and stimulate each other'.

The nature of the work had changed, however, from spontaneous performances to a more organized, didactic gallery programme. Ball wrote that they had 'surmounted the barbarisms of the cabaret. There is a span of time between Voltaire and the Galerie Dada in which everyone has worked very hard and has gathered new impressions and experiences.' There was, in addition, a new concentration on dance, possibly due to the influence of Sophie Taeuber, who worked with Rudolf von Laban and Mary Wigman. Ball wrote about dance as an art of the closest and most direct material: 'It is very close to the art of tattooing and to all primitive representative efforts that aim at personification; it often merged into them.' Sophie Taeuber's *Gesang der Flugfische und Seepferdchen* ('Song of the Flying-fish and Sea-horses') was 'a dance full of flashes and edges, full of dazzling light and penetrating intensity', according to Ball. A second *Der Sturm* show opened on 9 April 1917 and by the 10th, Ball was already preparing the second soirée:

52

65

'I am rehearsing a new dance with five Laban-ladies as negresses in long black caftans and face masks. The movements are symmetrical, the rhythm is strongly emphasized, the mimicry is of a studied deformed ugliness.'

They charged admission, but in spite of this, notes Ball, the gallery was too small for the number of visitors. The gallery had three faces: by day it was a kind of teaching body for schoolgirls and upper-class ladies. 'In the evenings the candlelit Kandinsky room is a club for the most esoteric philosophies. At the soirées, however, the parties have a brilliance and a frenzy such as Zurich has never seen before.' What was specially interesting was the 'boundless readiness for storytelling and exaggeration, a readiness that has become a principle. Absolute dance, absolute poetry, absolute art – what is meant is that a minimum of impressions is enough to evoke unusual images.'

The Galerie Dada lasted just eleven weeks. It had been calculated and educative in intent with three large-scale exhibitions, numerous lectures (including one by Ball on Kandinsky), soirées and demonstrations. In May 1917, there was a free afternoon tea for school parties and on the 20th a gallery tour for workmen. According to Ball, one single workman turned up. Meanwhile, Huelsenbeck lost interest in the whole affair, claiming it was a 'self-conscious little art business, characterized by tea-drinking old ladies trying to revive their vanishing sexual powers with the help of "something mad".' But for Ball, who was shortly to leave Dada for good, it provided the most serious attempt yet to review the traditions of art and literature and to establish a positive direction for the group.

Even before the Galerie Dada had officially closed down, Ball had left Zurich for the Alps and Huelsenbeck had departed for Berlin.

Huelsenbeck in Berlin

'The direct reason for my return to Germany in 1917,' wrote Richard Huelsenbeck, 'was the closing of the cabaret.' Keeping a low profile in Berlin for the next thirteen months, Huelsenbeck reflected on Zurich Dada, later publishing his writing in *En avant Dada: Eine Geschichte des Dadaismus* (1920), analysing some of the concepts that it had attempted to develop. Simultaneity, for example, had been first used by Marinetti in a literary sense, but Huelsenbeck insisted on its abstract nature: 'Simultaneity is a concept', he wrote,

> referring to the occurrence of different events at the same time, it turns the sequence of $a = b = c = d$ into an $a - b - c - d$, and attempts to transform the problem of the ear into a problem of the face. Simultaneity is against what has become, and for what is becoming. While I, for example, become successively aware that I boxed an old woman on the ear yesterday and washed my hands an

hour ago, the screeching of a tram brake and the crash of a brick falling off the roof next door reach my ear simultaneously and my (outward or inward) eye rouses itself to seize, in the simultaneity of these events, a swift meaning of life.

Likewise introduced into art by Marinetti, Bruitism could be described as 'noise with imitative effects' as heard for example in a 'chorus of typewriters, kettledrums, rattles and saucepan lids'.

These theoretical preoccupations were to take on a new meaning in the Berlin context. The early performers were far away. Ball and Emmy Hennings had moved to Agnuzzo in the Ticino where Ball intended to live a solitary life, while Tristan Tzara had remained in Zurich, keeping the Dada magazine alive with additional manifestos. But Berlin's literary bohemians had little in common with Zurich's pacifist exiles. Less inclined to an art-for-art's sake attitude, they were soon to influence Dada towards a political stance that it had not known before.

Berlin Dada's early performances resembled the Zurich ones, however. The literary clientèle of the Café des Westens had indeed been anxious to see the Dada legend materialize and, in February 1918, Huelsenbeck gave his first reading. With him were Max Herrmann-Neisse and Theodor Däubler, two Expressionist poets, and George Grosz, his old satirist and activist friend; this first Berlin Dada performance took place in a small room in the gallery of I.B. Neumann. Huelsenbeck once more resumed his part of the 'Dada drummer', flourishing his cane, violent, 'perhaps arrogant, and unmindful of the consequences', while Grosz recited his poetry: 'You-sons-of-bitches, materialists/bread-eaters, flesh = eaters = vegetarians!!/professors, butchers' apprentices, pimps!/you bums!' Then Grosz, now an eager subscriber to Dada's anarchy, urinated on an Expressionist painting.

To top this provocation, Huelsenbeck turned to another taboo subject, the war, yelling that the last one had not been bloody enough. At this point, a wooden-legged war veteran left the room in protest, accompanied by supportive applause from the angered audience. Undaunted, Huelsenbeck read from his *Phantastische Gebete* ('Fantastic Prayers') for the second time that evening and Däubler and Herrmann-Neisse persisted with their readings. The gallery director threatened to call the police but several persuasive Dadaists succeeded in stopping him. The following day newspapers ran front page headline stories covering the scandal. The scene for numerous succeeding Dada performances had been set.

When, only two months later, on 12 April 1918, Huelsenbeck and a differently composed band of Café des Westens habitués – Raoul Hausmann, Franz Jung, Gerhard Preiss and George Grosz – presented the second Dada soirée, it was a meticulously planned affair. Unlike the first improvised event, press releases were widely distributed, co-signers were solicited for

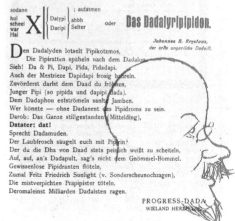

54 George Grosz dressed as Dada Death, a costume in which he walked the Kurfürstendamm in Berlin in 1918

55 John Heartfield, cover of *Jedermann sein eigner Fussball* ('Every Man His Own Football'), no. 1, 15 February 1919

56 Gerhard Preiss, also known as Musik-Dada, doing his famous 'Dada-Trott', from *Der Dada*, no. 3

Huelsenbeck's manifesto *Dadism in Life and Art* and an elaborate introduction prepared to familiarize the Berlin public with Dada ideas. Beginning with a frenzied attack on Expressionism, the evening continued with predictable Dada fare: Grosz recited his poems in quick succession; Else Hadwiger read Marinetti's poetry extolling the virtues of war; while Huelsenbeck played a toy trumpet and rattle. Another war veteran, still in uniform, responded to the energetic demonstration with an epileptic fit. But Hausmann just added to the commotion by continuing his lecture on 'The New Materials in Painting'. His diatribe against respectable art was shortlived, however. Worried about its paintings displayed on the walls, the management switched off the lights in the middle of his speech. That night Huelsenbeck went into hiding in his native city of Brandenburg.

But Dada was determined to conquer Berlin, to banish Expressionism from the city limits and to establish itself as an adversary to abstract art. The Berlin Dadaists pasted their slogans throughout the city – 'Dada kicks you in the behind and you like it!' They wore bizarre theatrical uniforms – Grosz walking the Kurfürstendamm dressed as Death – and took on 'revolutionary' 54 names: Huelsenbeck was Weltdada, Meisterdada; Hausmann was Dadasoph; Grosz variously Böff, Dadamarschall or Propagandada; and Gerhard Preiss, who invented the 'Dada-Trott', Musik-Dada. 56

57 Opening of the First Dada Fair, 5 June 1920, at the Burchard Gallery. *Left to right*, Raoul Hausmann, Hannah Höch (sitting), Otto Burchard, Johannes Baader, Wieland Herzfelde, Mrs Herzfelde, Otto Schmalhausen, George Grosz, John Heartfield. On the wall on the left, Otto Dix's *War Cripples*; on the end wall, Grosz's *Deutschland, ein Wintermärchen* (1917–19); suspended overhead, the uniformed dummy that led to the prosecution of Grosz and Herzfelde

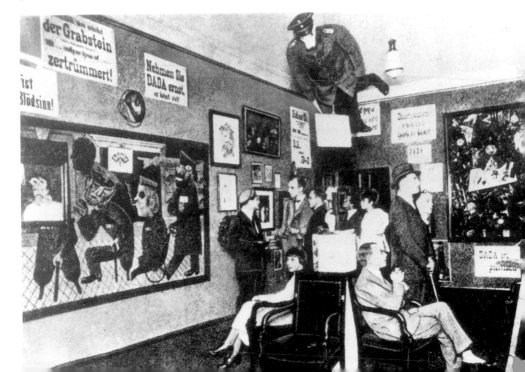

Manifestos appeared in quick succession. But the mood had changed; Berlin had transformed Dada, adding a more aggressive spirit than before. Besides Radical Communism, the Berlin Dadaists demanded 'the introduction of progressive unemployment through comprehensive mechanization of every field of activity', for, 'only by unemployment does it become possible for the individual to achieve certainty as to the truth of life and finally become accustomed to experience'. As well as the 'requisition of churches for the performances of Bruitist, simultaneist and Dadaist poems', they called for the 'immediate organization of a large-scale Dadaist propaganda campaign with 150 circuses for the enlightenment of the proletariat'. Matinées and soirées took place throughout the city, sometimes at the Café Austria, and newcomers to Berlin joined the swelling ranks of the increasingly militant Dada group. Newly arrived from Russia, Efim Golyschef added his *Antisymphony in Three Parts* (*The Circular Guillotine*) to the Dada repertory, while Johannes Baader, who had been certified as insane by the Berlin police force, added his own brand of Dada insanity.

In May 1918, huge elaborately painted posters were pasted over hundreds of Berlin walls and fences advertising the 'First German Postwar Renaissance of the Arts'. On 15 May a 'Great Art Festival' opened at the large Meister-Saal on the Kurfürstendamm with a race between a typewriter and a sewing machine. There followed a 'Pan-Germanic Poetry Contest' which took the form of a race, umpired by Grosz, between twelve poets reading their work simultaneously.

Dada was at the height of its notoriety and people flocked to Berlin to experience the Dada Rebellion at first hand. They clamoured for Grosz's and Mehring's 'Private Conversation of Two Senile Men Behind a Firescreen', Gerhard Preiss's 'Dada-Trott' and Hausmann's 'sixty-one-step' dance. The Berlin Dadaists also made a Czechoslovakian tour, Huelsenbeck opening each event with a typically provocative address to the audience.

Their return to Berlin at the end of 1919 was marked by the appearance on the Dada stage of the theatre director Erwin Piscator. At Die Tribüne, Piscator produced the first live photomontage with one of Huelsenbeck's sketches. Directing the action from the top of a tall ladder, Piscator held the stage while off-stage Dadaists shouted coarse speeches at the audience. Mehring's *Simply Classical – An Oresteia with a Happy Ending*, satirizing economic, political and military events, took place in the basement of Max Reinhardt's theatre, the Schall und Rauch. It employed two-foot-high marionettes designed by Grosz and executed by Heartfield and Hecker, as well as many technical innovations which were later used by both Piscator and Brecht in their productions.

57 Berlin Dada was drawing to an end. The First International Dada Fair at the Burchard Gallery in June 1920 ironically revealed Dada's exhaustion.

58 Text of Kurt Schwitters's *Ursonate* 59 Kurt Schwitters

Grosz and Heartfield, becoming increasingly politicized with the menace of current events, joined the more programmatic Proletarian Theatre of Schüller and Piscator, while Hausmann left Berlin to join Hanover Dada. Mehring, on the other hand, returned to the ever popular 'literary cabaret'. Huelsenbeck went on to complete his studies in medicine and in 1922 left for Dresden where he became assistant to a neuro-psychiatrist, later becoming a psycho-analyst.

German, Dutch, Rumanian and Czechoslovakian cities were equally besieged by visiting foreign Dadaists and locally formed groups. Kurt Schwitters travelled to Holland in 1923 and helped form a 'Holland Dada'; he also made regular visits to the Bauhaus where he mesmerized his audience with his staccato voice, intoning his famous poem *Anna Blume* or his 'Die Ursonate'. Schwitters even proposed a *Merz* theatre in a manifesto entitled 58,59 'To All the Theatres of the World I Demand the Merz Stage', calling for 'equality in principle of all materials, equality between complete human beings, idiots, whistling wire netting and thought pumps'.

In Cologne, Max Ernst organized a 'Dada-Vorfrühling' with Arp and Baargeld, which opened on 20 April 1920. Before the exhibition was

71

temporarily closed by the police, those that had a chance to visit it entered through the *pissoir* of a beer-hall. There they found Baargeld's *Fluidoskeptrik* – an aquarium filled with blood-coloured water, an alarm clock at the bottom, a woman's wig floating on the top and a wooden arm protruding from the water. Chained to an object of Ernst's was an axe, providing an open invitation to any willing passer-by to destroy the object. A young woman in first communion dress recited 'obscene' poems by Jakob van Hoddis. By 1921 Cologne Dada had run its course; like many Dadaists in Europe, Ernst too headed for Paris in that year.

Dada in New York and Barcelona

Meanwhile Dada's last years in Zurich were in the hands of Tristan Tzara. There he had transformed Dada from a haphazard series of mostly improvised events into a movement with its own mouthpiece, the magazine *Dada* (first issued in July 1917), which he would soon take with him to Paris. Some of the more reticent Cabaret Voltaire figures like the Viennese doctor, Walter Serner, came to the fore, and newcomers like Francis Picabia passed briefly through Zurich to make acquaintance with the Dada stalwarts.

Picabia, a wealthy, Parisian-born Cuban and temporarily resident in New York, Paris and Barcelona, introduced himself in 1918 to the Dada

60 Poster advertising the fight between the writer Arthur Cravan and the world boxing champion Jack Johnson, Madrid, 23 April 1916

contingent at a champagne party at the Hotel Elite in Zurich. Already known for his black and gold 'machine paintings' at the Dada exhibition held at the Galerie Wolfsberg in September 1918, he published a special Zurich issue of his magazine *391*. Picabia was more than familiar with the style of Zurich Dada. In New York, he and Duchamp had been at the forefront of avant-garde activities. With Walter Arensberg and others they organized the important Independents exhibition of 1917, marked by Duchamp's attempt to exhibit his notorious *Fountain* – a urinal. Consequently Picabia's published material – poems and drawings – preceded him to Zurich where he was welcomed by Tzara: 'Long live Descartes, long live Picabia the anti-painter just arrived from New York.'

Among those involved with *391* in Barcelona was the writer and amateur boxer Arthur Cravan (real name Fabian Lloyd), who had already acquired a following in Paris and New York with his polemical *Maintenant* (1912–15). Self-proclaimed French boxing champion, confidence man, muleteer, snake charmer, hotel thief and nephew of Oscar Wilde, he challenged the authentic world heavyweight champion, Jack Johnson, to a fight, which took place in Madrid on 23 April 1916. Cravan's amateur play as well as his drunken state 60 assured that he would be knocked out in the first round; nevertheless this somewhat brief event was a sensation in Madrid and was much appreciated by Cravan's supporters. A year later at the Independents exhibition in New York he was arrested for offending a gathering of society women and men. Invited by Duchamp and Picabia to lecture at the opening night, Cravan arrived obviously drunk and was soon raving obscenities at the audience. He then proceeded to undress. It was at this point that the police dragged him off to the city jail, only to be rescued by Walter Arensberg. Cravan's end was equally bizarre: he was last seen in 1918 in a small town on the coast of Mexico, carrying provisions to a small yacht which was to take him to Buenos Aires to join his wife Mina Loy. He took off in his boat and was never heard from again.

Dada's end in Zurich

With his new collaborators Tzara organized a Tristan Tzara night at the Salle zur Meise in Zurich on 23 July 1918, when he took the opportunity to read the first actual Dada manifesto: 'Let us destroy let us be good let us create a new force of gravity NO = YES Dada means nothing', it read. 'The bourgeois salad in the eternal basin is insipid and I hate good sense.' This caused the inevitable riot and was followed in quick succession by a profusion of Dada events.

The final Dada soirée in Zurich took place on 9 April 1919 at the Saal zur Kaufleuten. An exemplary affair which was to set the format for subsequent

soirées in Paris, it was produced by Walter Serner and precisely coordinated by Tzara. As Tzara alliteratively put it: '1500 persons filled the hall already boiling in the bubbles of bamboulas.' Hans Richter and Arp painted the sets for the dances by Suzanne Perrottet and Käthe Wulff, consisting of black abstract forms – 'like cucumbers' – on long strips of paper about two yards wide. Janco constructed enormous savage masks for the dancers and Serner armed himself with several curious props, among them a headless dummy.

The performance itself began on a sombre note: the Swedish film maker Viking Eggeling delivered a serious speech about elementary 'Gestaltung' and abstract art. This only irritated the audience primed for the usual combative confrontation with the Dadaists. Nor did Perrottet's dance to Schoenberg and Satie pacify the restless crowd. Only Tzara's simultaneous poem *Le Fièvre du mâle* ('The Fever of the Male'), read by twenty people, provided the absurdity they had anticipated. 'All hell broke loose', Richter noted. 'Shouts, whistles, chanting in unison, laughter all of which mingled more or less anti-harmoniously with the bellowing of the twenty on the platform.' Then Serner carried his headless dummy onto the stage, presenting it with a bouquet of artificial flowers. When he began reading from his anarchistic manifesto, *Letzte Lockerung* ('Final Dissolution') – 'a queen is an armchair and a dog is a hammock' – the crowd responded violently, smashing the dummy and forcing an interval of twenty minutes on the proceedings. The second part of the programme was somewhat more sedate: five Laban dancers presented *Nor Kakadu*, their faces covered by Janco's masks and bodies concealed in weird funnel-shaped objects. Tzara and Serner read more poems. Despite the peaceful finale, Tzara wrote that the performance had succeeded in establishing 'the circuit of absolute unconsciousness in the audience which forgot the frontiers of education of prejudices, experienced the commotion of the NEW'. It was, he said, Dada's final victory.

Actually, the Kaufleuten performance only marked the 'final victory' of Zurich Dada. To Tzara it was evident that after four years of activities in that city, it had become necessary to find fresh ground for Dada's anarchy if it was to remain at all effective. He had been preparing a move to Paris for some time: in January 1918 he had begun a correspondence with the group which in March 1919 was to found the literary magazine *Littérature* – André Breton, Paul Eluard, Philippe Soupault, Louis Aragon and others – hoping for contributions to *Dada 3* and their tacit support of Dada. Only Soupault replied with a brief poem, and although the whole Paris group, including Pierre Reverdy and Jean Cocteau, sent material for *Dada 4–5* (May 1919), it had become obvious that from such a distance not even the energetic Tzara could coerce the Parisians into further participation. So, in 1919, Tzara made his way to Paris.

Surrealism

First Paris performance

Tzara arrived unannounced at Picabia's home and spent his first night in Paris on a sofa. The news that he was in town quickly spread and he soon became the focus of attention of the avant-garde circles, just as he had anticipated. At the Café Certà and its annexe the Petit Grillon, he met the *Littérature* group with whom he had been corresponding, and it was not long before they arranged the first Dada event in Paris. On 23 January 1920, the first of the *Littérature* Fridays took place at the Palais des Fêtes in the rue Saint-Martin. André Salmon opened the performance with a recital of his poems, Jean Cocteau read poems by Max Jacob, and the young André Breton some by his favourite, Reverdy. 'The public was delighted', wrote Ribemont-Dessaignes. 'This, after all, was being "modern" – Parisians love that.' But what followed brought the audience to its feet. Tzara read a 'vulgar' newspaper article prefaced by an announcement that it was a 'poem' and accompanied by 'an inferno of bells and rattles' shaken by Eluard and Fraenkel. Masked figures recited a disjointed poem by Breton, and then Picabia executed large drawings in chalk on a blackboard, wiping out each section before going on to the next.

The matinée ended in an uproar. 'For the Dadaists themselves this was an extremely fruitful experiment', wrote Ribemont-Dessaignes. 'The destructive aspect of Dada appeared to them more clearly; the resultant indignation of the public which had come to beg for an artistic pittance, no matter what, as long as it was art, the effect produced by the presentation of the pictures and particularly of the manifesto, showed them how useless it was, by comparison, to have Max Jacob's poems read by Jean Cocteau.' Once again, Dada had 'triumphed'. Although the Zurich and Paris ingredients were the same – provocations against a respectful audience – it was clear that the transplant had been successful.

The following month, on 5 February 1920, crowds gathered at the Salon des Indépendants, lured by an advertisement stating that Charlie Chaplin would make an appearance. Not suprisingly, Chaplin was quite ignorant of his supposed presence. Similarly unaware of the falsity of the pre-performance publicity was the audience, which had to make do with thirty-

eight people reading various manifestos. Seven performers read the manifesto by Ribemont-Dessaignes warning the public that their 'decaying teeth, ears, tongues full of sores' would be pulled out and their 'putrid bones' broken. This barrage of insults was followed by Aragon's company chanting 'no more painters, no more musicians, no more sculptors, no more religions, no more republicans . . . no more of these idiocies, NOTHING, NOTHING, NOTHING!' According to Richter: 'These manifestos were chanted like psalms, through such an uproar that the lights had to be put out from time to time and the meeting suspended while the audience hurled all sorts of rubbish on to the platform.' The meeting broke up on an exciting note for the Dadaists.

Pre-Dada performance in Paris

Despite the apparent outrage of the Parisian public, the audience of the twenties was not entirely unfamiliar with such provocative events. For example, Alfred Jarry's *Ubu Roi* of twenty-five years earlier still retained a special place in the history of performance scandals and, needless to say, Jarry was somewhat of a hero to the Parisian Dadaists. The music of the eccentric French composer Erik Satie, for example the one-act comedy *Le Piège de*

61 Scene from Raymond Roussel's *Impressions d'Afrique*, presented for one week at the Théâtre Fémina, 1911. The setting shows the début of the Earthworm Zither Player, whose secretions struck the chords of the instrument producing 'music'

Méduse and his concept of 'furniture music' (*musique d'ameublement*), also contained many anticipations of Dada, while Raymond Roussel captured the imagination of the future Surrealists. Roussel's notorious *Impressions* 61 *d'Afrique*, an adaptation of his 1910 prose fantasy of the same name, with its contest of 'The Incomparables Club' including the début of the Earthworm Zither Player – a trained earthworm whose drops of mercury-like 'sweat' sliding down the chords of the instrument produced sound – was a particular favourite of Duchamp, who attended its one-week run at the Théâtre Fémina (1911) along with Picabia.

The ballet *Parade* too, the collaborative work of four artists each masters in their own fields, Erik Satie, Pablo Picasso, Jean Cocteau and Léonide Massine, had in May 1917 come in for its own noisy opposition from press and public alike. Indirectly employing Jarry-style tactics, *Parade* provided the Parisian public, just recovering from the long crises of the war, with a taste of what Guillaume Apollinaire described as the 'New Spirit'. *Parade* promised to 'modify the arts and the conduct of life from top to bottom in a universal joyousness', he wrote in the programme preface. Although only rarely performed, then as now, the ballet set the tone for performance of the postwar years.

Satie worked a full year on the text provided by Jean Cocteau. 'A simple roughly outlined action which combines the attractions of the circus and the music hall', it read. 'Parade', according to the Larousse dictionary and to Cocteau's notes, meant a 'comic act, put on at the entrance of a travelling theatre to attract a crowd'. So the scenario revolves around the idea of a travelling troupe whose 'parade' is mistaken by the crowd for the real circus act. Despite desperate appeals from the performers, the crowd never enters the circus tent. To prepare the scene, Picasso painted a drop curtain – a Cubist depiction of a cityscape with a miniature theatre at its centre. Satie's Prelude of the Red Curtain opened the production. The action itself began with the First Manager dressed in Picasso's ten-foot-high Cubist costume dancing to a 63 simple rhythmic theme, endlessly repeated. The Chinese Prestidigitator, mimed by Massine himself in pigtail and brightly coloured costume of vermilion, yellow and black, was followed by the appearance of a second manager, the American Manager. Dressed as a skyscraper, this figure 62 stamped with 'an organized accent . . . with the strictness of a fugue'. Jazz passages, described in the score as 'sad', accompanied the dance of the Little American Girl, who mimed the actions of catching a train, driving a car, and foiling a bank robbery. The Third Manager performed in silence on horseback and introduced the next act, two Acrobats who tumbled to a fast waltz of xylophones. The finale recalled various themes from the preceding sequences, and ended with the Little American Girl in tears as the crowds refused to enter the circus tent.

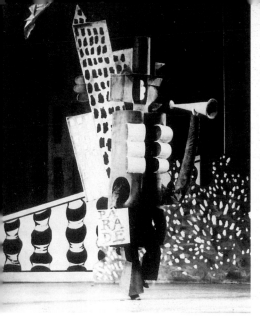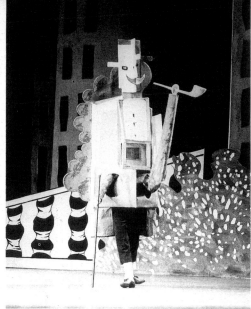

62 Picasso's costume for the American Manager in *Parade*, 1917

63 Picasso's costume for the First Manager in *Parade*, 1917

Parade was greeted with outrage. Conservative critics dismissed the entire production: the music, orchestrated by Satie to include some of Cocteau's suggestions for 'musical instruments', such as typewriters, sirens, aeroplane propellers, Morse tappers and lottery wheels (only a few of which were actually used in the production), was considered as 'unacceptable noise'. Satie's reply to one such critic – 'vous n'êtes qu'un cul, mais un cul sans musique' even resulted in a court case and then a lengthy appeal to lessen the heavy sentence imposed on him. In addition, critics objected to the enormous costumes which they felt made nonsense of traditional ballet movements. Nevertheless the scandal of *Parade* confirmed Satie's reputation at fifty (just as *Ubu Roi* had made Jarry's at twenty-three), and it set a mood for future productions by Apollinaire and Cocteau among others.

Apollinaire and Cocteau

Apollinaire's preface to *Parade* had correctly anticipated the emergence of this New Spirit; moreover, it suggested that the New Spirit contained a notion of 'surrealism [*surréalisme*]'. There was, in *Parade*, he wrote, a 'sort of surrealism in which I see the point of departure for a series of manifestations of the New Spirit'. Encouraged by this atmosphere, Apollinaire finally added the last
65 scene of Act II and a prologue to his own play *Les Mamelles de Tirésias* ('The Breasts of Tiresias'), actually written in 1903, the year that he met Alfred

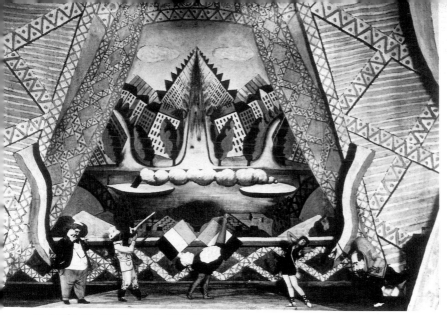

64 Set for *The Wedding on the Eiffel Tower*, 1921

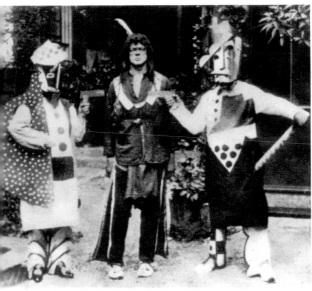

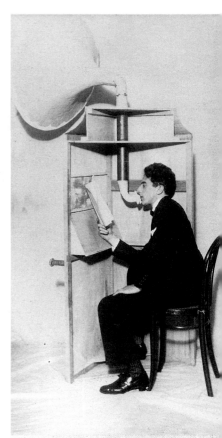

65 A scene from Apollinaire's *Les Mamelles de Tirésias*,
24 June 1917

66 Cocteau reciting through a megaphone in his
production of *The Wedding on the Eiffel Tower*, 1921

Jarry, and presented it one month after *Parade* in June 1917 at the Conservatoire René Maubel. In his introduction Apollinaire expanded his notion of surrealism: 'I have invented the adjective *surrealist* . . . which defines fairly well a tendency in art, which if not the newest thing under the sun, at least has never been formulated as a credo, an artistic and literary faith.' This 'surrealism' protested against the 'realism' of theatre, he wrote. Apollinaire went on to explain that this idea had developed naturally from contemporary sensibilities: 'When man wanted to imitate walking he created the wheel, which does not resemble a leg. In the same way, he has created surrealism.'

Employing some of Jarry's own ideas, such as representing the entire people of Zanzibar (where the action takes place) in one actor, he also included among the props a newspaper kiosk, which 'talked, sang and even danced'. The work was essentially an appeal to feminists who 'do not recognise the authority of men' not to abandon their child-producing facilites in the process of their emancipation. 'Because you made love to me in Connecticut/Doesn't mean I have to cook for you in Zanzibar', shouted the heroine Thérèse through a megaphone. Then she opened her blouse and let fly her breasts – two enormous balloons, one red one blue – which remained attached to her body by strings. With these all too prominent signs of her sex, she decided that it would be better to sacrifice beauty 'that may be the cause of sin', by getting rid of breasts altogether, and she exploded them with a lighter. With a full growth of beard and moustache, she announced that she would change her name to the masculine 'Tirésias'.

Les Mamelles de Tirésias was prophetically subtitled a 'drame sur-réaliste'. Apollinaire cautioned that 'in abstracting from contemporary literary movements a tendency of my own, I am in no way undertaking to form a school'; nevertheless, seven years later, the term 'Surrealist' came to describe exactly that.

Only four years later, in 1921, Cocteau elaborated this new aesthetic in his first solo production, *Les Mariés de la Tour Eiffel*. Resembling both *Ubu Roi* and *Les Mamelles de Tirésias*, this used many of the same techniques of the earlier works, particularly the habit of representing crowds in one person, as though this were the most basic and effective means to counteract traditional realist theatre. It also employed the vaudeville habit of a master and mistress of ceremonies announcing each new sequence and explaining the action to the audience. The performers, members of the Ballets Suédois, mimed to the direction of figures dressed as phonograph machines with horns for mouthpieces. Against a painted set of the Eiffel Tower, the work according to Cocteau could have 'the frightening appearance of a drop of poetry seen under a microscope'. This 'poetry' ended with a child shooting the entire wedding party in an attempt to get at some macaroons.

64,66

80

Typically the action was accompanied by noise music. But Cocteau had anticipated a new mixed media genre in French performance which would remain on the edges of theatre, ballet, light opera, dance and art. This 'revolution which flings doors wide open . . .', he wrote, would allow the 'new generation to continue its experiments in which the fantastic, the dance, acrobatics, mime, drama, satire, music and the spoken word combine'. *Les Mariés*, with its mix of music hall and absurdity, seemed to have taken the irrationality of Jarry's Pataphysics as far as it could go. Yet at the same time, the profusion of such performances provided an excellent excuse for the Dadaists to devise entirely new strategies.

Dada–Surrealism

The editors of *Littérature* devoted considerable space to these contemporary events, to Jarry and the twenty-fifth anniversary of his *Ubu Roi*. In addition they provided their own roll-call of anti-heroes, among them Jacques Vaché, a young nihilist soldier and friend of Breton. Vaché's refusal to 'produce anything at all' and his belief in the fact that 'art is an imbecility', expressed in letters to Breton, endeared him to the Dadaists. There he wrote that he objected to being killed in war and that he would die only when he wished to die, 'and then I shall die with somebody else'. Shortly after the Armistice, Vaché, twenty-three years old, was found shot dead with a friend. Breton's epitaph equated Vaché's brief life and premeditated death with Tzara's Dada proclamations of a few years earlier. 'Jacques Vaché quite independently confirmed Tzara's principal thesis', he wrote. 'Vaché always pushed the work of art to one side – the ball and chain that hold back the soul even after death.' And Breton's final remark – 'I do not think that the nature of the finished product is more important than the choice between cake and cherries for dessert' – summed up the spirit of Dada performances.

Consequently Breton and his friends saw the Dada soirées as a vehicle for such beliefs as well as a means to recreate some of the sensational scandals that the much admired Jarry had achieved. Not surprisingly, their search for scandal led them to attack in those places where their insults would be most felt; for example at Leo Poldes's exclusive Club du Faubourg, in February 1920. Essentially an enlarged version of the earlier Indépendants fiasco, their captive audience included such persons of public repute as Henri-Marx, Georges Pioch and Raymond Duncan, Isadora's brother. The Université Populaire du Faubourg Saint-Antoine was another stronghold of the intellectual and moneyed élite which supposedly represented the 'height of revolutionary activity' in France's educated circles. When the Dadaists performed there a few weeks later, Ribemont-Dessaignes pointed out that the only appeal of Dada to this informed gathering was its anarchy and its

'revolution of the mind'. To them, Dada represented the destruction of established order, which was acceptable. What was unacceptable, however, was the fact that they saw 'no new value arising from the ashes of past values'.

But this was precisely what the Parisian Dadaists refused to provide: a blueprint for anything better than what had gone before. Nevertheless this question did cause a rift in the new Dada contingent. Clearly it would have been pointless, they argued, to continue with soirées based on the Zurich formula. Some even felt that Dada ran the risk of 'turning to propaganda and consequently becoming codified'. So they decided to stage a large demonstration before a less homogeneous crowd, at the Salle Berlioz in the famed Maison de l'Oeuvre; on 27 March 1920 they presented a carefully planned performance which according to Ribemont-Dessaignes was arranged in a mood of collective enthusiasm. 'The attitude of the public was one of amazing and unprecedented violence', he wrote, 'which would have seemed mild beside Mme Lara's performance of Apollinaire's *Mamelles de Tiésias*'. The Dada–Surrealist group of Breton, Soupault, Aragon, Eluard, Ribemont-Dessaignes, Tzara and others, presented their own plays in what was, in many ways, not unlike a grand variety show.

The programme included Tzara's Zurich success *La Première Aventure céleste de M.Antipyrine*, *Le Serin muet* by Ribemont-Dessaignes, *Le ventriloque désaccordé* by Paul Dermée, and Picabia's *Manifeste cannibale dans l'obscurité*. Also performed was Breton's and Soupault's *S'il vous plaît*, one of the first scripts to use automatic writing before it became one of the preferred techniques of the Surrealists. A three-act performance, each entirely unrelated to the others, the first tells the brief tale of Paul (the lover), Valentine (his mistress) and François (Valentine's husband) who over a 'cloud of milk in a cup of tea' end their relationship with a shot-gun as Paul shoots Valentine. The second act takes place, according to the script, in 'an office at four o'clock in the afternoon' and the third in 'a café at three o'clock in the afternoon', including such lines as 'Automobiles are silent. It will rain blood', and ending with: 'Don't insist, sweetheart. You'll regret it. I've got the syph.' The last line of the script noted: 'The authors of *S'il vous plaît* do not want the fourth act printed.'

Salle Gaveau, May 1920

The Salle Berlioz performance had been an attempt to give a new direction to Dada activities. But it did nothing to placate those of the group strongly resisting the inevitable standardization of Dada performances. Picabia especially was highly critical; he was against all art which smacked of officialdom, whether André Gide – 'if you read André Gide aloud for ten minutes your mouth will smell bad', or Paul Cézanne – I hate Cézanne's

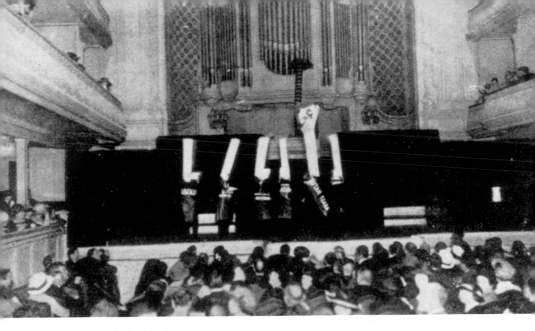

67 Dada Festival in the Salle Gaveau

68 Programme of the Dada Festival, 26 May 1920, at the Salle Gaveau, Paris

69 Breton with a placard by Picabia at the Dada Festival

paintings, they irritate me.' Tzara and Breton, the most forceful members of the group, who both equated Dada's fate with their own, were decidedly at odds as to where Dada would lead and how. But they managed to maintain some kind of working relationship, long enough to plan the next Dada 67–9 onslaught – the Dada Festival held at the plush Salle Gaveau on 26 May 1920.

A large crowd, lured by past performances and the advertisement that the Dadaists would have their hair shaved on stage, gathered at the hall. Although the hair cutting did not take place, a varied programme and curious costumes had been prepared beforehand for their amusement. Breton appeared with a revolver tied to each temple, Eluard in a ballerina's tutu, Fraenkel in an apron, and all the Dadaists wore funnel-shaped 'hats' on their heads. Despite these preparations, the performances themselves were unrehearsed, so that many of the events were delayed and broken up by shouts from the audience as performers attempted to straighten out their ideas. For example, Tzara's *Vaseline symphonique* presented the orchestra of twenty with considerable difficulties. Breton, who, by his own confession, had a horror of music, was openly hostile to Tzara's attempts at orchestration, and the Gaveau family was reportedly equally outraged to hear the great organs resound to the rhythm of a popular foxtrot, *Le Pélican*. Then Soupault, in a piece entitled *Le célèbre illusionniste*, let loose multi-coloured balloons bearing the names of famous people, and Paul Dermée presented his poem *Le Sexe de Dada*. Tzara's *La Deuxième Aventure de Monsieur Aa, l'Antipyrine* resulted in eggs, veal cutlets and tomatoes raining down on the 70 performers, and Breton's and Soupault's brief sketch *Vous m'oublierez* received similar treatment. Nevertheless the madness that manifested itself that night in the elegant hall created an enormous scandal, which of course was regarded as a great achievement by the somewhat disenchanted group, despite the fact that they were by then considerably at odds with one another.

70 Scene from *Vous m'oublierez* at the Dada Festival, with Paul Eluard (standing), Philippe Soupault (kneeling), André Breton (seated) and Théodore Fraenkel (with apron)

71 *Opposite*: The Dada excursion to the church of St Julien le Pauvre, 1920. *From left to right*, Jean Crotti, a journalist, André Breton, Jacques Rigaut, Paul Eluard, Georges Ribemont-Dessaignes, Benjamin Péret, Théodore Fraenkel, Louis Aragon, Tristan Tzara and Philippe Soupault

Excursion and the Barrès Trial

The performers were slow to recover from the Salle Gaveau festival. They met at Picabia's home or in the cafés to discuss a way out of the impasse of regular soirées. It had become obvious that the public was by then ready to accept 'a thousand repeat performances' of the evening at the Salle Gaveau, but Ribemont-Dessaignes insisted that 'at all costs, they must be prevented from accepting a shock as a work of art'. So they organized a Dada excursion 71 to the little-known, deserted church of St Julien le Pauvre on 14 April 1921. The guides were to be Buffet, Aragon, Breton, Eluard, Fraenkel, Huszar, Péret, Picabia, Ribemont-Dessaignes, Rigaut, Soupault and Tzara. However, Picabia, long dissatisfied with the course of Dada's activities, withdrew from the excursion on the actual day. Posters advertised the event throughout the city. They promised that the Dadaists would remedy the 'incompetence of suspect guides and cicerones', offering instead a series of visits to selected sites, 'particularly those which really have no reason for existing'. Participants in these events, they assured, would immediately 'become aware of human progress in possible works of destruction'. In addition the posters contained such aphorisms as 'cleanliness is the luxury of the poor, be dirty' and 'cut your nose as you cut your hair'.

Despite the promise of an unusual excursion led by Paris's youthful celebrities, the lack of an audience, partly attributed to the rain, was not encouraging. 'The result was what followed every Dada demonstration; collective nervous depression', commented Ribermont-Dessaignes. This depression was short-lived, however. They dismissed the idea of future tours and turned instead to their second alternative to soirées, arranging the *Trial and Sentencing of M.Maurice Barrès by Dada* on 13 May 1921 at the Salle des 72 Sociétés Savantes, rue Danton. The object of their attack, an eminent established writer, Maurice Barrès, had been only a few years earlier

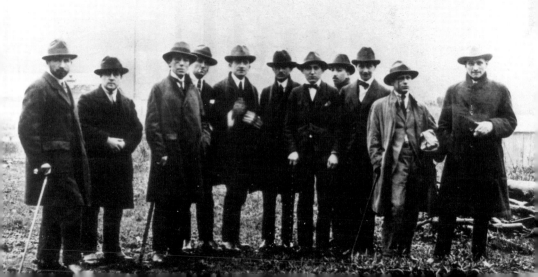

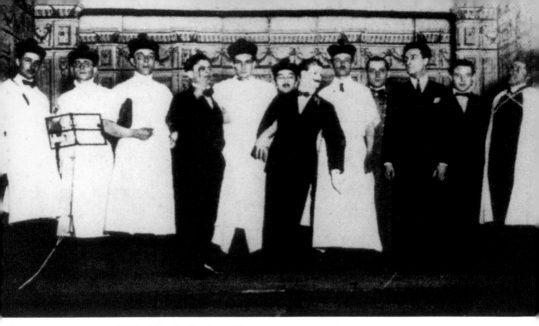

72 *Trial of Maurice Barrès*, 13 May 1921

somewhat of an ideal for the French Dadaists. According to the prosecution, Barrès had turned traitor when he became the mouthpiece of the reactionary newspaper *L'Echo de Paris*. The court representatives comprised Breton, the presiding judge, assisted by Fraenkel and Dermée, wearing white caps and aprons. Ribemont-Dessaignes was the public prosecutor, Aragon and Soupault the defence counsel, and Tzara, Rigaut, Péret and Giuseppe Ungaretti, among others, the witnesses. All wore scarlet caps. Barrès, tried by proxy, was himself represented by a wooden tailor's dummy. The accused was indicted for 'an offence against the security of the mind'.

The trial gave a public airing to the deep-rooted enmities that had been slowly brewing between Tzara and Breton, Picabia and the Dadaists. In fact Dada itself was on trial. It was also a signal for those for and against Dada to state their positions. Breton, who conducted proceedings in all seriousness, attacked the witness Tzara for his testimony that 'we are all nothing but a pack of fools, and that consequently the little differences – bigger fools or smaller fools – make no difference'. Breton's irritated reply was: 'Does the witness insist on acting like an utter imbecile, or is he trying to get himself put away?' Tzara retaliated with a song. Picabia made a brief appearance, having already published, two days earlier, his own repudiation of Dada in anticipation of the trial. 'The bourgeois represents the infinite', he wrote. 'Dada will be the same if it lasts too long.'

New directions

Following the trial, relations were strained between Picabia, Tzara and Breton. Those on the sidelines of this battle, Soupault, Ribemont-Dessaignes, Aragon, Eluard and Péret, organised a Dada Salon and exhibition at the Galerie Montaigne, which opened in June 1921. Breton and Picabia refused to have anything to do with it. Duchamp, who had been invited to contribute from New York, replied by telegram: 'peau de balle' [balls to you!].

Tzara however presented his work *Le Cœur à gaz* ('The Gas Heart'); first performed at this show, it was a complicated parody on nothing, with the characters, Neck, Eye, Nose, Mouth, Ear and Eyebrow dressed in elaborate cardboard costumes designed by Sonia Delaunay. Tzara introduced the event thus: 'It is the only and greatest three-act hoax of the century. It will satisfy only industrialized imbeciles who believe in the existence of men of genius.' Neck would remain downstage during the performance, Nose opposite, confronting the audience, the script explained. All the other characters would enter and leave as they pleased. The performance opened with Eye chanting monotonously: 'Statues, jewels, roasts', over and over, followed by 'Cigar, pimple, nose/Cigar, pimple, nose'. At this point Mouth commented, 'The conversation is lagging isn't it?' And the entire 'face' echoed this line for several minutes. At one point, a speaker stationed above the audience's heads, facing the stage, commented: 'It's charming, your play, but one can't understand a word of it.' The three acts continued with equally curious unrelated sentences, always at cross-purposes, and ended with the entire 'face' chanting 'go lie down/go lie down/go lie down'. Typically this verbal event ended in a brawl, with Breton and Eluard leading the attack against Tzara.

Meanwhile Breton was planning an event of his own. It was to be the Congress of Paris 'for the determination of directives and the defence of the modern spirit', scheduled for 1922. It would bring together all the various tendencies in Paris and elsewhere, with various groups represented by the artist–editors of the new magazines: Ozenfant (*L'Esprit Nouveau*), Vitrac (*Aventure*), Paulhan (*Nouvelle Revue Française*) and Breton (*Littérature*). Speakers would include Léger and Delaunay and, of course, the Dadaists. But the failure of the congress also marked the final break of Breton, Eluard, Aragon and Péret with the Dadaists. For Tzara contested the whole idea, finding it a contradiction in terms of Dada attitudes, to be presented on a comparative platform with Purists, Orphists and so on. Even before the event was finally cancelled, magazines published the various arguments for and against the congress. Breton made the mistake of using a 'common newspaper' in which to describe Tzara as an 'interloper from Zurich' and a 'publicity-seeking impostor'. This brought about the Dada contingent's

73 Costumes by Sonia Delaunay for Tristan Tzara's *Le Cœur à gaz*, revived for the Soirée du *Cœur à barbe* at the Théâtre Michel, 6–7 July 1923

resignation, published in a manifesto, *Le Cœur à barbe* ('The Bearded Heart').

A soirée held under the same name in July 1923 provided the ideal platform for the antagonisms that had brought about the failure of the congress to be aired once more. Following a programme of music by Auric, Milhaud and Stravinsky, designes by Delaunay and van Doesburg, and films by Sheeler, Richter and Man Ray, Tzara's second performance of *Le Cœur à gaz* became the focus of a nasty scene. Breton and Péret protested loudly from the stalls, before climbing onto the stage to engage in a physical battle with the performers. Pierre de Massot escaped with a broken arm and Eluard, after having fallen into the stage sets, received a bailiff's note demanding 8000 francs for damages.

While Tzara stood firmly for the rescue and preservation of Dada, Breton announced its death. 'Though Dada had its hour of fame', he wrote, 'it left few regrets.' 'Leave everything. Leave Dada. Leave your wife. Leave your mistress. Leave your hopes and fears. . . . Set off on the roads.'

Bureau of Surrealist Research

The year 1925 marked the official foundation of the Surrealist movement with the publication of the *Surrealist Manifesto*. By December of that year, the new group had published the first issue of the magazine *La Révolution Surréaliste*. They had their own premises, the Bureau of Surrealist Research –

'a romantic inn for unclassifiable ideas and continuing revolts' – at 15 rue de Grenelle. According to Aragon, they hung a woman on the ceiling of an empty room, 'and every day received visits from anxious men bearing heavy secrets'. These visitors, he said, 'helped elaborate this formidable machine for killing what is in order to fulfil what is not'. Press releases were issued carrying the address of the bureau, and newspaper advertisements specified that the research bureau, 'nourished by life itself', would receive all bearers of secrets: 'inventors, madmen, revolutionaries, misfits, dreamers'.

The notion of 'automatism' formed the core of Breton's early definition: '*Surrealism:* noun masc., pure psychic automatism, by which an attempt is made to express, either verbally, in writing, or in any other manner, the true functioning of thought.' In addition, Surrealism, it explained, rested on the belief in the 'higher reality of certain hitherto neglected forms of association, in the omnipotence of the dream, in the disinterested play of thought'.

Indirectly, these definitions provided for the first time a key to understanding some of the motives behind the seemingly nonsensical performances of the preceding years. With the *Surrealist Manifesto* those works could be seen as an attempt to give free rein in words and actions to the oddly juxtaposed images of the dream. Actually, Breton had already by 1919 become 'obsessed with Freud' and the examination of the unconscious. By 1921 Breton and Soupault had written the first 'automatic' Surrealist poem, *Les Champs magnétiques* ('Magnetic Fields'). So although the Parisians accepted the term 'Dada' as a description of their works, many of the performances during the early twenties already had a definitely Surrealist flavour and could in retrospect be considered as Surrealist works.

Even if performances followed the Dada principles of simultaneity and chance as much as they did the Surrealist dream notions, some had fairly straightforward plots. For example, Apollinaire's *Sky Blue*, performed two weeks after his death in 1918, was about three young spaceship adventurers who, finding their ideal woman to be one and the same lady, destroy themselves. Tzara's *Mouchoir des nuages* ('Cloud Handkerchief') of 1924, with lighting designed by the dancer Loie Fuller, told the story of a poet having an affair with a baker's wife. Aragon's *The Mirror Wardrobe* (1923), written in typical 'automatic writing' style, was simply a tale about a jealous husband – the only twist was that the wife constantly urged her husband to open the wardrobe where her lover was in hiding. On the other hand, numerous performances directly interpreted Surrealist notions of irrationality and the unconscious. Roger Gilbert-Lecomte's *The Odyssey of Ulysses the Palimped* (1924) even defied all performance possibilities by inserting into the script long passages 'to be read silently'. And Vitrac's *Le Peintre* ('The Painter') (1922) no more provided a narrative: a curious performance, it involved a painter who first paints a child's face red, then the child's mother's

and finally his own. Each of the characters left the stage in tears, having been branded in this way.

'Relâche'

While such Surrealist principles became more strongly asserted in the performances of the mid-twenties, the conflicts between Surrealists, Dadaists and anti-Dadaists continued. For example, the Surrealists, in an attempt to draw Picasso into their ranks, published a letter in *391* and *Paris-Journal* in praise of Picasso's sets and costumes for the ballet *Mercure* (1924). But at the same time they took the opportunity to attack Picasso for his collaboration with Satie, of whom they vehemently disapproved. This response to Satie's music was never explicitly stated (it may simply have been a result of Breton's well-known 'horror of music'), but Satie's association with deserters of the Dada and newly named Surrealist cause, like Picabia, certainly did not help
75 matters. Picabia and Satie retaliated with their 'ballet' *Relâche*, which owed as much to Picabia's commitment to the 'sensation of the *new*, of pleasure, the sensation of forgetting that one has to "reflect" and "know" in order to like something', as it did to the competition and feuding between the various individuals.

Despite the Surrealists' scorn, Picabia remained an avid admirer of Satie's. He even attributed the initial idea of *Relâche* to the composer: 'although I had made up my mind never to write a ballet,' Picabia wrote, 'Erik Satie persuaded me to do so. The mere fact that he was writing the music for it was for me the best reason.' And Picabia was enthusiastic about the results: 'I consider the music for *Relâche* perfect', he commented. Other collaborators on the performance, Duchamp, Man Ray, the young film maker René Clair and the director of the Ballets Suédois, Rolf de Maré, completed the 'perfect' team.

Opening night was scheduled for 27 November 1924. But that evening the principal dancer, Jean Borlin, fell ill. Consequently a sign, 'Relâche', the theatrical world's term for 'no performance tonight', was pasted on the doors of the Théâtre des Champs-Elysées. The crowd thought it was yet another Dada hoax, but for those who returned on 3 December, a dazzling spectacle was waiting. First they saw a brief cinematic prologue, which indicated something of what was to follow. Then they were confronted by an
74 enormous backdrop comprising metal discs, each reflecting a powerful light bulb. Satie's prelude, an adaptation of the well-known student song, 'The Turnip Vendor', soon had the audience roaring the scandalous chorus. From then on heckling and laughter accompanied the affectedly plain orchestration and the unfolding of the burlesque 'ballet'.

74 Jean Börlin and Edith von Barnsdorff in a scene from Picabia's *Relâche*, 1924, showing part of the wall of large silver disks, each inset with extra bright lights. The music was composed by Eric Satie

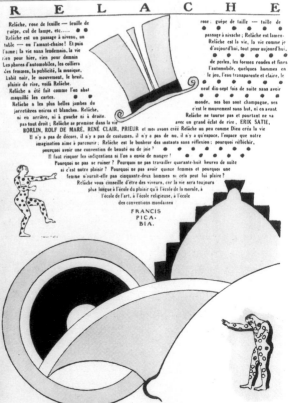

75 Poster by Robert Delaunay for the Soirée du *Coeur à barbe*

The first act consisted of a series of simultaneous events: downstage a figure (Man Ray) paced up and down, occasionally measuring the dimensions of the stage floor. A fireman, chain-smoking, poured water endlessly from one bucket into another. In the background the Ballets Suédois dancers revolved in darkness, an occasional spotlight revealing a
76 *tableau vivant* of a naked couple representing Cranach's *Adam and Eve* (Duchamp portraying Adam). Then came the interval. But it was no ordinary interval. Picabia's film *Entr'acte*, scripted by him and filmed by the
77–9 young cameraman René Clair, began rolling: a male dancer in a gauze skirt was seen from below, filmed through a glass plate; chess players (Man Ray, Duchamp and adjudicator Satie) were filmed from above, on the roof of the

92

76 *Opposite*: Duchamp (*à la* Cranach) as Adam in a scene from Picabia's *Relâche*

77–79 Stills, from René Clair's film *Entr'acte*, of Picabia dancing. *Entr'acte* was presented 'between acts' of *Relâche*. Duchamp and Man Ray also appeared in the film, playing chess

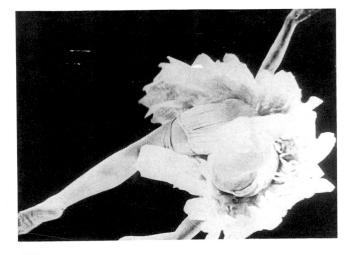

same Théâtre des Champs-Elyseés; a funeral procession took the viewers
80 through the Luna Park and around the Eiffel Tower as mourners followed a
camel-drawn hearse decked with advertising posters, bread, hams and
interlocking monograms of Picabia and Satie; and a soundtrack by Satie
closely matched the length of each shot in the film. No sooner had the slow-
motion procession ended with the coffin falling off the hearse and breaking
81 open to reveal a grinning corpse, than the cast broke through the 'End' paper,
marking the beginning of the second act.

80 Still from *Entr'acte* of the climactic scene in which a hearse is hauled round the Eiffel
Tower by a camel

81 Still from *Entr'acte* showing Jean Börlin as the corpse in the coffin

The stage was hung with banners proclaiming: 'Erik Satie is the greatest musician in the world', and 'if you are not satisfied you can buy whistles at the box office for a few farthings.' Borlin, Edith Bonsdorf and the corps de ballet danced 'gloomy and oppressive' dances. For the final curtain-call, Satie and other creators of the work drove around the stage in a miniature five-horsepower Citroën.

The evening ended inevitably in tumult. The press attacked the fifty-eight-year-old Satie with 'Adieu, Satie . . .' and the scandal was to remain with him till his death less than a year later. Picabia was delighted: 'Relâche is life,' he wrote, 'life as I like it, all for today, nothing for yesterday, nothing for tomorrow.' Though 'intelligent people, Protestant pastors [may say] it isn't a ballet [or] it is only a Ballet Suédois [or] Picabia is mocking the world', he wrote, it was 'in a word, total success! Relâche is not for the erudite, to be sure . . . not for great thinkers, leaders of artistic schools who, like stationmasters, send out trains to the big ships that are always ready to take on board the lovers of "intelligent" art.' Fernand Léger, who had himself in 1923 provided the décor and extraordinary costumes for the Ballets Suédois's *La Création du monde*, declared *Relâche* 'a break, a rupture with traditional ballet'. 'To hell with the scenario and all literature! *Relâche* is a lot of kicks in a lot of backsides whether hallowed or not.' Above all Léger celebrated the fact that *Relâche* had broken the watertight compartment separating ballet from music hall. 'The author, the dancer, the acrobat, the screen, the stage, all these means of "presenting a performance" are integrated and organized to achieve a total effect . . .'.

Surrealist love and death

The success of *Relâche* did nothing to deter the Surrealists' own directions. Although *Entr'acte*, more than the 'ballet' itself, had contained elements of the nightmare farces that Surrealists would develop in subsequent performances and films, the unstageable Surrealist 'plays for reading' by Salacrou, Daumal and Gilbert-Lecomte were leading to a dead end. Antonin Artaud was soon to provide a way out of that impasse: he and Roger Vitrac founded the Théâtre Alfred Jarry in 1927, dedicated to that innovator, to 'return to the theatre that total liberty which exists in music, poetry, or painting, and of which it has been curiously bereft up to now'.

Artaud's *Le Jet de sang* ('The Jet of Blood') of 1927 only barely escaped the classification 'play for reading'. Cinematic images ran throughout the brief scenario (less than 350 words): 'a hurricane separates the two [lovers]; then 2 stars crash into each other and we see a number of live pieces of human bodies falling down; hands, feet, scalps, masks, colonnade . . .' The Knight, Nurse, Priest, Whore, Young Man and Young Girl, engaged in a series of

disconnected emotional exchanges, created a violent and lurid fantasy world. At one point the Whore bit 'God's wrist' resulting in an 'immense jet of blood' shooting across the stage. Despite the brevity and virtually unrealisable images of the play, the work reflected the Surrealist dream world and its obsession with memory. When Surrealism would take your hand into death, Breton had written, 'it will glove your hand, burying therein the profound M with which the word Memory begins'. It was this same M that in its distorted way characterized Roger Vitrac's *Les Mystères de l'amour* ('The Mysteries of Love'), produced by Artaud in the same year. 'There is death', Lea concluded at the end of the fifth tableau of this rhetorical work. 'Yes,' Patrick replied, 'the heart is red already as far as the end of the theatre where someone is about to die.' And Lea fired a shot into the audience, pretending to kill a spectator. A 'drame surréaliste', Vitrac's play was perfectly consistent with Surrealism's 'automatic writing' and its own brand of lucidity.

Such lucidity was to dominate the extensive writings of Breton and the numerous Surrealist writers, painters and film makers. But by 1938 when Surrealism had showed its ability to dominate political, artistic and philosophical life, the Second World War was to put a stop to further group activities and performances. As a final gesture, and before Breton would depart for the United States, the Surrealists arranged an International Exhibition of Surrealism in 1938 at the Galerie des Beaux-Arts, Paris. This grand finale of works by sixty artists from fourteen nations was presented in a series of rooms described in the catalogue as follows: 'Ceiling covered with 1200 sacks of coal, revolving doors, Mazda lamps, echoes, odours from Brazil, and the rest in keeping.' Also presented were Salvador Dali's *Raining Taxi* and *La Rue Surréaliste* and a dance by Helen Vanel entitled *The Unconsummated Act*, around a pool filled with water lilies.

Despite this exhibition and subsequent shows in London and New York, Surrealist performance itself had already marked the end of an era and the beginning of a new one. In Paris, from the 1890s on, Jarry's and Satie's inventions had radically altered the course of 'theatrical' developments as well as providing the breeding-ground for the New Spirit, punctuated through the years by Roussel, Apollinaire, Cocteau, the 'imported' and local Dadaists and Surrealists, to name only a few of the extraordinary figures who made Paris a thriving cultural capital for so many years. Surrealism had introduced psychological studies into art so that the vast realms of the mind literally became material for new explorations in performance. Actually Surrealist performance was to affect most strongly the world of the theatre with its concentration on language, rather than subsequent performance art. For it was to the basic tenets of Dada and Futurism – chance, simultaneity and surprise – that artists, indirectly or even directly, turned following the Second World War.

Bauhaus

The development of performance in the twenties in Germany was due largely to the pioneering work of Oskar Schlemmer at the Bauhaus. When he wrote in 1928, 'I have now pronounced the death sentence for theatre at the Bauhaus', at a time when the Dessau City Council had issued a publicly read decree forbidding parties at the Bauhaus, 'including for good measure our next party, which would have been a lovely one', these were the ironical words of a man who had set performance work of the period on its course.

The Stage workshop 1921–3

The Bauhaus, a teaching institution for the arts, had opened its doors in April 1919 in a very different mood. Unlike the rebellious Futurist or Dada provocations, Gropius's Romantic Bauhaus manifesto had called for the unification of all the arts in a 'cathedral of Socialism'. The cautious optimism expressed in the manifesto provided a hopeful yardstick for cultural recovery in a divided and impoverished postwar Germany.

Artists and artisans of widely varying sensibilities, such as Paul Klee, Ida Kerkovius, Johannes Itten, Gunta Stölzl, Wassily Kandinsky, Oskar Schlemmer, Lyonel Feininger, Alma Buscher, László Moholy-Nagy and their families (to name only a few), began arriving in the provincial town of Weimar, taking up residence in and around the stately Grand Ducal Fine Arts Academy, and the former homes of Goethe and Nietzsche. As tutors at the Bauhaus, these people took responsibility for the various workshops – metal, sculpture, weaving, cabinet making, wall-painting, drawing, stained glass; at the same time they formed a self-contained community within the conservative town.

A stage workshop, the first ever course on performance in an art school, had been discussed from the first months as an essential aspect of the interdisciplinary curriculum. Lothar Schreyer, the Expressionist painter and dramatist, and a member of the *Sturm* group in Berlin, arrived to supervise the early Bauhaus performance programme. A collaborative venture from the start, Schreyer and students were soon building figurines for his productions of *Kindsterben* and *Mann* (Schreyer's own works), in line with his

simple maxim that 'work on the stage is a work of art'. They also devised a
82 complex scheme for their production of *Crucifixion*, executed in woodcut by
Margarete Schreyer, which gave detailed directions as to the tones and
accents of words, direction and emphasis of movements, and 'emotional
states' that the performers would adopt.

But Schreyer's workshop introduced few innovations: essentially these
early productions were an extension of Expressionist theatre of the previous
five years in Munich and Berlin. They resembled religious plays where
language was reduced to emotionally charged stammering, movement to
pantomimic gestures and where sound, colour and light merely reinforced
the melodramatic content of the work. Subsequently *feelings* became the
significant form of theatrical communication, which was at odds with the
Bauhaus goal of achieving a synthesis of art and technology in 'pure' forms.
Indeed, the first public exhibition of the school, the Bauhaus Week of 1923,
was mounted under the title 'Art and Technology – A New Unity', making
Schreyer's workshop something of an anomaly within the school. During
the months of preparation for the exhibition, opposition to Schreyer caused
serious ideological battles and, under constant fire from students and staff
alike, Schreyer's resignation was inevitable. He left the Bauhaus in the
autumn of that year.

The direction of the Bauhaus Stage was immediately transferred to Oskar
Schlemmer, who had been invited to the school on the basis of his reputation
as a painter and sculptor as much as on that of his early dance productions in
his native Stuttgart. Schlemmer took the opportunity of the Bauhaus Week
to introduce his own programme with a series of performances and
demonstrations. On the fourth day of the Week, 17 August 1923, members
84,85 of the much altered stage workshop presented *The Figural Cabinet I*, which
had been performed a year earlier at a Bauhaus party.

98

Schlemmer described the performance as 'half shooting gallery – half *metaphysicum abstractum*', using cabaret techniques to parody the 'faith in progress' so prevalent at the time. A medley of sense and nonsense, characterized by 'Colour, Form, Nature and Art; Man and Machine, Acoustics and Mechanics', Schlemmer attributed its 'direction' to Caligari (referring to the 1919 film *The Cabinet of Dr Caligari*), America, and himself. The 'Violin Body', the 'Chequered One', the 'Elemental One', the 'Better-Class Citizen', the 'Questionable One', 'Miss Rosy Red', and the 'Turk' were represented in full, half and quarter figures. Set in motion by invisible hands, the figures 'walk, stand, float, slide, roll or rollick for a quarter of an hour'. According to Schlemmer, the production was 'Babylonian confusion, full of method, a pot-pourri for the eye, in form, style and colour'. *Figural Cabinet II* was a projected variation of the first, with metallic figures on wires dashing from background to foreground and back again.

The performance was a great success precisely because its mechanical devices and overall pictorial design reflected both the art and technology sensibilities of the Bauhaus. Schlemmer's ability to translate his painterly talents (the early plans for the figurines had already been suggested in his paintings) into innovative performances was much appreciated within a school which specifically aimed at attracting artists who would work beyond the boundaries of their own disciplines. Schlemmer's refusal to accept the limits of art categories resulted in performances which quickly became the focus of Bauhaus activities, while his position as overall director of the Bauhaus Stage became firmly established.

Bauhaus festivities

The Bauhaus community was held together as much by its manifesto and Gropius's novel vision of a teaching school for all the arts, as by the social events they organized to make Weimar a lively cultural centre. The 'Bauhaus Festivities' soon became famous and drew party-goers from the local communities of Weimar (and later Dessau), as well as from surrounding cities such as Berlin. Parties were elaborately prepared around themes, such as 'Meta', 'The Beard, Nose and Heart Festival' or 'The White Festival' (where everyone was instructed to appear in a costume 'dotted, chequered and striped'), which more often than not were devised and coordinated by Schlemmer and his students.

These events provided the group with the opportunity to experiment with new performance ideas: for example, the *Figural Cabinet* performance was an elaboration of one such festive evening. On the other hand, *Meta*, [83] performed at a rented hall in Weimar in 1924, was the basis for a festive evening held at the Ilm Chalet in the summer of that year. In the staged

performance, the simple plot was 'freed from all accessories' and defined only by placards bearing directions such as 'entrance', 'intermission', 'passion', 'climax' and so on. The actors performed the designated actions around the props of a couch, stairs, ladder, door and parallel bars. For the Ilm Chalet evening, there were similar signals for action.

It was at the Ilm Chalet Gasthaus, only a bicycle ride from Weimar, that the Bauhaus band first tried out their combinations. One such evening was described by a visiting reporter from Berlin: 'What an imaginative and dainty name and what a shack that adorns itself with it', he wrote of the Ilm Chalet. But there was more 'artistic and youthful energy in this royal chamber of Victoriana' than in any stylishly decorated State Art Society Annual Dance in Berlin. The Bauhaus jazz band, playing the *Banana Shimmy* and *Java Girls*, was the best he had ever heard, and the pantomime and costumes without equal. Another famous Bauhaus dance, held in February 1929, was the Metallic Festival. As the title suggests, the entire school was decorated in metallic colour and substances, and for those who took up the invitations printed on elegant metal-coloured card, a chute awaited them at the entrance to the school. Down this miniature dipper they sped through the hallway between the two Bauhaus buildings, to be greeted in the main festive room by tinkling bells and a loud flourish played by a four-piece village band.

86

83 Oskar Schlemmer, scene from *Meta or the Pantomime of Scenes*, 1924

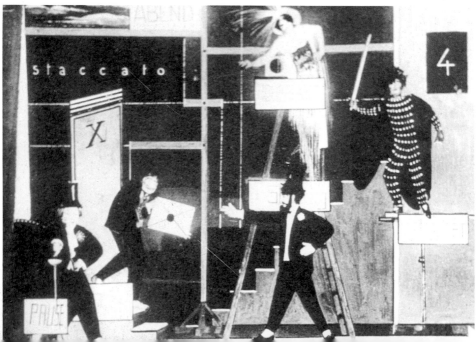

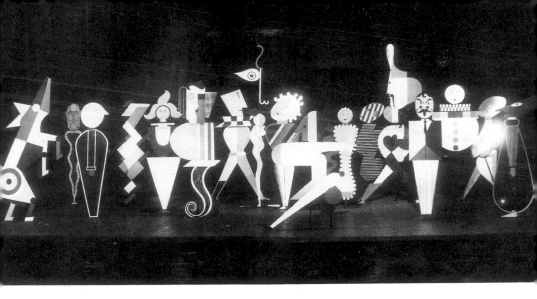

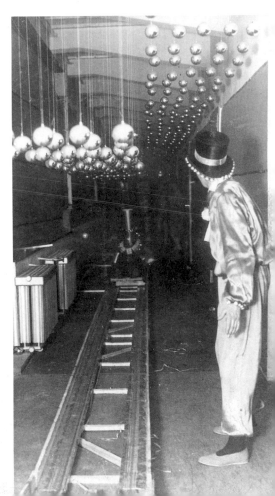

84 Maquettes for *The Figural Cabinet 1*
executed by Carl Schlemmer, 1922–3

85 Schlemmer, *The Figural Cabinet 1* (made by
Carl Schlemmer), which was performed for
the first time at a Bauhaus party in 1922. It was
staged again during the Bauhaus week in 1923
and during a tour of the Bauhaus Stage in 1926

86 Metallic Festival, 9 February 1929. A chute
connected the wing between two Bauhaus
buildings. The figure in costume prepares to
take off on the chute which would bring him
into the main festival rooms

In fact it was to those earlier festivities that Schlemmer attributed the original spirit of Bauhaus performance. 'From the first day of its existence, the Bauhaus sensed the impulse for creative theatre,' he wrote, 'for from that first day the play instinct was present. It was expressed in our exuberant parties, in improvisations, and in the imaginative masks and costumes that we made.' In addition, Schlemmer pointed out that there was a distinct feeling for satire and parody. 'It was probably a legacy of the Dadaists to ridicule automatically everything that smacked of solemnity or ethical precepts.' And so, he wrote, the grotesque flourished again. 'It found its nourishment in travesty and in mocking the antiquated forms of the contemporary theatre. Though its tendency was fundamentally negative, its evident recognition of the origin, conditions, and laws of theatrical play was a positive feature.'

This same disregard for 'antiquated forms' meant that the Stage workshop imposed no qualifying requirements on the students beyond their will to perform. With few exceptions, those students who joined Schlemmer's course were not professionally trained dancers. Nor for that matter was Schlemmer, but over the years, through directing and demonstrating numerous productions, he became involved in actually dancing his own work. One of the dance students, Andreas Weininger, was also leader of the famous Bauhaus jazz band.

Schlemmer's theory of performance

Parallel to this satiric and often absurd aspect of many of the performances and festivities, Schlemmer developed a more specific theory of performance. Maintained throughout his various manifestos on the aims of the Stage workshop, as well as in his private writings, kept in a diary from early 1911

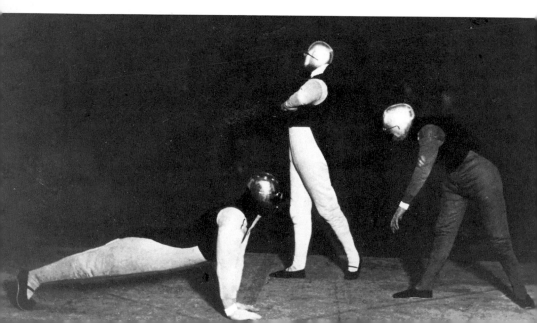

until his death, Schlemmer's theory of performance was a unique contribution to the Bauhaus. In it he obsessively analysed the problem of theory and practice that was central to such an educational programme. Schlemmer expressed this questioning in the form of the classic mythological opposition between Apollo and Dionysus: theory pertained to Apollo, the god of intellect, while practice was symbolized by the wild festivities of Dionysus.

Schlemmer's own alternations between theory and practice reflected a puritan ethic. He considered painting and drawing to be the aspect of his work that was most rigorously intellectual, while the unadulterated pleasure he obtained from his experiments in theatre was, he wrote, constantly suspect for this reason. In his paintings, as in his theatrical experiments, the essential investigation was of space; the paintings delineated the two-dimensional elements of space, while theatre provided a place in which to 'experience' space.

Although beset with doubts as to the specificity of the two media, theatre and painting, Schlemmer did consider them as complementary activities: in his writings he clearly described painting as theoretical research, while performance was the 'practice' of that classical equation. 'The dance is Dionysian and wholly emotional in origin', he wrote. But this satisfied only one aspect of his temperament: 'I struggle between two souls in my breast – one painting-oriented, or rather philosophical–artistic; the other theatrical; or, to put it bluntly, an ethical soul and an aesthetic one.'

In a piece entitled *Gesture Dance* performed in 1926–7, Schlemmer devised 87,88 a dance demonstration to illustrate these abstract theories. He first prepared a notation system which graphically described the linear paths of motion and the forward movements of the dancers. Following these directions, three figures, dressed in the primary colours of red, yellow and blue, executed

87 *Opposite*: Scene from *Gesture Dance* with Schlemmer, Siedhoff, Kaminsky

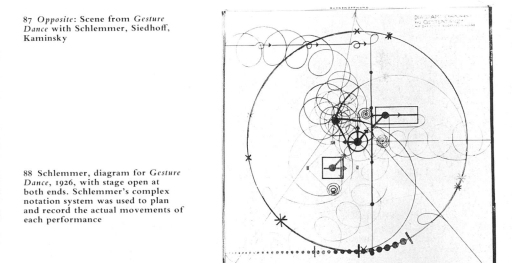

88 Schlemmer, diagram for *Gesture Dance*, 1926, with stage open at both ends. Schlemmer's complex notation system was used to plan and record the actual movements of each performance

complicated 'geometric' gestures and banal 'everyday actions', such as 'pointed sneezing, broad laughing and soft listening', which were 'always a means towards isolating abstract form'. This demonstration was intentionally didactic and at the same time it revealed Schlemmer's methodical transition from one medium to another: he moved from the two-dimensional surface (notation and painting) to the plastic (reliefs and sculptures) to the animatedly plastic art of the human body.

So preparing a performance involved these various stages: words or abstract printed signs, demonstrations, and physical images in the form of paintings, which all became a means for representing layers of real space and time changes. In this way notation as well as painting involved for Schlemmer the theory of space, while performance in real space provided the 'practice' to complement that theory.

Performance space

The opposition of visual plane and spatial depth was a complex problem that preoccupied many of those working at the Bauhaus during Schlemmer's time there. 'Space: as the unifying element in architecture' was what Schlemmer considered to be the common denominator of the mixed interests of the Bauhaus staff. What characterized the 1920s' discussion on space was the notion of *Raumempfindung* or 'felt volume', and it was to this 'sensation of space' that Schlemmer attributed the origins of each of his dance productions. He explained that 'out of the plane geometry, out of the pursuit of the straight line, the diagonal, the circle and the curve, a stereometry of space evolves, by the moving vertical line of the dancing figure'. The relationship of the 'geometry of the plane' to the 'stereometry of the space' could be *felt* if one were to imagine 'a space filled with a soft pliable substance in which the figures of the sequence of the dancer's movements were to harden as a negative form.'

In a lecture–demonstration given at the Bauhaus in 1927, Schlemmer and students illustrated these abstract theories: first the square surface of the floor was divided into bisecting axes and diagonals, completed by a circle. Then taut wires crossed the empty stage, defining the 'volume' or cubic dimension of the space. Following these guidelines, the dancers moved within the 'spatial linear web', their movement dictated by the already geometrically divided stage. Phase two added costumes emphasizing various parts of the body, leading to gestures, characterization, and abstract colour harmonies provided by the coloured attire. Thus the demonstration led the viewers through the 'mathematical dance' to the 'space dance' to the 'gesture dance', culminating in the combination of elements of variety theatre and circus suggested by the masks and props in the final sequence.

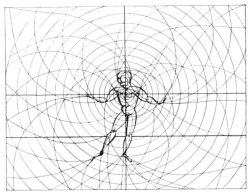

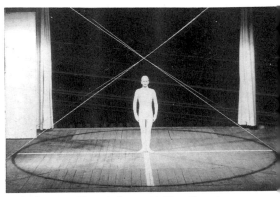

89 Schlemmer, drawing from *Mensch und Kunstfigur*, 1925

90 Schlemmer, *Figure in Space with Plane Geometry and Spatial Delineations*, performed by Werner Siedhoff

91 *Dance in Space (Delineation of Space with Figure)*, multiple exposure photograph by Lux Feininger; Bauhaus Stage demonstration, 1927

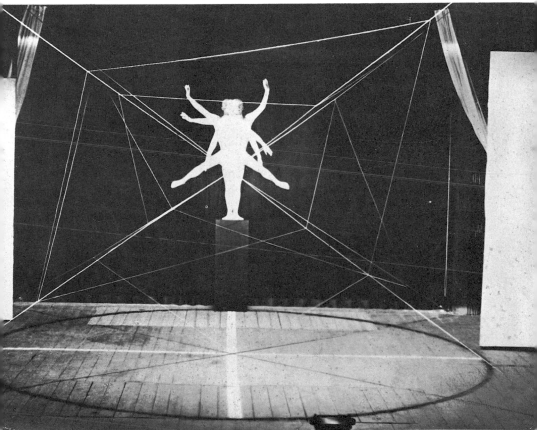

92 The projection booth for Ludwig Hirschfeld-Mack's *Reflected Light Compositions*, 1922–3; Hirschfeld-Mack at the piano

93 Hirschfeld-Mack, *Cross Composition*, reflected light compositions, 1923–4

92,93 By contrast, the students Ludwig Hirschfeld-Mack and Kurt Schwerdtfeger, independently of the Stage workshop, experimented with 'flattening' space in their *Reflected Light Compositions*. The 'light plays' began as an experiment for one of the Bauhaus festivites of 1922: 'Originally we had planned a quite simple shadow-show for a Lantern Festival. Accidentally, through the replacement of one of the acetylene lamps, the shadows of the paper screen doubled themselves, and because of the many differently coloured acetylene flames, a "cold" and a "warm" shadow became visible . . .'.

The next step was to multiply the sources of light, adding layers of coloured glass which were projected on the back of a transparent screen, producing kinetic, abstract designs. Sometimes the players followed intricate scores which indicated the light source and sequence of colours, rheostat settings, speed and direction of 'dissolves' and 'fade-outs'. These were 'played' on a specially constructed apparatus and accompanied by Hirschfeld-Mack's piano playing. Believing that these demonstrations would be a 'bridge of understanding for those many people who stand perplexed before abstract paintings and other new tendencies', these light projection plays were publicly shown for the first time at the Bauhaus Week in 1923, and in subsequent tours to Vienna and Berlin.

Mechanical ballets

'Man and Machine' was as much a consideration within the Bauhaus analysis of art and technology as it has been for the Russian Constructivist or the Italian Futurist performers. Costumes of the Stage workshop were designed to metamorphose the human figure into a mechanical object. In the *Slat*

Dance (1927), performed by Manda von Kreibig, the actions of lifting and bending the limbs of the body could be seen only in the movements of the long, thin slats projecting from the body of the dancer. *Glass Dance* (1929), executed by Carla Grosch wearing a hooped skirt of glass rods, head covered in a glass globe and carrying glass spheres, equally restricted the dancer's movements. Costumes ranged from down-filled 'soft figures' to bodies covered in concentric hoops, and in each case the very constrictions of the elaborate attire totally transformed traditional dance movements.

In this way Schlemmer emphasized the 'object' quality of the dancers and each performance achieved his desired 'mechanical effect', not unlike that of puppets: 'Might not the dancers be real puppets, moved by strings, or better still, self-propelled by means of a precise mechanism, almost free of human intervention, at most directed by remote control?', Schlemmer noted, in one of his passionate diary entries. And it was Heinrich von Kleist's essay *Über das*

94 Schlemmer, *Glass Dance*, 1929

95 Schlemmer, scene from his pantomime *Treppenwitz*, c. 1926–7, performed by Hildebrandt, Siedhoff, Schlemmer and Weininger

Marionettentheater (1810), where a ballet-master walking through a park observed an afternoon puppet-show, that inspired the so-called puppet theory. Kleist had written:

> Each puppet has a focal point in movement, a centre of gravity, and when this centre is moved, the limbs follow without any additional handling. The limbs are pendula, echoing automatically the movement of the centre. Every time the centre of gravity is guided in a straight line, the limbs describe curves that complement and extend the basically simple movement.

By 1923 puppets and mechanically operated figures, masks and geometrical costumes had become central features of many Bauhaus perfor-

mances. Kurt Schmidt designed a *Mechanical Ballet* in which abstract, movable figures, identified by the letters A,B,C,D,E, were carried by 'invisible' dancers, creating an illusion of dancing automatons. Equally, Schmidt's production of *Man + Machine* (1924) underlined the geometric and mechanical aspects of movement, and his *Die Abenteuer des kleinen* 97 *Buckligen* (' *The Adventures of the Little Hunchback*') (1924), also based on von Kleist's ideas, led to the formation of a flexible marionette stage, under the direction of Ilse Fehling. Xanti Schawinsky added 'animal' puppets to his performance of *Circus* (1924): dressed in black leotard, Schawinsky invisibly 96 played the lion-tamer to von Fritsch's cardboard lion (with a traffic signal for the tail). Performed for the Bauhaus community and guests on the stage of a dance hall about a half-hour's walk from the institute, the work was 'essentially of a formal and pictorial concept. It was visual theatre, a realisation of painting and constructions in motion, ideas in colour, form and space and their dramatic inter-action', Schawinsky wrote.

Typically, Schlemmer's own *Treppenwitz* (1926–7) verged on the absurd. 95 A pantomime on stairs, it included such characters as the Musical Clown (Andreas Weininger). Dressed in a padded white costume with a large funnel-shaped object which totally transformed his left leg, and a violin hanging from his right leg, carrying an accordion, a paper-shaker and an umbrella with spokes only, Weininger was forced, on account of the rushed preparations for this production, to perform his own puppet-like gestures held together by safety-pins.

96 Xanti Schawinsky, scene from *Circus*, with Schawinsky as the lion-tamer and von Fritsch as the 'lion', 1924

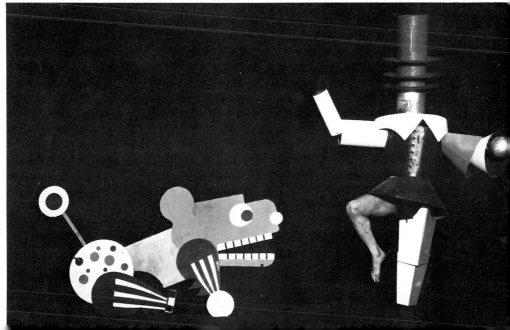

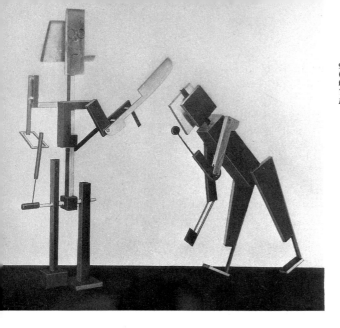

Yet it was a circus artiste who was to become one of the favourites of the Bauhaus performers. Rastelli, whom Schlemmer had met in Berlin in 1924, used to perform a spectacular nine-ball juggling act which soon became a standard exercise at the Bauhaus. The students would practise the particular skills of the juggler, developing at the same time the balance and coordination that characterizes the juggling art. The usual dance-training practice of studied attitudes at the barre was replaced by the warming-up exercise of an Italian juggler.

Painting and Performance

The relationship between painting and performance was a constant preoccupation in the development of Bauhaus performance. In his 1917 ballet *Parade*, Picasso had split the figures in half, as it were, their torsos covered in gigantic structures and their legs in trousers or traditional ballet tights and shoes. Moreover these figurines derived from Picasso's Cubist paintings. Schlemmer had found this adaptation of Picasso's own painting forms into figurines to be a vulgarization.

In an unusual production, *Chorus of Masks* (1928), he attempted a more indirect translation of painting to performance. The starting-point of this mostly improvised performance was a painting of 1923, *Tischgesellschaft*. The atmosphere of the painting was recreated in a 'light blue horizon'. 'In the darkened centre of the stage stood a long, empty table with chairs and glasses.

A large shadow, probably three times life-size, appeared on the horizon and shrank to normal human scale. A grotesque masked being entered and sat down at the table. This continued until a weird round table of twelve masked characters had assembled. Three characters descended from above, out of nowhere: an "infinitely long one", a "fantastically short one" and a "nobly dressed one". Then a gruesomely solemn drinking ceremony was celebrated. After that the drinking party came to the very front of the stage.' So Schlemmer reconstructed the atmosphere of the painting as well as its deep perspective by presenting the figures in masks, graded in size according to their position at the table, which was set at a right angle to the audience.

In a different way, Wassily Kandinsky had, in 1928, used paintings as the 'characters' of the performance itself. *Pictures at an Exhibition*, presented at the Friedrich Theater in Dessau, illustrated a 'musical poem' by Kandinsky's fellow-countryman, Modest Mussorgsky. Mussorgsky had for his part been inspired by an exhibition of naturalistic watercolours. So Kandinsky designed visual equivalents to Mussorgsky's musical phrases, with movable coloured forms and light projections. With the exception of two pictures out of sixteen, the whole setting was abstract. Kandinsky explained that only a few shapes were 'vaguely objective'. Therefore he did not proceed 'programmatically' but rather 'made use of the forms that appeared to my mind's eye while listening to the music'. The chief means, he said, were the shapes themselves, the colours of the shapes, the lighting — colour as intensified painting, and the building up of each picture, linked to the music, and 'where necessary, its dismantlement'. For instance, in the fourth picture, 'The Ancient Castle', only three long vertical strips were visible towards the back of the stage, whose black plush curtain, hung well back, created an 'immaterial' depth. These strips vanished, to be replaced by large red backdrops from the right of the stage, and a green backdrop from the left. The scene, brightly illuminated with intense colour, became increasingly dim with the *poco largamente*, falling into complete darkness with the *piano* section.

'Triadic Ballet'

Schlemmer's *Triadic Ballet* gained him an international reputation far beyond 98,99 any of his other performances. As early as 1912 he had been considering various ideas which would finally materialize in its first performance at the Stuttgart Landestheater in 1922. Performed over a ten-year period, this production contained a virtual encyclopaedia of Schlemmer's performance propositions. 'Why Triadic?', the director noted: 'Triadic — from triad (three) because of the three dancers and the three parts of the symphonic architectonic composition and the fusion of the dance, the costumes and the music.' Accompanied by a Hindemith score for player-piano, 'the mechani-

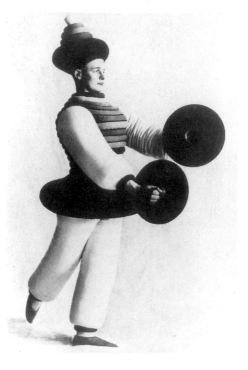

98 Schlemmer as the 'Türke' in his *Triadic Ballet*, 1922

99 Schlemmer, designs for *Triadic Ballet*, 1922 and 1926

cal instrument which corresponds to the stereotypal dance style', the music provided a parallel to the costumes and to the mathematical and mechanical outlines of the body. In addition, the doll-like quality of the dancers corresponded to the music-box quality of the music, thus making a 'unity of concept and style'.

99

Lasting several hours, the *Triadic Ballet* was a 'metaphysical review', using three dancers wearing eighteen costumes in twelve dances. The quality of the dance followed the symphonic elements of the music: for example the first section he characterized as 'scherzo' and the third 'eroica'. His interest in the 'floor geometry' determined the path of the dancers: 'for instance, a dancer moves only from downstage to the footlights along a straight line. Then the diagonal or the circle, ellipse, and so on'. The work had developed in a surprisingly pragmatic way: 'First came the costume, the figurine. Then came the search for the music which would best suit them. Music and the figurine led to the dance. This was the process.' Schlemmer noted, in addition, that dance movements should 'start with one's own life, with standing and walking, leaving leaping and dancing for much later.'

Not surprisingly, this work was the ultimate 'balance of opposites', of abstract concepts and emotional impulses. This of course fitted well into the

particular art–technology interests of the Bauhaus. Schlemmer had finally transformed the theatre workshop from its originally Expressionist bias – under Lothar Schreyer's direction – to one more in line with Bauhaus sensibilities. It had been said that students came to the Bauhaus to be 'cured of Expressionism'. Cured they may have been, only to be introduced by Schlemmer to the more philosophical notion of 'metaphysical dance' or to his love for variety theatre, Japanese theatre, Javanese puppet theatre and the various arts of circus performers. Besides eurhythmics and 'the chorus of movement developed out of them', students also analysed the eukinetics and notation systems of Rudolf von Laban in Switzerland and Laban's protégée Mary Wigman, as well as the Russian Constructivist productions (which were to be seen in Berlin, only a two-hour train ride away).

The Bauhaus Stage

Since no actual theatre existed at the school during the Weimar period, Schlemmer and his students developed performances directly in the studios, considering each experiment a search for the 'elements of movement and space'. By 1925, when the Bauhaus moved to Dessau, where Gropius had

designed the new building complex, the theatre workshop had become important enough to warrant a specially designed theatre. Even that remained a simple elevated stage in a cubelike auditorium, constructed in such a way as to accommodate the various lighting, screens and steplike structures which Schlemmer, Kandinsky, Xanti Schawinsky, and Joost Schmidt, among others, needed to realise their work.

Despite the simple efficiency of the Dessau stage, various members of staff and students designed their own versions of the ideal stage, based on the needs of experimental performances as diverse as those presented at the Bauhaus. Walter Gropius had written that the architectonic problem of stage space had particular significance for work at the Bauhaus. 'Today's deep stage, which lets the spectator look at the other world of the stage as through a window, or which separates [itself from him] by a curtain, has almost entirely pushed aside the central arena of the past.' Gropius explained that this earlier 'arena' had formed an indivisible spatial unity with the spectators, drawing them into the action of the play. In addition he noted that the 'picture-frame' deep stage presented a two-dimensional problem, while the central arena stage presented a three-dimensional one: instead of changing the action plane, the arena stage provided an action space, in which bodies moved as sculptural forms. Gropius's Total Theatre was designed in 1926 for the director Erwin Piscator, but owing to financial difficulties was never actually built.

Joost Schmidt's Mechanical Stage of 1925 was intended for use by the Bauhaus itself. A multi-purpose structure, it extended the ideas set out by Farkas Molnár the previous year. Molnár's U-Theatre consisted of three stages, arranged one behind the other, 12 × 12, 6 × 12, and 12 × 8 metres in size. In addition, Molnár provided a fourth stage that was supposed to be hung above the centre stage. The first stage protruded into the audience so that all actions could be viewed from three sides; the second stage was designed to be variable in height, depth and sides; and the third corresponded roughly to the 'picture-frame' principle. Although distinguished for their remarkable inventiveness and flexibility, neither Schmidt's nor Molnár's design was actually executed.

Andreas Weininger's Spherical Theatre was designed to house 'mechanical plays'. The spectators, seated around the inner wall of the sphere, would, according to Weininger, find themselves in 'a new relationship to space', and in a 'new psychic, optical and acoustical relationship' with the action of the performance. Heinz Loew's Mechanical Stage, on the other hand, was designed to bring to the fore the technical apparatus which in traditional theatre 'is scrupulously hidden from audience view. Paradoxically, this often results in backstage activities becoming the more interesting aspect of theatre.' Consequently Loew proposed that the task of the future theatre would be 'to develop a technical personnel as important as the actors, one

whose job it would be to bring this apparatus into view, undisguised and as an end in itself'.

Frederick Kiesler

Settings even attracted the attention of the police, as was the case when Frederick Kiesler presented his extraordinary backdrops for Karel Čapek's R.U.R. at the Theater am Kurfürstendamm, Berlin, in 1922. Although never 100 directly associated with the Bauhaus, Kiesler, with his 'space stage' and R.U.R. production, was assured of a considerable reputation there. Moreover, in 1924 in Vienna he had organized the first international Theatre and Music Festival, which included numerous productions and lectures by key European performers and directors, among them those of the Bauhaus.

For Čapek's play, Kiesler introduced the ultimate in 'machine age' aesthetics: the play itself proposed manufacturing human beings as the most efficient method towards a futuristic society. The inventor, his laboratory and the factory where the humans were on the production line, as well as a screening system for the factory director to admit only 'desirable visitors' into the secret organization, were all interpreted by Kiesler in a kinetic stage. 'The R.U.R. play was my occasion to use for the first time in a theatre a motion picture instead of a painted backdrop', Kiesler explained. For the factory director's screening device, Kiesler built a large square panel window in the middle of the stage drop, resembling an enormous television screen; this could be opened by remote control so that when he pushed a button at his desk, 'the panel opened and the audience saw two human beings reflected from a mirror arrangement backstage'. Diminished in size by the mirrors, the figures viewing the factory from the 'outside' were then given permission to enter and 'the whole thing closed from their small projected image to them walking on stage full size'.

When the director wished to demonstrate to his visitors the modernity of his robot factory, a huge diaphragm in the back of the stage would open to reveal a moving picture (projected from the back of the stage onto a circular screen). What the audience and visitors saw there was the interior of an enormous factory, workers busily in action. This illusion was particularly effective, 'since the camera was walking into the interior of the factory and the audience had the impression that the actors on the stage walked into the perspective of the moving picture too'. Another feature was a series of flashing neon lights of abstract design, which represented the laboratory of the inventor. The control chamber of the factory was an eight-foot iris from which spotlights shone into the audience.

The Berlin police were provoked into action by the back-projection equipment used at various stages throughout the play to give an idea of

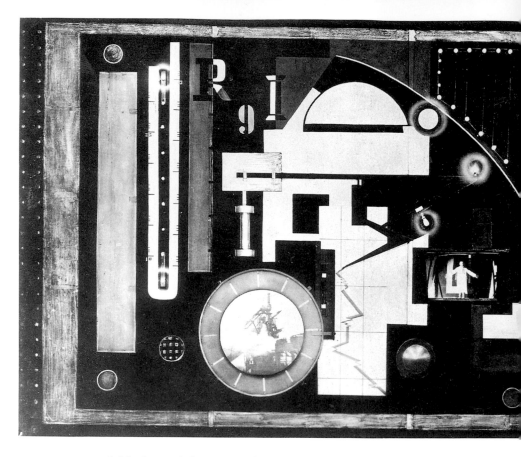

activities beyond the main 'office' of the factory, fearing that it could easily cause a fire. So each evening, as the film began rolling, they sounded a fire alarm, much to Kiesler's amusement. After several interruptions of this kind, he capitulated to their noisy protests and built a trough of water above the canvas projection screen. Thus the film was projected onto a continuously flowing wall of water, producing a 'beautifully translucent effect'. For Kiesler, even this accidental feature contributed to the overall production: 'From the beginning to the end, the entire play was in motion and so acted by the actors. The side walls moved too. It was a theatrical concept to create tension in space.'

Meanwhile, at the Bauhaus Moholy-Nagy was prescribing a 'theatre of totality' as a 'great dynamic-rhythmic process, which can compress the greatest clashing masses or accumulations of media – as qualitative and quantitative tensions – into elemental form.' 'Nothing', he wrote in his essay *Theatre, Circus, Variety* (1924), 'stands in the way of making use of complex

100 Frederick Kiesler, setting for Karel Čapek's *R.U.R.*, Berlin, 1922. The setting comprised a mobile wall relief, 'television' panels (accomplished with mirrors) and film projection – the first time film and live performance were combined

APPARATUS such as film, automobile, lift, aeroplane, and other machinery, as well as optical instruments, reflecting equipment, and so on.' 'It is time to produce a kind of stage activity which will no longer permit the masses to be silent specators which will . . . allow them to fuse with the action on the stage.' To realise such a process, he concluded, a 'thousand-eyed NEW DIRECTOR, equipped with all the modern means of understanding and communication' was needed. It was with this vision that artists at the Bauhaus involved themselves so closely with stage-space design.

Bauhaus touring company

During the Dessau years, from 1926 onwards, Bauhaus performance gained an international reputation. This was made possible because Gropius strongly supported the Bauhaus theatre, and the students were enthusiastic participants. So much importance and encouragement were given the theatre

experiment that Schlemmer announced in his lecture demonstration of 1927: 'the point of our endeavour: to become a travelling company of actors which will perform its works wherever there is a desire to see them'. By then such a desire was widespread, and Schlemmer and company toured numerous European cities, among them Berlin, Breslau, Frankfurt, Stuttgart and Basle. The repertory, essentially a summary of three years of Bauhaus performance, included *Dance in Space*, *Slat Dance*, *Dance of Forms*, *Metal Dance*, *Gesture Dance*, *Dance of Hoops* and *Chorus of Masks*, to name only a few.

102 *Metal Dance* was reported in the *Basler National Zeitung*, on 30 April 1929: 'The curtain rises. Black backdrop and black stage floor. Deep down stage, a cave lights up, not much larger than a door. The cave is made of highly reflecting corrugated tin plate set on edge. A female figure steps out from inside. She is wearing white tights. Head and hands are enclosed by shiny, silvery spheres. Metallically crisp, smooth and shining music sets the figure to performing crisp movements . . . the whole thing is very brief, fading away like an apparition.'

 Dance in Space opened with a bare stage, whose black floor was outlined with a large white square. Circles and diagonals filled the square. A dancer in yellow tights and metal globular mask tripped across the stage, hopping along the white lines. A second masked figure in red tights covered the same geometrical shapes, but with large strides. Finally a third figure in blue tights calmly walked through the stage space, ignoring the one-way directions of the diagram on the floor. Essentially it represented three typical human gaits, and in Schlemmer's habitual multiples of three, it showed three characteristics of colour and their representation in form: 'yellow – pointed hopping; red – full paces; blue – calm strides'.

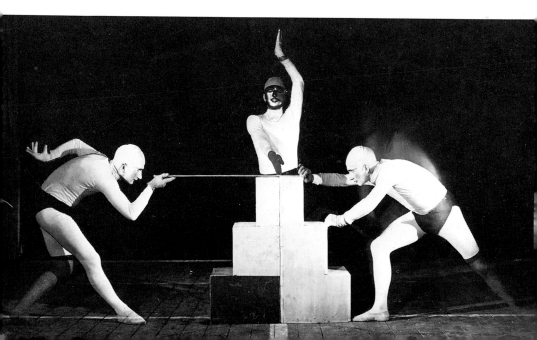

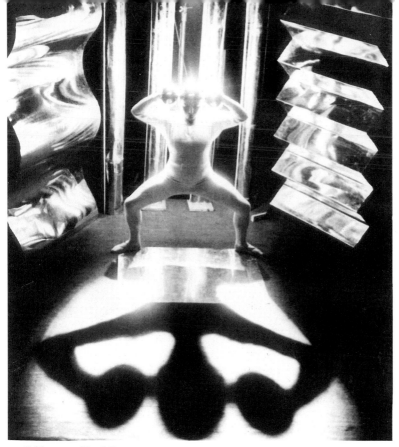

102 Schlemmer, *Metal Dance*, 1929

The eighth dance in this retrospective of Bauhaus performance was a *Game with Building Blocks*. On stage was a wall of building blocks, from 101 behind which three figures crawled. Piece by piece they dismantled the wall, carrying each block to another area of the stage. Throwing each block towards the next person with the rhythm that bricklayers throw bricks in chain formation, they finally built a central tower, around which a dance took place.

The *Dance of the Stage Wings* consisted of a number of partitions placed one behind the other. Hands, heads, feet, bodies and words appeared in short broken rhythm in the spaces between the partitions – 'dismembered, crazy, meaningless, foolish, banal and mysterious', the same Swiss journalist noted. 'It was extremely silly and extremely frightening', but above all, for the reporter, the work revealed the 'entire meaning and the entire stupidity of the phenomenon "stage wings" '. While acknowledging the intended absurdity

101 *Opposite*: **Schlemmer, 1926,** *Game with Building Blocks*, **performed by Werner Siedhoff, Bauhaus stage, 1927**

of many of the brief sequences, the journalist summed up his enthusiastic appraisal: 'People who are trying to discover "something" behind all this – will not find anything, because there is nothing to discover *behind* this. Everything is there, right in what one perceives! There are no feelings which are "expressed", rather, feelings are evoked. The whole thing is a "game". It is a freed and freeing "game". . . . Pure absolute form. Just as the music is . . .'.

Such favourable responses led the company to Paris to present the *Triadic Ballet* at the International Dance Congress in 1932. But it was also their last performance. The disintegration of the Bauhaus following Gropius's nine-year tenure there; the demands of a very different director, Hannes Meyer, who was against the 'formal and personal' aspects of Schlemmer's dance work; the censorship imposed by the new Prussian government: all made Schlemmer's dream a short-lived one.

The Dessau Bauhaus was finally closed down in 1932. Its then director, Mies van der Rohe, attempted to run the school as a private institution in a disused telephone factory in Berlin. But by then, the Bauhaus stage had firmly established its significance in the history of performance. Performance had been a means for extending the Bauhaus principle of a 'total art work', resulting in carefully choreographed and designed productions. It had directly translated aesthetic and artistic preoccupations into live art and 'real space'. Although often playful and satirical, it was never intentionally provocative or overtly political as the Futurists, Dadaists or Surrealists had been. Nevertheless, like them, the Bauhaus reinforced the importance of performance as a medium in its own right and with the approach of the Second World War there was a marked decrease in performance activities, not only in Germany but also in many other European centres.

103 **Members of the Stage workshop dressed in masks and costumes on the roof of the Dessau Studio,** *c.* **1926**

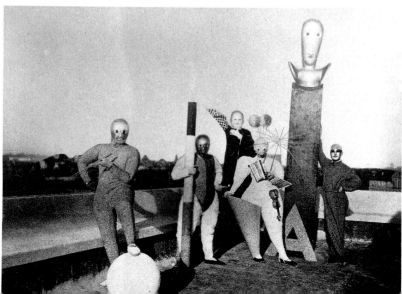

Living Art c. 1933 to the 1970s

Performance in the United States began to emerge in the late thirties with the arrival of European war exiles in New York. By 1945 it had become an activity in its own right, recognised as such by artists and going beyond the provocations of earlier performances.

Black Mountain College, North Carolina

In the autumn of 1933, twenty-two students and nine faculty members moved into a huge white-columned building complex overlooking the town of Black Mountain, three miles away, and its surrounding valley and mountains. This small community soon attracted artists, writers, playwrights, dancers and musicians to its rural southern outpost, despite minimal funds and the makeshift programme which the director, John Price, had managed to draw up.

Looking for an artist who would create a focal point for the diverse curriculum, Price invited Josef and Anni Albers to join the community school. Albers, who had taught at the Bauhaus prior to its closure by the Nazis, quickly provided just that necessary combination of discipline and inventiveness that had characterized his years at the Bauhaus: 'art is concerned with the HOW and not the WHAT; not with literal content, but with the performance of the factual content. The performance – how it is done – that is the content of art', he explained to the students in a lecture.

Despite the lack of explicit manifesto or public declaration of its ends, the small community slowly acquired a reputation as an interdisciplinary educational hide-out. Days and nights spent in the same company would easily turn into brief improvised performances, considered more as entertainment. But in 1936, Albers invited his former Bauhaus colleague Xanti Schawinsky to help expand the art faculty. Given the freedom to devise his own programme, Schawinsky soon outlined his 'stage studies' programme, largely an extension of earlier Bauhaus experiments. 'This course is not intended as a training for any particular branch of the contemporary theatre', Schawinsky explained. Rather it would be a general study of fundamental phenomena; 'space, form, colour, light, sound, movement, music, time, etc.'

The first staged performance from his Bauhaus repertory, *Spectrodrama*, was 'an educational method aiming at the interchange between the arts and sciences and using the theatre as a laboratory and place of action and experimentation'.

The working group, composed of students from all disciplines, 'tackled prevailing concepts and phenomena from different viewpoints, creating stage representations expressing them'.

Focusing on the visual interplay of light and geometric forms, *Spectrodrama* drew on the earlier light reflection experiments of Hirschfeld-Mack. Such scenes as, for example, a yellow square that 'moves to the left and disappears, uncovering in succession three white shapes; a triangle, a circle and a square', would have been typical of an evening's performance at the Bauhaus. 'The work we did was of a formal and pictorial concept', Schawinsky explained. 'It was visual theatre.' A second performance, *Danse macabre* (1938), was less a visual spectacle than a production in the round, with audiences dressed in cloaks and masks. Both works, together with Schawinsky's course, served to introduce performance as a focal point for collaboration among members of the various art faculties. Schawinsky left the college in 1938 to join the New Bauhaus in Chicago, but there were soon brief visits from artists and writers including Aldous Huxley, Fernand Léger, Lyonel Feininger and Thornton Wilder. Two years later the college moved to Lake Eden, not far from Asheville, North Carolina, and by 1944 had inaugurated a summer school which was to attract large numbers of innovative artists of varying disciplines.

104 Xanti Schawinsky's *Danse macabre*, presented at Black Mountain College in 1938

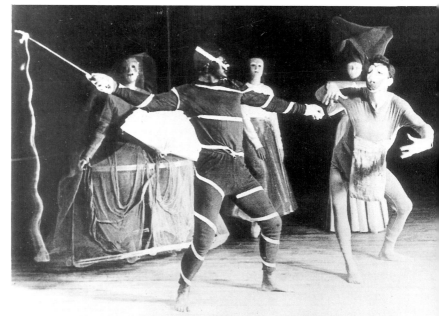

105 John Cage's New York début at the Museum of Modern Art, 1943

John Cage and Merce Cunningham

At the same time that the Black Mountain College was increasing its reputation as an experimental institution, a young musician, John Cage, and a young dancer, Merce Cunningham, were beginning to make their own ideas felt in small circles in New York and on the West Coast. In 1937, Cage, who had briefly studied Fine Arts at Pomona College in California, and composition with Schoenberg, expressed his views on music in a manifesto called *The Future of Music*. It was based on the idea that 'wherever we are, what we hear is mostly noise . . . Whether the sound of a truck at 50 mph, rain, or static between radio stations, we find noise fascinating.' Cage intended to 'capture and control these sounds, to use them, not as sound effects, but as musical instruments'. Included in this 'library of sounds' were the sound effects from film studios which would make it possible, for instance, 'to compose and perform a quartet for explosive motor, wind, heart beat and landslide'. A critic on the *Chicago Daily News* reviewed a concert which illustrated those ideas, given in Chicago in 1942. Under the headline 'People Call it Noise – But he Calls it Music', the critic noted that the 'musicians' played beer bottles, flowerpots, cowbells, automobile brake-drums, dinner bells, thundersheets and 'in the words of Mr Cage, "anything we can lay our hands on"'.

Despite the somewhat puzzled response of the press to this work, Cage was invited to give a concert at the Museum of Modern Art in New York, the 105 following year. Jawbones were banged, Chinese soup bowls tinkled and oxbells struck, while an audience 'which was very high-brow', according to

123

Life magazine, 'listened intently without seeming to be disturbed by the noisy results'. By all accounts, the New York audiences were far more tolerant of these experimental concerts than the audiences of almost thirty years earlier that had angrily attacked the Futurist 'noise musicians'. Indeed, Cage's concerts soon produced a serious body of analysis of his and earlier experimental music, and Cage himself wrote prolifically on the subject. According to Cage, in order to understand the 'sense of musical renaissance and the possibility of invention' that had taken place around 1935, one should turn to Luigi Russolo's *The Art of Noises* and Henry Cowell's *New Musical Resources*. He also referred his readers to McLuhan, Norman O. Brown, Fuller, and Duchamp – 'one way to write music: study Duchamp'.

On a theoretical level, Cage pointed out that composers who chose to be faced with the 'entire field of sound' necessarily had to devise entirely new methods of notation for such music. He found models in oriental music for the 'improvised rhythmic structures' proposed in his manifesto, and although largely 'unwritten' the philosophy on which they were based led Cage to insist on the notions of chance and indeterminacy. 'An indeterminate piece', he wrote, 'even though it might sound like a totally determined one, is made essentially without intention so that, in opposition to music of results, two performances of it will be different.' Essentially, indeterminacy allowed for 'flexibility, changeability, fluency and so forth', and it also led to Cage's notion of 'non-intentional music'. Such music, he explained, would make it clear to the listener that 'the hearing of the piece is his own action – that the music, so to speak, is his, rather than the composer's'.

Such theories and attitudes reflected Cage's deeply felt sympathy for Zen Buddhism and oriental philosphy in general and found a parallel in the work of Merce Cunningham who, like Cage, had by 1950 introduced chance procedures and indeterminacy as a means of arriving at a new dance practice. Having danced for several years as a leading figure in Martha Graham's company, Cunningham soon abandoned the dramatic and narrative thread of Graham's style, as well as its dependence on music for rhythmic direction. Just as Cage found music in the everyday sounds of our environment, so too Cunningham proposed that walking, standing, leaping and the full range of natural movement possibilities could be considered as dance. 'It occurred to me that the dancers could do the gestures they did ordinarily. These were accepted as movement in daily life, why not on stage?'

While Cage had noted that 'every smaller unit of a larger composition reflected as a microcosm the features of the whole', Cunningham emphasized 'each element in the spectacle'. It was necessary, he said, to take each circumstance for what it was, so that each movement was something in itself. This respect for given circumstances was reinforced by the use of chance in preparing works, such as *Sixteen Dances for Soloist and Company of Three*

106

124

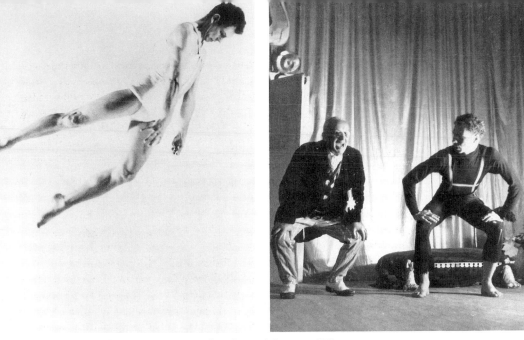

106 Merce Cunningham in *Sixteen Dances for Soloist and Company of Three*, 1951

107 Erik Satie's *The Ruse of the Medusa*, reconstructed at Black Mountain College in 1948. Buckminster Fuller (*left*) as Baron Méduse and Merce Cunningham as the 'mechanical monkey'

(1951), where the order of the 'nine permanent emotions of the Indian classical theatre' was decided by the toss of a coin.

By 1948 the dancer and the musician had been collaborating on several projects for almost a decade and both were invited to join the summer school at Black Mountain College held that year. Willem de Kooning and Buckminster Fuller were also there. Together they reconstructed Erik Satie's *The Ruse of the Medusa* 'set in Paris, the day before yesterday'. The performance featured Elaine de Kooning as the leading lady, Fuller as Baron Méduse, choreography for the 'mechanical monkey' by Cunningham and sets by Willem de Kooning. Directed by Helen Livingston and Arthur Penn, the performance introduced the little-known absurdities of Satie's 'drama' and his eccentric musical ideas to the Black Mountain community. Cage, however, had to fight for the acceptance of Satie's ideas as he was soon to do for his own. His lecture 'In Defence of Satie', accompanied by a series of twenty-five half-hour concerts three nights a week, following the evening meal, stated that 'we cannot, ought not agree on matters of material' and reflected preoccupations in his own work: the strings of his 'prepared piano' were already jammed with odd materials – rubber bands, wooden spoons, bits of paper and metal – creating the sounds of a compact 'percussion orchestra'.

In 1952, Cage took these experiments even further, arriving at his famous silent work. *4' 33"* was a 'piece in three movements during which no sounds are intentionally produced'; it abandoned intervention by the musician altogether. The work's first interpreter, David Tudor, sat at the piano for four minutes and thirty-three seconds, silently moving his arms three times; within that time the spectators were to understand that everything they heard was 'music'. 'My favorite piece', Cage had written, 'is the one we hear all the time if we are quiet.'

Black Mountain College untitled event 1952

That same year, Cage and Cunningham had returned to Black Mountain College for yet another summer school. An evening of performance that took place in the college dining hall that summer created a precedent for innumerable events that were to follow in the late fifties and sixties. Before the actual performance, Cage gave a reading of the Huang Po Doctrine of Universal Mind which, in its curious way, anticipated the event itself. Cage's comments on Zen were noted by Francine Duplessix-Gray, then a young student: 'In Zen Buddhism nothing is either good or bad. Or ugly or beautiful. . . . Art should not be different [from] life but an action within life. Like all of life, with its accidents and chances and variety and disorder and only momentary beauties.' Preparation for the performance was minimal: performers were given a 'score' which indicated 'time brackets' only and each was expected to fill out privately moments of action, inaction and silence as indicated on the score, none of which was to be revealed until the performance itself. In this way there would be no 'causal relationship' between one incident and the next, and according to Cage, 'anything that happened after that happened in the observer himself'.

108 Spectators took their seats in the square arena forming four triangles created by diagonal aisles, each holding the white cup which had been placed on their chair. White paintings by a visiting student, Robert Rauschenberg, hung overhead. From a step-ladder, Cage, in black suit and tie, read a text on 'the relation of music to Zen Buddism' and excerpts from Meister Eckhart. Then he performed a 'composition with a radio', following the prearranged 'time brackets'. At the same time, Rauschenberg played old records on a hand-wound gramophone and David Tudor played a 'prepared piano'. Later Tudor turned to two buckets, pouring water from one to the other while, planted in the audience, Charles Olsen and Mary Caroline Richards read poetry. Cunningham and others danced through the aisles chased by an excited dog, Rauschenberg flashed 'abstract' slides (created by coloured gelatine sandwiched between the glass) and film clips projected onto the ceiling showed first the school cook, and then, as they gradually moved from

108 Diagram of *Untitled Event*, held at Black Mountain College in the summer of 1952, showing seating arrangement

the ceiling down the wall, the setting sun. In a corner, the composer Jay Watt played exotic musical instruments and 'whistles blew, babies screamed and coffee was served by four boys dressed in white'.

The country audience was delighted. Only the composer Stefan Wolpe walked out in protest, and Cage proclaimed the evening a success. An 'anarchic' event; 'purposeless in that we didn't know what was going to happen', it suggested endless possibilities for future collaborations. And it provided Cunningham with a new décor and costume designer for his dance company: Robert Rauschenberg.

The New School

Despite its remote location and limited audience, news of the untitled event spread to New York, where it became the talking-point of Cage and the students who were pursuing his course on the composition of experimental music, begun in 1956 at the New School for Social Research. The small classes included painters and film makers, musicians and poets, Allan Kaprow, Jackson MacLow, George Brecht, Al Hansen and Dick Higgins among them. Friends of the regular students, George Segal, Larry Poons and Jim Dine, often attended. Each in their different ways had already absorbed Dada and Surrealist-like notions of chance and 'non-intentional' actions in their work. Some were painters making works which went beyond the conventional canvas format, taking up where the Surrealist environmental exhibitions, Rauschenberg's 'combines' and Jackson Pollock's action paintings had left off. Most were to be deeply influenced by Cage's classes and by reports of the Black Mountain event.

Live art

Allen Kaprow

Live art was the logical next step from environments and assemblages. And most of these events would directly reflect contemporary painting. For Kaprow, environments were 'spatial representations of a multileveled attitude to painting', and a means to 'act out dramas of tin-soldiers, stories and musical structures that I once had tried to embody in paint alone'. Claes Oldenburg's performances mirrored the sculptural objects and paintings he made at the same time, providing a means for him to transform those inanimate but real objects – typewriters, ping-pong tables, articles of clothing, ice-cream cones, hamburgers, cakes, etc. – into objects of motion. Jim Dine's performances were for him an extension of everyday life rather than of his paintings, even if he acknowledged that they were actually 'about what I was painting'. Red Grooms found inspiration for his paintings and performances in the circus and amusement arcades, and Robert Whitman, despite his painterly origins, considered his performances essentially as theatrical events. 'It takes time', he wrote; and for him time was a material like paint or plaster. Al Hansen, on the other hand, turned to performance in revolt against 'the complete absence of anything interesting in the more conventional forms of theater'. The artwork that interested him most, he said, was one that 'enclosed the observer [and] that overlapped and interpenetrated different art forms'. Acknowledging that these ideas stemmed from the Futurists, Dadaists and Surrealists, he proposed a form of theatre in which 'one puts parts together in the manner of making a collage'.

'18 Happenings in 6 Parts'

109 Kaprow's *18 Happenings in 6 Parts* at the Reuben Gallery, New York, in the autumn of 1959, was one of the earliest opportunities for a wider public to attend the live events that several artists had performed more privately for various friends. Having decided that it was time to 'increase the "responsibility" of the observer', Kaprow issued invitations that included the statement 'you will become a part of the happenings; you will simultaneously experience them'. Shortly after this first announcement, some of the same people who had been invited received mysterious plastic envelopes containing bits of paper, photographs, wood, painted fragments and cut-out figures. They were also given a vague idea of what to expect: 'there are three rooms for this work, each different in size and feeling. . . . Some guests will also act.'

Those who came to the Reuben Gallery found a second-floor loft with divided plastic walls. In the three rooms thus created, chairs were arranged in circles and rectangles forcing the visitors to face in different directions. Coloured lights were strung through the subdivided space; a slatted

128

109 Allan Kaprow, from *18 Happenings in 6 Parts*, 1959: one room of a three-room
environment at the Reuben Gallery, New York

construction in the third room concealed the 'control room' from which
performers would enter and exit. Full-length mirrors in the first and second
rooms reflected the complex environment. Each visitor was presented with a
programme and three small cards stapled together. 'The performance is
divided into six parts', the notes explained. 'Each part contains three
happenings which occur at once. The beginning and end of each will be
signalled by a bell. At the end of the performance two strokes of the bell will
be heard.' Spectators were warned to follow instructions carefully: during
parts one and two they may be seated in the second room, during parts three
and four they might move to the first room, and so on, each time at the ring of
a bell. Intervals would be exactly two minutes long, and two fifteen-minute
intervals would separate the larger sets. 'There will be *no applause after each set*,
but you may applaud after the sixth set if you wish.'

The visitors (whom the programme notes designated as part of the cast)
took their seats at the ring of a bell. Loud amplified sounds announced the

beginning of the performance: figures marched stiffly in single file down the narrow corridors between the makeshift rooms and in one room a woman stood still for ten seconds, left arm raised, forearm pointing to the floor. Slides were shown in an adjacent room. Then two performers read from hand-held placards: 'it is said that time is essence . . . we have known time . . . spiritually . . .'; or in another room: 'I was about to speak yesterday on a subject most dear to you all – art . . . but I was unable to begin.' Flute, ukulele and violin were played, painters painted on unprimed canvas set into the walls, gramophones were rolled in on trolleys, and finally, after ninety minutes of eighteen simultaneous happenings, four nine-foot scrolls toppled off a horizontal bar between the male and female performers reciting mono-syllabic words – 'but . . .', 'well . . .'. As promised, a bell rang twice signalling the end.

The audience was left to make what it could of the fragmented events, for Kaprow had warned that 'the actions will mean nothing clearly formulable so far as the artist is concerned'. Equally, the term 'happening' was meaningless: it was intended to indicate 'something spontaneous, something that just happens to happen'. Nevertheless the entire piece was carefully rehearsed for two weeks before the opening, and daily during the week's programme. Moreover, performers had memorized stick drawings and time scores precisely indicated by Kaprow so that each movement sequence was carefully controlled.

More New York happenings

The apparent lack of meaning in *18 Happenings* was reflected in many other performances of the time. Most artists developed their own private 'iconography' for the objects and actions of their work. Kaprow's *Courtyard* (1962), which took place in the courtyard of a derelict hotel in Greenwich Village, included a twenty-five-foot paper 'mountain', an 'inverted moun-tain', a woman in night dress, and a cyclist, all of which had specific symbolic connotations. For instance, the 'dream girl' was the 'embodiment of a number of old, archetypal symbols, she is nature goddess (Mother Nature) and Aphrodite (Miss America).' Robert Whitman's concentric tunnels in *The American Moon* (1960) represented 'time capsules' through which performers were led to a central space which was 'nowhere' and were disoriented further by layers of burlap and plastic curtains. For Oldenburg, an individual event could be 'realistic' with 'fragments of action immobilized by instantaneous illuminations', as in *Snapshots from the City* (1960), a collaged city landscape with built-in street and immobile figures on a stage against a textured wall, flickering lights and found objects on the floor; or it could be a transformation of real and 'dreamed' events as in *Autobodys* (Los Angeles,

1963), which was triggered off by television images of slowly moving black automobiles in President Kennedy's funeral procession.

Performances followed in quick succession: six weeks after Kaprow's *Courtyard*, Red Grooms's *The Burning Building* took place at the Delancey Street Museum (actually Grooms's loft), Hansen's *Hi-Ho Bibbe* at the Pratt Institute, Kaprow's *The Big Laugh* and Whitman's *Small Cannon* at the Reuben Gallery. An evening of varied events was planned for February 1960 at the Judson Memorial Church in Washington Square, which had recently opened its doors to artists' performances. *Ray Gun Spex*, organized by Claes Oldenburg, with Whitman, Kaprow, Hansen, Higgins, Dine and Grooms, drew a crowd of about two hundred. The church's gallery, ante-room, gymnasium and hall were taken over for Oldenburg's *Snapshots from the City* and Hansen's *Requiem for W.C. Fields Who Died of Acute Alcoholism* – a poem and 'film environment' with clips from W.C. Fields films projected onto Hansen's white-shirted chest. In the main gymnasium, covered in canvas flats, an enormous boot walked around the space as part of Kaprow's *Coca Cola, Shirley Cannonball?*. Jim Dine revealed his obsession for paint in *The Smiling Workman*: dressed in a red smock, with hands and head painted red, 110 and a large black mouth, he drank from jars of paint while painting 'I love what I'm . . .' on a large canvas, before pouring the remaining paint over his head and leaping through the canvas. The evening ended with Dick Higgins counting in German until everybody left.

110 Jim Dine, from *The Smiling Workman*, 1960, at the Judson Church, New York. Dine is shown drinking from a can of paint before he crashed through the canvas on which he had written 'I love what I'm . . .'

Despite the very different sensibilities and structures of these works, they were all thrown together by the press under the general heading of 'happenings', following Kaprow's *18 Happenings*. None of the artists ever agreed to the term, and despite the desire of many of them for clarification, no 'happening' group was formed, no collective manifestos, magazines or propaganda issued. But whether they liked it or not, the term 'happening' remained. It covered this wide range of activity, however much it failed to distinguish between the different intentions of the work or between those who endorsed and those who refuted Kaprow's definition of a happening as an event that could be performed only once.

Indeed, Dick Higgins, Bob Watts, Al Hansen, George Macunias, Jackson MacLow, Richard Maxfield, Yoko Ono, La Monte Young and Alison Knowles presented very different performances at the Café A Gogo, Larry Poons's Epitome Café, Yoko Ono's Chambers Street loft, and the uptown Gallery A/G, all of which came under the general name of Fluxus, a term coined in 1961 by Macunias as the title for an anthology of work by many of these artists. The Fluxus group soon acquired their own exhibition spaces, Fluxhall and Fluxshop. However, Walter de Maria, Terry Jennings, Terry Riley, Dennis Johnson, Henry Flynt, Ray Johnson and Joseph Byrd presented works that could be classified under neither of these headings, despite the tendency of the press and critics to fit them neatly into an intelligible fashion.

Dancers such as Simone Forti and Yvonne Rainer, who had worked with Ann Halprin in California and who took to New York some of the radical innovations that Halprin had developed there, were to add to the variety of performances taking place in New York at this time. And these dancers would in turn strongly affect many of the performing artists who were to emerge later, such as Robert Morris and Robert Whitman, with whom they were to collaborate eventually.

The only common denominator of these diverse activities was New York City, with its downtown lofts, alternative galleries, cafés and bars that housed the performers of the early sixties. Outside America, however, European and Japanese artists were developing an equally large and varied body of performances at the same time. By 1963, many of those, such as Robert Filiou, Ben Vautier, Daniel Spoerri, Ben Patterson, Joseph Beuys, Emmett Williams, Nam June Paik, Tomas Schmit, Wolf Vostell and Jean-Jacques Lebel, would have either visited New York or sent work that indicated the radically different ideas being developed in Europe. Japanese artists such as Takesisa Kosugi, Shigeko Kubota and Toshi Ichiyanagi arrived in New York from Japan where the Gutai Group of Osaka – Akira Kanayama, Sadamasa Motonaga, Shuso Mukai, Saburo Mirakami, Shozo Shinamoto, Kazuo Shiraga and others – had presented their own spectacles.

'Yam' and 'You'

More and more performance programmes were organized throughout New York. The *Yam Festival* lasted an entire year from May 1962 to May 1963. It included a variety of activities such as Al Hansen's *Auction*, Alison Knowles's *Yam Hat Sale*, an exhibition of Vostell's 'décollages', as well as an all-day excursion to George Segal's farm in New Brunswick. Michael Kirby's *The First and Second Wilderness, a Civil War Game* opened on 27 May 1963 at his downtown loft, where the space was demarcated to indicate 'Washington' and 'Richmond' and an infantry of two-foot-high cardboard soldiers waged battle accompanied by cheers from cheerleaders and audience, while scores were marked up on a large scoreboard by a bikini-clad woman on a ladder.

Performance concerts were held at the Carnegie Recital Hall, where Charlotte Moorman organized the first Avant-Garde Festival in August 1963. Initially a musical programme, the festival soon expanded to include artists' performance, particularly a reconstruction of Stockhausen's *Originale* orchestrated by Kaprow and including Max Neufield, Nam June Paik, Robert Delford-Brown, Lette Eisenhauer, and Olga Adorno, among others. Various dissidents – Henry Flynt, George Macunias, Ay-O, Takaka Saito and Tony Conrad – picketed this performance, regarding the foreign import as 'cultural imperialism'.

The schism between locals and foreigners continued when, in April 1964, Vostell presented *You* at the home of Robert and Rhett Delford-Brown in suburban Great Neck. A 'décollage' happening, *You* took place in and around a swimming pool, tennis court and orchard, scattered with four hundred pounds of beef bones. A narrow path, 'so narrow that only one person can pass at a time', littered with coloured advertisements from *Life* magazine and punctuated by loudspeakers greeting each passer-by with 'You, You, You!', wound between the three main locations of activity. In the deep end of the swimming pool were water and several typewriters as well as plastic sacks and waterpistols filled with brilliant yellow, red, green and blue dye. 'Lie down on the bottom of the pool and build a mass grave. While lying there, decide whether or not you will shoot other people with the colour', the participants were instructed. On the pool edges were three colour television sets on a hospital bed, each showing distorted images of a different baseball game; Lette Eisenhauer covered in flesh-toned fabric, lying on a trampoline between a pair of inflatable cow's lungs; and a naked girl on a table embracing a vacuum cleaner tank. 'Allow yourself to be tied to the beds where the T.V.s are playing Free yourself Put on a gas mask when the T.V. burns and try to be as friendly as possible to everyone', the instructions continued.

You, Vostell later explained, was intended to bring the public 'face to face, in satire, with the unreasonable demands of life in the form of chaos', confronting them with the most 'absurd and repugnant scenes of horror to

111

133

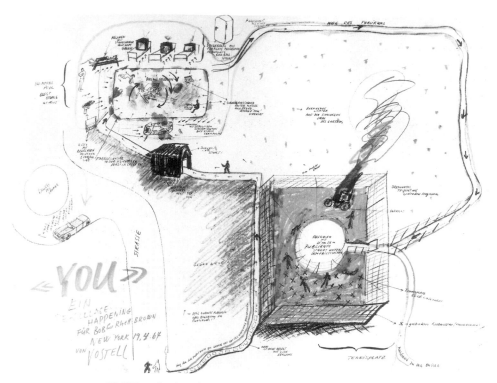

111 **Wolf Vostell, plan of** *You,* **1964, an all-day event held in the country, on the farm of the Delford-Browns in New York State**

awaken consciousness . . . What is important is what the public itself takes away as a result of my images and the Happening.'

The element of place

Similar group events flourished throughout New York, from Central Park to the 69th Street Armory, where performances by Cage, Rauschenberg and Whitman, among others, celebrated 'Art and Technology' in 1966. The actual venue of this event was an important consideration: Oldenburg noted that 'the place in which the piece occurs, this large object, is part of the effect, and usually the first and most important factor determining the events (materials at hand being the second and players the third)'. The place 'could have any extent, a room or a nation': hence the scenes of such works as Oldenburg's *Autobodys* (1963 – a car park), *Injun* (1962 – a Dallas farmhouse), *Washes* (1965 – a swimming pool) and *Moviehouse* (1965 – a cinema). He had already presented in 1961 his *Store Days* or Ray Gun Mgs. Co in a shop on East

2nd Street, that served as a showcase for his objects, a studio, a performance space, and a place where those objects could be bought and sold, thus providing a means for artists 'to overcome the sense of guilt connected with money and sales'.

Ken Dewey's *City Scale* (1963), with Anthony Martin and Ramon Sender, began in the evening with spectators filling out government forms at one end of the city, only to be led through the streets to a series of occurrences and places: a model undressing at an apartment window, a car ballet in a car park, a singer in a shop window, weather balloons in a desolate park, a cafeteria, a bookshop, and as the sun came up on the next day, a brief finale by a 'celery man' in a cinema.

A Washington skating rink was the venue for Rauschenberg's *Pelican* 112 (1963), his first performance, after years of improvising a wide range of extraordinary décors and costumes for Cunningham's dance company. *Pelican* opened with two performers, Rauschenberg and Alex Hay, wearing roller skates and back-packs, kneeling on a mobile trolley of wooden planks which they propelled with their hands into the central arena. The two skaters glided at speed around a dancer in ballet shoes, Carolyn Brown, who slowly executed a series of movements on points. Then the back-packs on the skaters opened into parachutes, thus considerably slowing down their movements.

112 Robert Rauschenberg, *Pelican*, 1963, with Rauschenberg and Alex Hay on roller skates, and Carolyn Brown on points, performed on a skating rink in Washington

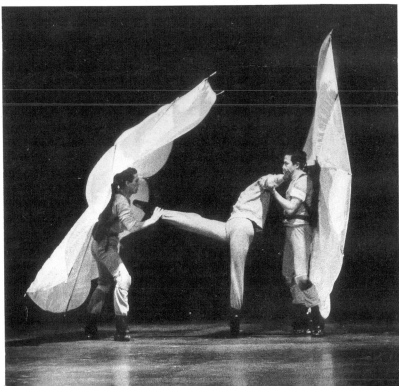

At the same time the dancer speeded up her own stylized routine. There the element of place, as well as objects such as parachutes, ballet shoes and roller skates, determined the nature of the performance.

Rauschenberg's later *Map Room II*, performed in a cinema, the Filmmaker's Cinémathèque, equally reflected his concern that 'the first information I need is where it is to be done and when . . . which has a lot to do with the shape it takes, with the kinds of activity'. So, in the cinema where his idea was to use 'a confined stage within a traditional stage', which also extended into the audience, he created a moving collage of elements such as tyres and an old couch. The dancers taking part – Trisha Brown, Deborah Hay, Steve Paxton, Lucinda Childs and Alex Hay – ex-students of Cunningham and all strongly to influence the shaping of many of Rauschenberg's pieces, transformed the props into mobile, abstract forms. Rauschenberg's aim was that the dancers' costumes, for instance, 'would match the object so closely that integration would happen', leaving no distinction between inanimate object and live dancer.

The Filmmaker's Cinémathèque also provided the venue for rather different works of the same time by Oldenburg (*Moviehouse*) and Whitman (*Prune Flat*). While Oldenburg used the setting to activate the audience both

113 John Cage, *Variations V*, 1965. An audio-visual performance without score. In the background are Merce Cunningham (the choreographer) and Barbara Lloyd. In the foreground (*left to right*) Cage, Tudor and Mumma

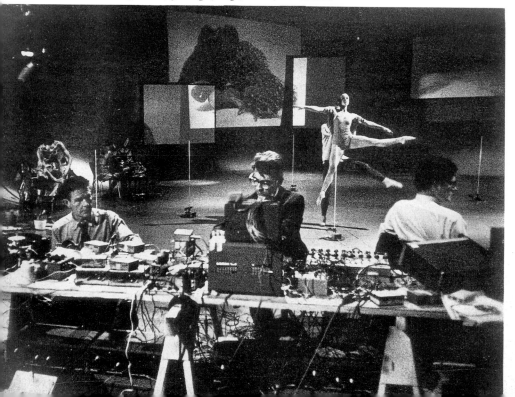

in their seats and in the aisles, with performers supplying the various typical gestures such as eating popcorn and sneezing, Whitman was more interested in 'the separation between the audience and the stage, which I tried to keep and make even stronger'. Compared with Whitman's earlier pieces such as *The American Moon* (1960), *Water* and *Flower* (both 1963), *Prune Flat* was more theatrical, on account of its auditorium setting. Originally conceiving the setting as a 'flat' space, Whitman decided to project images of people onto themselves, adding ultra-violet lighting which 'kept the people flat, but also made them come away from the screen a little bit', causing the figures to look 'strange and fantastic'. While certain images were projected directly onto the figures, others created a filmic background, often with the film sequence transposed. For example, two girls are shown on the film walking across the screen, while the same girls walk simultaneously across the stage; an electrical company's flickering warning light, which by chance formed part of the film footage, was duplicated on stage. Other transformations of film images into live ones were created through the use of mirrors as performers matched themselves against the screen images. Subsequently time and space became the central features of the work, with the preliminary film made in the 'past', and the distortions and repetition of past action in present time on the stage.

114

114 Robert Whitman, *Prune Flat*, 1965, performed at the Filmmaker's Cinémathèque, New York. The photograph shows a more recent reconstruction of the same event

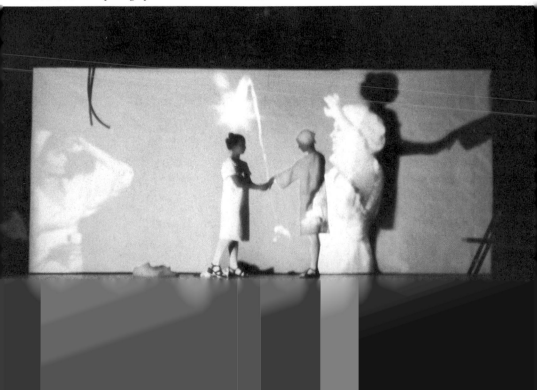

Carolee Schneemann's *Meat Joy*, of the preceding year, performed at the Judson Memorial Church, New York, transformed the body itself into a moving 'painterly' collage. A 'flesh celebration', relating to 'Artaud, McClure, and French butcher shops', it used the blood of carcasses instead of paint to cover the writhing naked and near-naked bodies. 'Taking substance from the materials . . . means that any particular space, any debris unique to Paris [where the event was also performed] and any "found" performers . . . would be potential structural elements for the piece', Schneeman wrote. 'What I find will be what I need', both in terms of performers and of 'metaphorically imposed space relations'.

Also in 1964, John Cage presented *Variations IV*, described by one critic as 'the kitchen-sink sonata, the everything piece, the minestrone masterpiece of modern music'. His *Variations V*, given in July 1965 at the Philharmonic Hall in New York, was a collaborative work with Cunningham, Barbara Lloyd, David Tudor and Gordon Mumma; its script was written *after* the performance by chance methods, for possible repeats. The performance space was crossed with a grid of photo-electric cells, which when activated by the movement of the dancers, produced corresponding lighting and sound effects. In the same year came *Rozart Mix*, which Cage wrote 'for twelve tape machines, several performers, one conductor and eighty-eight loops of tape'.

The new dance

Essential to the evolving styles and exchange of ideas and sensibilities between artists from all disciplines which characterized most performance work of this period, was the influence of dancers in New York from early 1960. Many of these – Simone Forti, Yvonne Rainer, Trisha Brown, Lucinda Childs, Steve Paxton, David Gordon, Barbara Lloyd and Deborah Hay, to name a few – had started in a traditional dance context and then having worked with Cage and Cunningham, quickly found in the art world a more responsive and understanding audience.

Whether inspired by Cage's initial exploration of material and chance or the permissive Happenings and Fluxus events, these dancers began to incorporate similar experiments in their work. Their introduction of quite different movement and dance possibilities added, in turn, a radical dimension to performances by artists, leading them far beyond their initial 'environments' and quasi-theatrical tableaux. On matters of principle the dancers often shared the same concerns as the artists, such as the refusal to separate art activities from everyday life and the subsequent incorporation of everyday actions and objects as performance material. In practice, however, they suggested entirely original attitudes to space and the body that the more visually oriented artists had not previously considered.

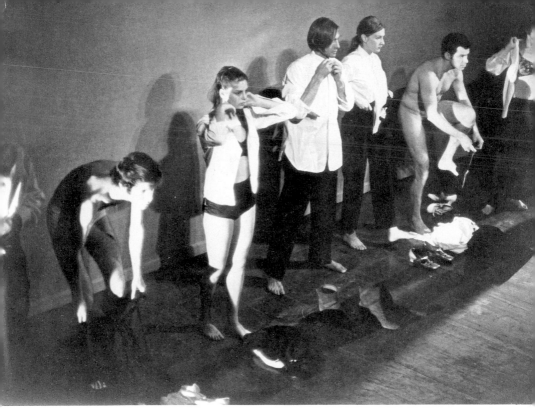

115 **Ann Halprin,** *Parades and Changes,* 1964

Dancers' Workshop Company, San Francisco

Although the Futurist and Dada precedents of performance of the fifties are
the most familiar, they are not the only ones. The view of 'dance as a way of
life, that uses everyday activities such as walking, eating, bathing and
touching' had its historical origin in the work of dance pioneers like Loie
Fuller, Isadora Duncan, Rudolf von Laban and Mary Wigman. In the
Dancers' Workshop Company formed, in 1955, just outside San Francisco,
Ann Halprin picked up the threads of those earlier ideas. She collaborated
with the dancers Simone Forti, Trisha Brown, Yvonne Rainer and Steve
Paxton, the musicians Terry Riley, La Monte Young and Warner Jepson, as
well as with architects, painters, sculptors and untrained people in any of
these fields, encouraging them to explore unusual choreographic ideas, often
on an outdoor platform. And it was these dancers who, in 1962, were to form
the core of the inventive and energetic Judson Dance Group in New York.

Using improvisation 'to find out what *our* bodies could do, not learning somebody else's pattern or technique', Halprin's system involved 'putting everything on charts, where every possible anatomical combination of movement was put to paper and given numbers'. Free association became an important part of the work, and *Birds of America or Gardens Without Walls* showed 'non-representational aspects of dance, whereby movement unrestricted by music or interpretative ideas' developed according to its own inherent principles. Props such as long bamboo poles provided extra scope for the invention of new movements. *Five-Legged Stool* (1962), *Esposizione* (1963) and *Parades and Changes* (1964) all revolved around task-oriented movements, such as carrying forty wine bottles onto the stage, pouring water from one can into another, changing clothes; and the varied settings, such as 'cell blocks' in *Parades and Changes*, allowed each performer to develop a series of separate movements that expressed their own sensory responses to light, material and space.

The Judson Dance Group

When the members of the Dancers' Workshop Company arrived in New York in 1960 they translated Halprin's obsession for an individual's sense of the straightforward physical movement of their own bodies in space into public performances, in programmes of happenings and events held at the Reuben Gallery and the Judson Church. The following year Robert Dunn began a composition class at the Cunningham studios which was made up of these same dancers, some of whom were then studying with Cunningham. Dunn separated 'composition' from choreography or technique and encouraged the dancers to arrange their material through chance procedures, experimenting at the same time with Cage's chance scores and Satie's erratic musical structures. Written texts, instructions (e.g. to draw a long line across the floor, which lasted the whole evening), and game assignments, all became part of the exploratory process.

Gradually the class built up its own repertory: Forti would do very simple bodily actions, extremely slowly or repeated many times; Rainer performed *Satie Spoons*; Steve Paxton spun a ball; and Trisha Brown discovered new movements at the throw of dice. By the late spring of 1962 there was more than enough material for a first public concert. In July when three hundred people arrived at the Judson Church in the intense summer heat, a three-hour marathon awaited them. The programme began with a fifteen-minute film by Elaine Summers and John McDowell followed by Ruth Emerson's *Shoulder*, Rainer's *Dance for 3 People and 6 Arms*, David Gordon's macabre *Mannequin Dance*, Steve Paxton's *Transit*, Fred Herko's *Once or Twice a Week I Put on Sneakers to Go Uptown* (on roller skates), Deborah Hay's *Rain Fur* and

5 *Things* (often hobbling on her knees) and many others. The evening was a great success.

With a regular venue for their workshop, as well as a readily available concert space, the Judson Dance Group was formed, and dance programmes followed in quick succession throughout the following year, including works by Trisha Brown, Lucinda Childs, Sally Gross, Carolee Schneemann, John McDowell and Philip Corner, among others.

On 28 April 1963, Yvonne Rainer presented *Terrain*, a ninety-minute work in five sections ('Diagonal', 'Duet', 'Solo Section', 'Play' and 'Bach') for six performers, dressed in black leotards and white shirts. After sections based on the calling of letters or numbers, with the dancers creating random figurations, there came the 'Solo' phase accompanied by essays written by Spencer Holst and spoken by the dancers as they executed a memorized sequence of movements. When not performing their solos the dancers congregated casually around a street barricade; the last section, 'Bach', was a seven-minute compendium of sixty-seven phases of movement from the preceding sections.

Terrain illustrated some of Rainer's basic principles: 'NO to spectacle no to virtuosity no to transformations and magic and make-believe no to the glamour and transcendency of the star image no to the heroic no to the anti-heroic no to trash imagery no to involvement of performer or spectator no to style no to camp no to seduction of spectator by the wiles of the performer no to eccentricity no to moving or being moved.' The challenge, she added, 'might be defined as how to move in the space between theatrical bloat with its burden of dramatic psychological "Meaning" – and – the imagery and atmospheric effects of the non-dramatic, non-verbal theatre (i.e. dancing and some "happenings") – and – theatre of spectator participation and/or assault'. It was this radical dismissal of so much of the past and the present that drew many artists into direct collaboration with the new dancers and their innovative performances.

Dance and minimalism

By 1963 many artists involved in live events were actively participating in the Judson Dance Group concerts. Rauschenberg, for instance, who was responsible for the lighting of *Terrain*, created many of his own performances with the same dancers, making it difficult for some to distinguish whether these works were 'dances' or 'happenings'. Simone Forti worked for many years with Robert Whitman and both she and Yvonne Rainer collaborated with Robert Morris, as in Forti's *See-Saw* (1961). That the dancers were leading performance beyond the earlier happenings and their Abstract Expressionist painterly origins is exemplified by the fact that a sculptor like

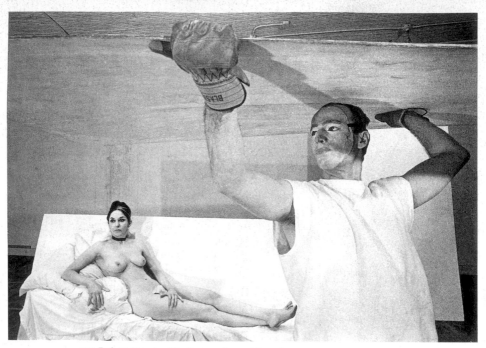

116 Robert Morris, *Site*, first performed in 1965

Morris created performances as an expression of his interest in the 'body in motion'. Unlike the earlier task-oriented activities he was able to manipulate objects so that they 'did not dominate my actions nor subvert my performances'.

These objects became a means for him to 'focus on a set of specific problems involving time, space, alternate forms of a unit, etc.' And so in *Waterman Switch* (March 1965, with Childs and Rainer) he emphasized the 'coexistence of the static and the mobile elements of objects': in one sequence he projected Muybridge slides showing a nude man lifting a stone, followed by the same action performed live by another nude male, illuminated by the beam of a slide projector. Again, in *Site* (May 1965, with Carolee Schneemann), the space was 'reduced to context . . . riveting it to maximum frontality' through a series of white panels which formed a triangular spatial arrangement. Dressed in white and wearing a rubber mask designed by Jasper Johns to reproduce exactly the features of his own face, Morris manipulated the volume of the space by shifting the boards into different positions. As he did so he revealed a naked woman reclining on a couch in the pose of Manet's *Olympia*; ignoring the statuesque figure and accompanied by the sound of a saw and a hammer working on some planks, Morris continued arranging the

142

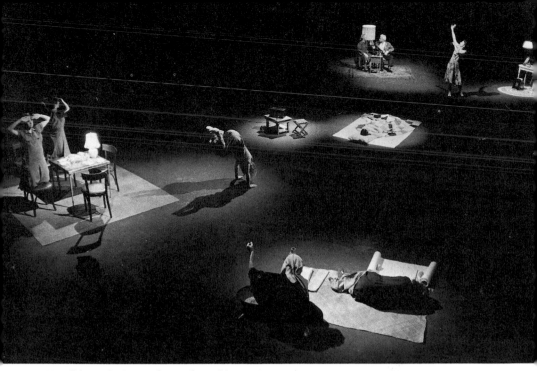

117 Meredith Monk, *Quarry*, first performed in 1976

panels, implying a relationship between the volumes of the static figure and that created by the movable boards.

At the same time, the increasing preoccupations towards 'minimalism' in sculpture could, for those who wished, explain the entirely different performance sensibilities. Rainer prefaced the script of her 1966 *The Mind is a Muscle* with a 'Quasi Survey of Some "Minimalist" tendencies in the Quantitatively Minimal Dance Activity . . .', mentioning the 'one-to-one relationship between aspects of so-called minimal sculpture and recent dancing'. Although she acknowledged that such a chart was in itself questionable, the objects of the minimal sculptors – for example 'role of artist's hand', 'simplicity', 'literalness', 'factory fabrication' – provided an interesting contrast to the 'phrasing', 'singular action', 'event or tone', 'task-like activity' or 'found' movement of the dancers. Indeed, Rainer emphasized the object quality of the dancer's body when she said that she wished to use the body 'so that it could be handled like an object, picked up and carried, and so that objects and bodies could be interchangeable'.

So when Meredith Monk presented her own performance, *Juice*, at the Guggenheim Museum in 1969, she had already absorbed the happenings procedure (as a participant in many early works) as well as the new

explorations of the Judson Dance Group. The first part of *Juice* – a 'three-part theatre cantata' – took place in the enormous spiralling space of the Guggenheim, with eighty-five performers. With the audience seated on the circular floor of the museum, dancers created moving tableaux at intervals of forty, fifty and sixty feet above their heads. The second part took place in a conventional theatre and the third in an unfurnished loft. The separation of time, place and content, of different spaces and changing sensibilities, would later be combined by Monk into large operetta-like performances such as 117 *Education of a Girl Child* (1972) and *Quarry* (1976).

<center>★ ★ ★</center>

The development of European performance in the late fifties paralleled that in the United States in so far as performance came to be accepted by artists as a viable medium. Only ten years after a debilitating major war, many artists felt that they could not accept the essentially apolitical content of the then overwhelmingly popular Abstract Expressionism. It came to be considered socially irresponsible for artists to paint in secluded studios, when so many real political issues were at stake. This politically aware mood encouraged Dada-like manifestations and gestures as a means to attack establishment art values. By the early sixties, some artists had taken to the streets and staged aggressive Fluxus-style events in Amsterdam, Cologne, Düsseldorf and Paris. Others, more introspectively, created works intended to capture the 'spirit' of the artist as an energetic and catalytic force in society. The three artists in Europe at this time whose work best illustrates these attitudes were the Frenchman Yves Klein, the Italian Piero Manzoni and the German Joseph Beuys.

Yves Klein and Piero Manzoni

Yves Klein, born in Nice in 1928, was throughout his life determined to find a vessel for a 'spiritual' pictorial space, and it was this that led him eventually to live actions. To Klein, painting was 'like the window of a prison, where the lines, contours, forms and composition are determined by the bars'. Monochrome paintings, begun around 1955, freed him from such constraints. Later, he said, he remembered the colour blue, 'the blue of the sky in Nice that was at the origin of my career as a monochromist' and at an exhibition in Milan in January 1957, he showed work entirely from what he called his 'blue period', having searched, as he said, 'for the most perfect expression of blue for more than a year'. In May of the same year, he had a double exhibition in Paris, one at the Galerie Iris Clert (10 May) and the other at the Galerie Colette Allendy (14 May). The invitation card announcing both exhibitions displayed Klein's own International Klein Blue monogram. For the Clert opening he presented his first Aerostatic Sculpture, composed of 1001 blue balloons released 'into the sky of Saint Germain-des-Prés, never

to return', marking the beginning of his 'pneumatic period'. Blue paintings were exhibited in the gallery, accompanied by Pierre Henry's first taped version of the *Symphonie Monotone*. In the garden of the Galerie Colette Allendy he showed his *One Minute Fire Painting*, composed of a blue panel into which were set sixteen firecrackers which produced brilliant blue flames.

It was at this time that Klein wrote 'my paintings are now invisible' and his work *The Surfaces and Volumes of Invisible Pictorial Sensibility*, exhibited in one of the rooms at the Allendy, was precisely that – invisible. It consisted of a completely empty space. In April 1958, he presented another invisible work at the Clert, known as *Le Vide* ('The Void'). This time the empty white space was contrasted with his inimitable blue, painted on the exterior of the gallery and on the canopy at the entrance. According to Klein the empty space 'was crammed with a blue sensibility within the frame of the white walls of the gallery'. While the physical blue, he explained, had been left at the door, outside, in the street, 'the real blue was inside . . .'. Among the three thousand people who attended was Albert Camus, who signed the gallery visitors' book with 'avec le vide, les pleins pouvoirs' ('with the void, a free hand').

Klein's *Blue Revolution* and *Théâtre du vide* were given full coverage in his four-page newspaper *Le Journal d'un seul jour, Dimanche* (27 November 1960), which closely resembled the Paris newspaper *Dimanche*. It showed a photograph of Klein leaping into the void. For Klein art was a view of life, not simply a painter with a brush in a studio. All his actions protested against that limiting image of the artist. If colours 'are the real dwellers of space' and 'the void' the colour of blue, his argument went, then the artist may just as well abandon the inevitable palette, brush and artist's model in a studio. In this context, the model became 'the effective atmosphere of the flesh itself'.

Working with somewhat bemused models Klein realised that he did not have to paint *from* models at all, but could paint *with* them. So he emptied his studio of paintings and rolled the nude models in his perfect blue paint, requesting that they press their paint-drenched bodies against the prepared canvases. 'They became living brushes . . . at my direction the flesh itself applied the colour to the surface and with perfect exactness.' He was delighted that these monochromes were created from 'immediate experience' and also by the fact that he 'stayed clean, no longer dirtied with colour', unlike the paint-smeared women. 'The work finished itself there in front of me with the complete collaboration of the model. And I could salute its birth into the tangible world in a fitting manner, in evening dress.' It was in evening dress that he presented this work, entitled *The Anthropometries of the* 119,120 *Blue Period*, at Robert Godet's in Paris in the spring of 1958, and publicly at the Galerie Internationale d'Art Contemporain in Paris on 9 March 1960, accompanied by an orchestra also in full evening dress, playing the *Symphonie Monotone*.

118 Carolee Schneemann's *Meat Joy*, 1964, also performed in Paris, used the blood of meat carcasses instead of paint to cover the performers' bodies

119 A Paris audience viewing Yves Klein's 'live' painting *Anthropometries of the Blue Period*, 1960

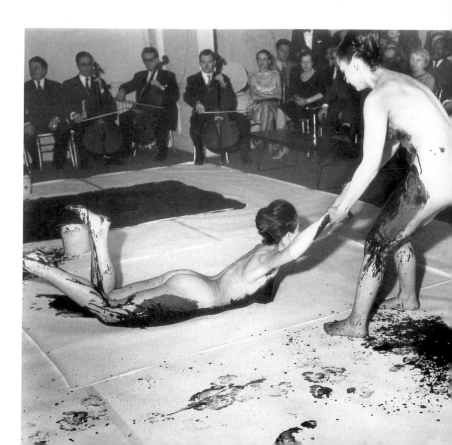

121 Klein throwing 20g of gold leaf into the Seine for *Immaterial Pictorial Sensitivity Zone 5*, 26 January 1962. The buyer is burning his cheque

Klein considered these demonstrations as a means to 'tear down the temple veil of the studio . . . to keep nothing of my process hidden'; they were 'spiritual marks of captured moments'. The International Klein Blue of his 'paintings' was, he said, an expression of this spirit. Moreover, Klein sought a way to evaluate his 'immaterial pictorial sensitivity' and decided that pure gold would be a fair exchange. He offered to sell it to any person willing to purchase such an extraordinary, if intangible, commodity, in exchange for gold leaf. Several 'sales ceremonies' were conducted: one took place on the banks of the River Seine on 10 February 1962. Gold leaf and a receipt changed hands between the artist and the purchaser. But since 'immaterial sensitivity' could be nothing but a spiritual quality, Klein insisted that all remains of the transaction be destroyed: he threw the gold leaf into the river and requested 121 that the purchaser burn the receipt. There were seven purchasers in all.

In Milan, Piero Manzoni went about his work in a not unsimilar manner. But Manzoni's actions were less a declaration of 'universal spirit' than the affirmation of the body itself as a valid art material. Both artists believed that it was essential to reveal the process of art, to demystify pictorial sensitivity, and to prevent their art from becoming relics in galleries or museums. While Klein's demonstrations were based on an almost mystical fervour, Manzoni's centred on the everyday reality of his own body – its functions and its forms – as an expression of personality.

◁120 On 9 March 1960, the first public exhibition was given of Klein's *Anthropometries*. Klein directed three nude models to cover themselves in blue paint and press themselves against the prepared canvases, while twenty musicians played Henry's *Symphonie Monotone*

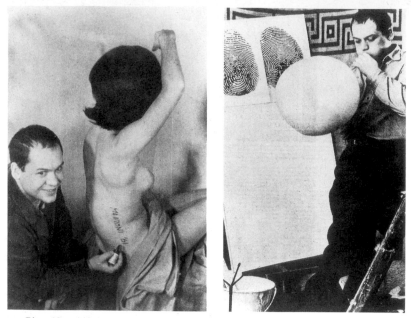

122 Piero Manzoni, *Living Sculpture*, 1961. Manzoni signed various individuals, thus turning them into 'living sculpture' 123 Manzoni making *Artist's Breath*, 1961

Klein and Manzoni met briefly at Klein's monochrome exhibition in Milan in 1957. Five months later, Manzoni wrote his yellow pamphlet *For the Discovery of a Zone of Images* in which he stated that it was essential for artists 'to establish the universal validity of individual mythology'. Just as Klein had considered painting a prison from which monochromes would liberate him, so Manzoni saw painting as 'an area of freedom in which we seek the discovery of our first images'. His all-white paintings called *Achromes*, generally dated from 1957 until his death, were intended to give 'an integrally white [or rather integrally colourless] surface beyond all forms of pictorial phenomena, beyond any extraneous intervention upon the value of the surface. . . . A white surface that is a white surface and that is all . . .'.

Where Klein had made paintings by pressing live models against canvas, Manzoni made works which eliminated the canvas altogether. On 22 April 1961 his exhibition of *Living Sculpture* (1961) opened in Milan. Following Manzoni's own signature on some part of the live sculpture's anatomy, the individual concerned would receive a 'certificate of authenticity' with the inscription: 'This is to certify that X has been signed by my hand and is therefore, from this date on, to be considered an authentic and true work of art.' Amongst those signed were Henk Peters, Marcel Broodthaers, Mario Schifano and Anina Nosei Webber. The certificate was in each case marked by a coloured stamp, indicating the designated area of artwork: red indicated

that the person was a complete work of art and would remain so until death; yellow that only the part of the body signed would qualify as art; green imposed a condition and limitation on the attitude or pose involved (sleeping, singing, drinking, talking and so on); and mauve had the same function as red, except that it had been obtained by payment.

A logical development from this was that the world too could be declared an artwork. So Manzoni's *Base of the World* (1961), erected in a park on the outskirts of Herning, Denmark, metaphorically set the world on a sculptural pedestal. The artist's physical output was equally important in this art/life equation. First he made forty-five *Bodies of Air* – balloons filled with air and sold for thirty thousand lire. Uninflated balloons were packaged in wooden pencil-boxes, along with a small tripod which would serve as an exhibition stand for the balloon when inflated. Like the *Living Sculpture*, they were variously valued: those balloons inflated by the artist himself would be exhibited as *Artist's Breath* and such works were sold for two hundred lire a litre (maximum capacity for any one balloon being about three hundred litres). Then in May 1961, Manzoni produced and packaged ninety cans of *Artist's Shit* (weighing thirty grams each), naturally preserved and 'made in Italy'. They were sold at the current price of gold, and soon became 'rare' art specimens. 123

Manzoni died of cirrhosis of the liver at the age of thirty in his studio in Milan, in 1963. Klein died of a heart attack at thirty-four, only eight months later, soon after seeing one of his *Anthropometries* spliced into the film *Mondo Cane* at the Cannes Film Festival.

Joseph Beuys

The German artist Joseph Beuys believed that art should effectively transform people's everyday lives. He too resorted to dramatic actions and lectures in an attempt to change consciousness. 'We have to revolutionize human thought', he said, 'First of all revolution takes place within man. When man is really a free, creative being who can produce something new and original, he can revolutionize time.'

Beuys's actions often resembled Passion plays with their stark symbolism and complex and systematic iconography. Objects and materials – felt, butter, dead hares, sleighs, shovels – all became metaphorical protagonists in his performances. At the Galerie Schmela in Düsseldorf, on 26 November 1965, Beuys, his head covered in honey and gold leaf, took a dead hare in his arms and quietly carried it round the exhibition of his drawings and paintings, 'letting it touch the pictures with its paws'. Then he sat on a stool in a dimly lit corner and proceeded to explain the meaning of the works to the dead animal, 'because I do not really like explaining them to people', and

since 'even in death a hare has more sensitivity and instinctive understanding than some men with their stubborn rationality'.

Such meditative conversation with himself was central to Beuys's work. In terms of artists' performances it marked a turning point from earlier Fluxus actions. Yet his meetings with Fluxus had confirmed Beuys's own teaching methods at the Düsseldorf Academy where he had become professor of sculpture in 1961, at the age of 40. There he had encouraged the students to use any material for their work and, more concerned with their humanity than their eventual success in the art world, conducted most of his classes in the form of dialogues with students. In 1963, he organized, at the Academy, a Fluxus Festival with many American Fluxus artists participating. Beuys's polemical art and anti-art attitudes soon began to disturb the authorities; considered a disruptive element within the institution, he was always up against considerable opposition there and was finally, in 1972, dismissed amidst violent student protest.

Beuys's *Twenty-four Hours* (1965) was also given as part of a Fluxus event which included Bazon Brock, Charlotte Moorman, Nam June Paik, Tomas Schmit and Wolf Vostell. Having fasted for several days before the opening of the performance at midnight on 5 June, Beuys confined himself to a box for twenty-four hours, stretching out from time to time to collect objects around him, his feet never leaving the box. 'Action' and 'time' – 'elements to be controlled and directed by human will' – were reinforced in this lengthy and meditative concentration on objects.

Eurasia (1966) was Beuys's attempt to examine the political, spiritual and social polarities that characterize existence. Its central motif was 'the division of the cross', which for Beuys symbolized the division of people since Roman times. On a blackboard he drew only the upper section of the emblem, and proceeded, through a series of actions, to 'redirect the historical process'. Two small wooden crosses embedded with stopwatches lay on the floor; nearby was a dead hare transfixed by a series of thin wooden sticks. As the alarmbells of the stopwatches rang, he strewed white powder between the legs of the hare, stuck a thermometer in its mouth and blew in a tube. Then he walked over to a metal plate on the ground, kicking it with force. To Beuys, the crosses represented the division between east and west, Rome and Byzantium; the half cross on the blackboard the separation between Europe and Asia; the hare the messenger between the two; and the plate a metaphor for the arduous and frozen trans-Siberian journey.

Beuys's fervour took him to Northern Ireland, Edinburgh, New York, 124 London, Berlin and Kassel. *Coyote: I Like America and America Likes Me* was a dramatic one-week event which began on the journey from Düsseldorf to New York in May 1974. Beuys arrived at Kennedy Airport wrapped from head to toe in felt, the material which was for him an insulator, both

physically and metaphorically. Loaded into an ambulance, he was driven to the space which he would share with a wild coyote for seven days. During that time, he conversed privately with the animal, only a chainlink fence separating them from the visitors to the gallery. His daily rituals included a series of interactions with the coyote, introducing it to objects – felt, walking stick, gloves, electric torch, and the *Wall Street Journal* (delivered daily) – which it pawed and urinated on, as if acknowledging in its own way the man's presence.

Coyote was an 'American' action in Beuys's terms, the 'coyote complex' reflecting the American Indians' history of persecution as much as 'the whole relationship between the United States and Europe'. 'I wanted to concentrate only on the coyote. I wanted to isolate myself, insulate myself, see nothing of America other than the coyote . . . and exchange roles with it.' According to Beuys, this action also represented a transformation of ideology into the idea of freedom.

To Beuys, this transformation remained a key to his actions. His idea of 'social sculpture', consisting of lengthy discussions with large gatherings of people in various contexts, was a means primarily to extend the definition of art beyond specialist activity. Carried out by artists, 'social sculpture' would mobilize every individual's latent creativity, ultimately moulding the society of the future. The Free University, an international, multi-disciplinary network set up by Beuys in conjunction with artists, economists, psychologists etc., is based on the same premises.

124 Joseph Beuys, *Coyote*, 1974, at the René Block gallery in New York

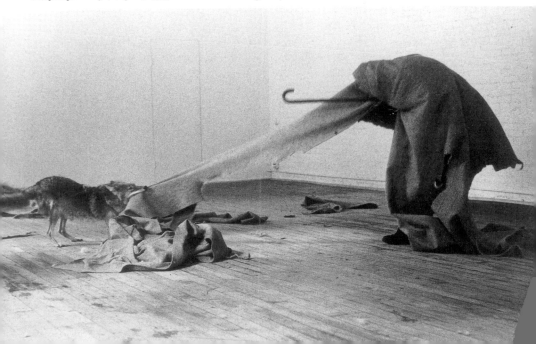

The Art of Ideas and the Media Generation 1968 to 1986

The Art of Ideas

The year 1968 prematurely marked the beginning of the decade of the seventies. In that year political events severely unsettled cultural and social life throughout Europe and the United States. The mood was one of irritation and anger with prevailing values and structures. While students and workers shouted slogans and erected street barricades in protest against 'the establishment', many younger artists approached the institution of art with equal, if less violent, disdain. They questioned the accepted premises of art and attempted to re-define its meaning and function. Moreover, artists took it upon themselves to express these new directions in lengthy texts, rather than leave that responsibility to the traditional mediator, the art critic. The gallery was attacked as an institution of commercialism and other outlets sought for communicating ideas to the public. On a personal level, it was a time when each artist re-evaluated his or her own intentions for making art, and when each action was to be seen as part of an overall investigation of art processes and not, paradoxically, as an appeal for popular acceptance.

The art object came to be considered entirely superfluous within this aesthetic and the notion of 'conceptual art' was formulated as 'an art of which the material is concepts'. Disregard for the art object was linked to its being seen as a mere pawn in the art market: if the function of the art object was to be an economic one, the argument went, then conceptual work could have no such use. Although economic necessities made this a short-lived dream, performance – in this context – became an extension of such an idea: although visible, it was intangible, it left no traces and it could not be bought and sold. Finally, performance was seen as reducing the element of alienation between performer and viewer – something that fitted well into the often leftist inspiration of the investigation of the function of art – since both audience and performer experienced the work simultaneously.

Performance in the last two years of the sixties and of the early seventies reflected conceptual art's rejection of traditional materials of canvas, brush or chisel, with performers turning to their own bodies as art material, just as Klein and Manzoni had done some years previously. For conceptual art

implied the *experience* of time, space and material rather than their representation in the form of objects, and the body became the most direct medium of expression. Performance was therefore an ideal means to materialize art concepts and as such was the practice corresponding to many of those theories. For example, ideas on space could just as well be interpreted in actual space as in the conventional two-dimensional format of the painted canvas; time could be suggested in the duration of a performance or with the aid of video monitors and video feedback. Sensibilities attributed to sculpture – such as the texture of material or objects in space – became even more tangible in live presentation. This translation of concepts into live works resulted in many performances which often appeared quite abstract to the viewer since there was seldom an attempt to create an overall visual impression or to provide clues to the work through the use of objects or narrative. Rather the viewer could, by association, gain insight into the particular experience that the performer demonstrated.

The demonstrations which concentrated on the artist's body as material came to be known as 'body art'. However, this term was a loose one, allowing for a wide variety of interpretation. While some body artists used their own persons as art material, others positioned themselves against walls, in corners, or in open fields, making human sculptural forms in space. Others constructed spaces in which both they and the viewer's sensation of space would be determined by the particular environment. Performers who had pioneered the so-called 'new dance' several years earlier, refined their movements to precise configurations developing a vocabulary of movements for the body in space.

Some artists, dissatisfied with the somewhat materialist exploration of the body, assumed poses and wore costumes (in performance and also in everyday life), creating 'living sculpture'. This concentration on the personality and appearance of the artist led directly to a large body of work which came to be called 'autobiographical', since the content of these performances used aspects of the performer's personal history. Such a reconstruction of private memory had its complement in the work of many performers who turned to 'collective memory' – the study of rituals and ceremonies – for the sources of their work: pagan, Christian or American-Indian rites often suggested the format of live events. A further clue to the style and content of many performances was the original discipline of many artists, whether in poetry, music, dance, painting, sculpture or theatre.

Yet another performance strategy relied on the presence of the artist in public as interlocutor, as earlier in Beuys's question and answer sessions. Some artists gave instructions to the viewer, suggesting that they enact the performances themselves. Above all, audiences were provoked into asking just what were the boundaries of art: where, for instance, did scientific or

philosophical enquiry end and art begin, or what distinguished the fine line between art and life?

Four years of conceptual art, from about 1968 on, had an enormous effect on an even younger generation of artists emerging from art schools where conceptual artists were teaching. By 1972 the fundamental questions raised had to some extent been absorbed in the new work. But the enthusiasm for social change and emancipation – students', women's, children's – had been considerably dampened. World monetary and energy crises subtly altered both life styles and preoccupations. The institution of the gallery, once rejected for its exploitation of artists, was reinstated as a convenient outlet. Not surprisingly, performance reflected these new attitudes. Partly in response to the cerebral issues of conceptual art, partly in response to the extraordinary productions of pop concerts – from the Rolling Stones to The Who, from Roxy Music to Alice Cooper – the new performance became stylish, flamboyant, and entertaining.

The performances that resulted from this period of intensive enquiry were numerous. They covered a wide range of materials, sensitivities and intentions, which crossed all disciplinary boundaries. Yet even so, it was possible to characterize various kinds of work. While a grouping of these trends may appear arbitrary, it nevertheless serves as a necessary key to comprehending performance of the seventies.

Instructions and questions

Some early conceptual 'actions' were more written instructions than actual performance, a set of proposals which the reader could perform or not, at will. For instance, Yoko Ono, in her contribution to the exhibition 'Information' at the Museum of Modern Art, New York, in the summer of 1970, instructed the reader to 'draw an imaginary map . . . go walking on an actual street according to the map . . .'; the Dutch artist Stanley Brouwn suggested that visitors to the exhibition 'Prospect 1969' 'walk during a few moments very consciously in a certain direction . . .'. In each case those who followed the instructions would supposedly experience the city or country-side with an enhanced consciousness. It was after all with just such a heightened awareness that artists had painted canvases of their surroundings; rather than passively viewing a finished artwork, the observer was now per-suaded to see the environment as though through the eyes of the artist.

Some artists saw performance as a means to explore the interrelationship between museum and gallery architecture and the art exhibited in them. The French artist Daniel Buren, for instance – who had done striped paintings since 1966 – began to paste stripes on a curved ceiling to emphasize the architecture of the building rather than submit to its overwhelming presence.

He also suggested in several performances that a work of art could be free of architecture altogether. *Dans les rues de Paris* (1968) consisted of men wearing sandwich boards painted with stripes, walking through the streets of Paris, while *Manifestation III* at the Théâtre des Arts Décoratifs in Paris (1967) consisted of a forty-minute play. The audience found on arrival at the theatre that the only 'dramatic action' was a stage curtain of stripes. Such works were 125 intended to change the viewers' perception of the museum landscape as much as the urban one, and to provoke them to question the *situations* in which they normally viewed art.

The American artist James Lee Byars attempted to change the perception of viewers by confronting them individually in a question and answer exchange. The questions were often paradoxical and obscure and, depending on the endurance of the selected individual, could go on for any length of time. He even set up a World Question Center at the Los Angeles County Museum as part of the 'Art and Technology' exhibition (1969). The French artist Bernar Venet posed questions by implication and proxy: he invited specialists in mathematics or physics to deliver lectures on their subjects to art audiences. *Relativity Track* (1968) at the Judson Memorial Church in New York consisted of four simultaneous lectures by three physicists on relativity and one medical doctor on the larynx. Such demonstrations suggested that 'art' was not necessarily *about* art only, while at the same time they introduced audiences to current questions in other disciplines.

125 David Buren, detail from Act 3, New York City, 1973

The artist's body

This attempt to translate the essential elements of one discipline into another characterized the early work of the New York artist Vito Acconci. Around 1969, Acconci used his body to provide an alternative 'ground' to the 'page ground' he had used as a poet; it was a way, he said, of shifting the focus from words to himself as an 'image'. So instead of writing a poem about 'following', Acconci acted out *Following Piece* as part of 'Street Works IV' (1969). The piece consisted simply of Acconci following randomly chosen individuals in the street, abandoning them once they left the street to enter a building. It was invisible in that people were unaware that it was going on; Acconci made several other pieces which were equally private. Though introspective, they were also the work of an artist looking at himself as an image, seeing 'the artist' as others might see him: Acconci saw himself 'as a marginal presence . . . tying in to ongoing situations . . .'. Each work dealt with a new image: for example, in *Conversion* (1970), he attempted to conceal his masculinity by burning his body hair, pulling at each breast – 'in a futile attempt to produce female breasts' – and hid his penis between his legs. But such private activities only underlined even more emphatically the self-contradictory character of his attitude; for whatever discoveries he made in this process of self-searching, he had no way of 'publishing' them as one would a poem. It became necessary, therefore, for him to make this 'body poetry' more public.

The first public works were equally introspective and poetic. For example, *Telling Secrets* (1971) took place in a dark deserted shed on the Hudson River in the early hours of the cold winter morning. From 1 to 2 am, Acconci whispered secrets – 'which could have been totally detrimental to me if publically revealed' – to the late night visitors. Again this work could be read as the equivalent of a poet jotting down private thoughts which once released for publication could be detrimental in certain contexts.

The implication of others in his subsequent performances led Acconci to the notion of 'power-fields' as described by the psychologist Kurt Lewin in *The Principle of Topological Psychology*. In that work, Acconci found a description of how each individual radiated a personal power-field which included all possible interaction with other people and objects in a particular physical space. His works from 1971 dealt with this power-field between himself and others in specially constructed spaces: he was concerned with 'setting up a field in which the audience was, so that they became a part of what I was doing . . . they became part of the physical space in which I moved'. *Seedbed* (1971), performed at the Sonnabend Gallery, New York, became the most notorious of these works. In it Acconci masturbated under a ramp built into the gallery over which the visitors walked.

These works led Acconci to a further interpretation of the power-field, designing a space which *suggested* his personal presence. These 'potential performances' were just as important as actual performances. Finally Acconci withdrew from performance altogether: *Command Performance* (1974) consisted of an empty space, an empty chair and a video monitor, the soundtrack inviting the viewer to create his or her own performance.

While many of Acconci's performances suggested his background in poetry, those of Dennis Oppenheim showed traces of his training as a sculptor in California. Like many artists of the time, he wished to counteract the overwhelming influence of minimalist sculpture. According to Oppenheim, body art became 'a calculated, malicious and strategic ploy' against the minimalists' preoccupation with the essence of the object. It was a means to focus on the 'objectifier' – the maker – rather than on the object itself. So Oppenheim made several works in which the prime concern was the *experience* of sculptural forms and activities, rather than their actual construction. In *Parallel Stress* (1970) he constructed a large mound of earth 126 that would act as a model for his own demonstration. Then he hung himself from parallel brick walls – holding onto the walls with his hands and feet – creating a body curve which echoed the shape of the mound.

126 Dennis Oppenheim, *Parallel Stress*, 1970

Lead Sink for Sebastian (1970) was designed for a man who had one artificial leg, the intention being similarly to act out certain sculptural sensations, such as smelting and reduction. The artificial leg was replaced by a lead pipe which was then melted by a blowtorch, causing the man's body to tilt unevenly as the 'sculpture' was liquidized. In that same year, Oppenheim took these experiments further in a work which he executed on Jones Beach, Long Island. In *Reading Position for a Second Degree Burn* he was concerned with the notion of colour change, 'a traditional painter's concern', but in this case his own skin became 'pigment': lying on the beach, a large book covering his bare chest, Oppenheim remained until the sun had burnt the area exposed to it, effecting a 'colour change' by the simplest means.

Oppenheim believed that body art was limitless in its application. It was both a conductor of 'energy and experience' and a didactic instrument for explaining the sensations that go into making artwork. Considered in this way, it also represented a refusal to sublimate creative energy into producing objects. By 1972, like many body artists involved in similar introspective and often physically dangerous explorations, he tired of live performance. Just as Acconci had done with his power-fields, Oppenheim devised works which suggested performance but which often used puppets rather than human performers. The little wooden figures, accompanied by recorded songs and phrases, continued to ask the fundamental questions raised by conceptual art; what were the roots of art, what were the motives for making art, and what lay behind seemingly autonomous artistic decisions? One example was 127 *Theme for a Major Hit* (1975) where, in a dimly lit room, a lonely puppet jerked endlessly to its own theme song.

127 Oppenheim, *Theme for a Major Hit,* **1975**

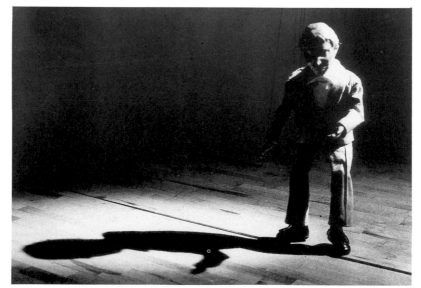

The Californian artist Chris Burden went through a similar transition to that of Acconci and Oppenheim, beginning with performances that carried physical exertion and concentration beyond the bounds of normal endurance, and withdrawing from performance after several years of death-defying acts. His first performance took place while he was still a student, in the students' locker-room at the University of California, Irvine, in 1971. Burden installed himself in a 2′ × 2′ × 3′ locker for five days, his only supplies for this tight-fitting stay being a large bottle of water, the contents of which were piped to him via the locker above. In the same year, in Venice, California, he asked a friend to shoot him in the left arm, in a work entitled *Shooting Piece*. The bullet, fired from fifteen feet away, should have grazed his arm, but instead blew away a large piece of flesh.

Deadman of the following year was another all-too-serious game with death. He lay wrapped in a canvas bag in the middle of a busy Los Angeles boulevard. Luckily he was unhurt, and the police put an end to this work by arresting him for causing a false emergency to be reported. Similarly death-defying acts were repeated at regular intervals; each could have ended in Burden's death, but the calculated risk involved was, he said, an energizing factor. Burden's painful exercises were meant to transcend physical reality: they were also a means to 're-enact certain American classics – like shooting people'. Presented in semi-controlled conditions he hoped that they would alter people's perception of violence. Certainly such danger had been portrayed on canvas or simulated in theatre scenes; Burden's performances, involving real danger, had a grandiose aim: to alter the history of representation of such themes for all time.

The body in space

At the same time that artists were working on their bodies as objects, manipulating them as they would a piece of sculpture or a page of poetry, others developed more structured performances which explored the body as an element in space. For example, the Californian artist Bruce Nauman executed works such as *Walking in an Exaggerated Manner Around the Perimeter of a Square* (1968), which had a direct relationship to his sculpture. By walking round the square, he could experience at first hand the volume and dimensions of his sculptural works which also dealt with volume and the placement of objects in space. The German artist Klaus Rinke methodically translated the three-dimensional properties of sculpture into actual space in a series of *Primary Demonstrations* begun in 1970. These were 'static sculptures' 128 created with his partner Monika Baumgartl: together they made geometric configurations, moving slowly from one position to the next, usually for several hours at a time. A wall-clock contrasted normal time with the time it

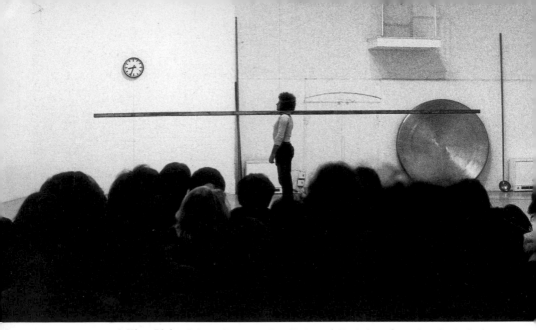

128 Klaus Rinke, *Primary Demonstration: Horizontal–Vertical*, performed at the Oxford Museum of Modern Art, 1976

took to make each sculptural shape. According to Rinke, these works contained the same theoretical premises as stone sculpture in space, but the additional elements of time and movement altered the viewer's understanding of those premises: they could actually see the *process* of making sculpture. Rinke hoped that these didactic demonstrations would change the viewer's perception of their own physical reality.

Similarly, the Hamburg artist Franz Erhard Walther was concerned with increasing the viewer's awareness of spatial relationships within real space and real time. In Walther's demonstrations, the viewer would, through a series of rehearsals, become the recipient of the action. For instance, *Going On* (1967) was a typical collaborative work, consisting of a line of twenty-eight pockets of equal size sewn into long lengths of fabric laid out in a field. Four participants climbed into four pockets and by the end of the work had climbed in and out of all the pockets, changing the original configuration of the fabric through their actions. Each of Walther's works provided a means for the spectators to experience the sculptural object themselves, as well as to initiate the unfolding design. Their active role in influencing the shape and procedure of the sculptures was an important element of the work.

The study of active and passive conduct of the viewer became the basis of many of the New York artist Dan Graham's performances from the early seventies. However, Graham wished to combine the role of active performer

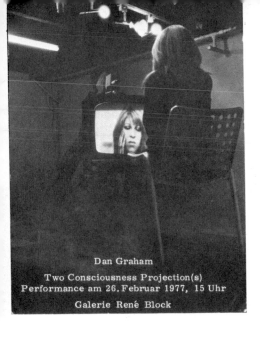

Dan Graham
Two Consciousness Projection(s)
Performance am 26. Februar 1977, 15 Uhr
Galerie René Block

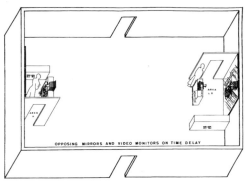

OPPOSING MIRRORS AND VIDEO MONITORS ON TIME DELAY

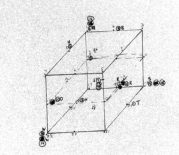

129 Dan Graham, *Two Consciousness Projection(s)*, invitation card to event presented in February 1977 at the Galerie René Block. Photo from a performance in 1974 with Suzanne Brenner, at the Lisson Gallery, London

130 Graham, diagram for *Opposing Mirrors and Video Monitors on Time Delay*, 1974

131 Trisha Brown, notation used in preparing *Locus*, 1975

132 Brown, *Locus*, 1975

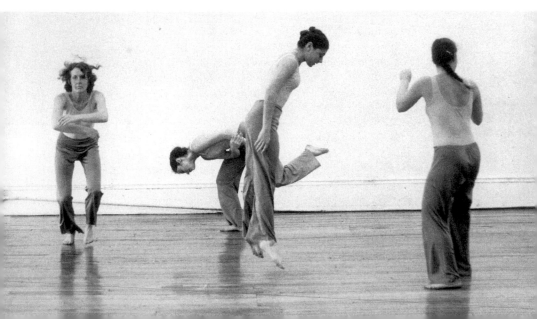

and passive spectator in one and the same person. So he introduced mirrors and video equipment which would allow performers to be the spectators of their own actions. This self-scrutiny was intended to set up a heightened consciousness of every gesture. In *Two Consciousness Projection* (1973) Graham created a situation which would increase that consciousness even further, since two people were asked to verbalize (in front of an audience) how they viewed one of the partners. A woman sat in front of a video screen which showed her face, while a man looked through the video camera trained on her face. As she examined her features and described what she saw, the man, at the same time, related how he read her face. In this way, both the man and woman were active in that they were creating the performance, but they were also passive spectators in that they were watching themselves performing.

Graham's theory of audience–performer relationships was based on Bertold Brecht's idea of imposing an uncomfortable and self-conscious state on the audience in an attempt to reduce the gap between the two. In subsequent works Graham explored this further, adding the elements of time and space. Video techniques and mirrors were used to create a sense of past, present and future, within one constructed space. In a work such as *Present Continuous Past* (1974), the mirror acted as a reflection of present time, while video feedback showed the performer/spectator (in this case the public) their past actions. According to Graham, 'mirrors reflect instantaneous time without duration . . . whereas video feedback does just the opposite, it relates the two in a kind of durational time flow'. So on entering the constructed cube lined with mirrors, the viewers saw themselves first in the mirror and then, eight seconds later, saw those mirrored actions relayed on the video. 'Present time' was the viewer's immediate action, which was then picked up by the mirror and video in rotation. The viewers therefore would see before them what they had recently performed but also knew that any further actions would appear on the video as 'future time'.

The New York performer Trisha Brown added a further dimension to the viewer's notion of the body in space. Works such as *Man Walking Down the Side of a Building* (1969), or *Walking on the Wall* (1970), were designed to disorient the audience's sense of gravitational balance. The first consisted of a man, strapped in mountaineering harness, walking down the vertical wall-face of a seven-story building in lower Manhattan. The second work, using the same mechanical support, took place in a gallery at the Whitney Museum, where performers moved along the wall at right angles to the audience. Similar works explored movement possibilities in space, while *Locus* (1975) related the actual movements in space to a two-dimensional plan. The performance was devised entirely through drawings, and Brown worked on three methods of notation simultaneously to achieve the final

effect: first she drew a cube, then she wrote out a number sequence based on her name which was then matched with the intersecting lines of the cube. She and three dancers choreographed a work determined by the finished drawing.

Also in New York, Lucinda Childs created several performances according to carefully worked out notation. *Congeries on Edges for 20 Obliques* (1975) was one such work where five dancers travelled on sets of diagonals across the space, exploring throughout the dance the various combinations indicated in the drawing. Similarly, Laura Dean and her colleagues followed precise 'phrasing patterns' indicated on the score, as in *Circle Dance* (1972).

The influence of American new dance exponents was felt in England where the Ting Theatre of Mistakes set up a collaborative workshop in 1974 to continue the earlier experiments. They put together the various notions developed by American dance pioneers from the fifties and sixties in a handbook, *The Elements of Performance Art*, published in 1976. One of the few such explicit texts on the theory and practice of performance, the book outlined a series of exercises for potential performers. *A Waterfall* (1977), presented on the forecourt and one of the terraces of the Hayward Gallery in London, illustrated some of the notions expressed in the book, such as task-oriented actions, theatre in the round, or the use of objects as spatial and temporal indicators. This particular work developed from the company's interest in structuring performances according to so-called 'additive methods'. With performers positioned at various levels on a large scaffolding, and holding containers, water was conveyed up and then down again, creating a series of 'waterfalls' each one hour long.

Ritual

In contrast to performances which dealt with formal properties of the body in space and time, others were far more emotive and expressionistic in nature. Those of the Austrian artist Hermann Nitsch, beginning in 1962, involving ritual and blood, were described as 'an aesthetic way of praying'. Ancient Dionysian and Christian rites were re-enacted in a modern context, supposedly illustrating Aristotle's notion of catharsis through fear, terror and compassion. Nitsch saw these ritualistic orgies as an extension of action painting, recalling the Futurist Carrà's suggestion: you must paint, as drunkards sing and vomit, sounds, noises and smells.

His *Orgies, Mysteries, Theatre* projects were repeated at regular intervals 133 throughout the seventies. A typical action lasted several hours: it would begin with the sound of loud music – 'the ecstasy created by the loudest possible created noise' – followed by Nitsch giving orders for the ceremony to begin. A slaughtered lamb would be brought on stage by assistants, fastened head

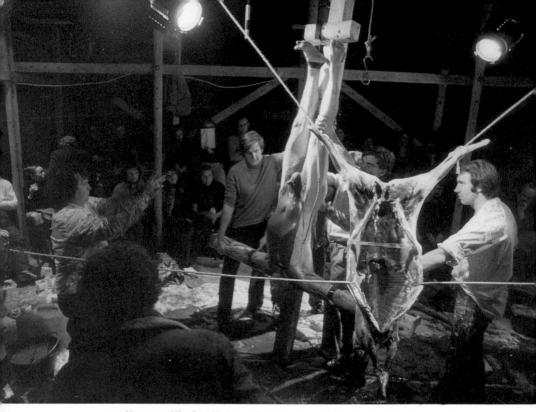

133 Hermann Nitsch, *(Aktion) 48th Action*, presented at the Munich Modernes Theater, 1974

down as if crucified. Then the animal would be disembowelled; entrails and buckets of blood were poured over a nude woman or man, while the drained animal was strung up over their heads. Such activities sprang from Nitsch's belief that humankind's aggressive instincts had been repressed and muted through the media. Even the ritual of killing animals, so natural to primitive man, had been removed from modern-day experience. These ritualized acts were a means of releasing that repressed energy as well as an act of purification and redemption through suffering.

Viennese 'actionism', according to another ritualistic performer, Otto Mühl, was 'not only a form of art, but above all an existential attitude', a description appropriate to the works of Günter Brus, Arnulf Rainer, and Valie Export. Common to these actions was the artist's dramatic self-expression, the intensity of which was reminiscent of Viennese Expressionist painters of fifty years earlier. Not surprisingly, another characteristic of Viennese action artists was their interest in psychology; the studies of Sigmund Freud and Wilhelm Reich led to performances dealing specifically with art as therapy. Arnulf Rainer, for example, recreated the gestures of

the mentally insane. In Innsbruck, Rudolf Schwartzkogler created what he called 'artistic nudes – similar to a wreckage'; but his wreckage-like self-mutilations ultimately led to his death in 1969.

In Paris, Gina Pane's self-inflicted cuts to her back, face and hands were no less dangerous. Like Nitsch, she believed that ritualized pain had a purifying effect: such work was necessary 'in order to reach an anaesthetized society'. Using blood, fire, milk and the recreation of pain as the 'elements' of her performances, she succeeded – in her own terms – 'in making the public understand right off that my body is my artistic material'. A typical work, *The Conditioning* (part 1 of 'Auto-Portrait(s)', 1972), consisted of Pane lying on an iron bed with a few crossbars, below which fifteen long candles burnt.

Similarly seeking to understand the ritualized pain of self-abuse, particularly as it is exhibited by psychologically disturbed patients, and the disconnectedness that occurs between the body and the self, Marina Abramovic in Belgrade created equally harrowing work. In 1974, in a work entitled *Rhythm O*, she permitted a room-full of spectators in a Naples gallery to abuse her at their will for six hours, using instruments of pain and pleasure that had been placed on a table for their convenience. By the third hour, her clothes had been cut from her body with razor blades, her skin slashed; a loaded gun held to her head finally caused a fight between her tormentors, bringing the proceeding to an unnerving halt. This passive aggression between individuals she continued to explore in later works executed with the artist Ulay, who became her collaborator in 1975. Together they explored the pain and endurance of relationships, between themselves, and between themselves and the public. *Imponderabilia* (1977) consisted of their two naked bodies, standing facing each other against the frames of a door; the public was obliged to enter the exhibition space through the small gap left between their bodies. Another work, *Relation in Movement* (1977), consisted of Ulay driving a car for sixteen hours in a small circle, while Marina, also in the car, announced the number of circles over a loudspeaker.

Stuart Brisley's actions in London were equally a response to what he considered to be society's anaesthetization and alienation. *And for Today, Nothing* (1972) took place in a darkened bathroom at Gallery House, London, in a bath filled with black liquid and floating debris where Brisley lay for a period of two weeks. According to Brisley, the work was inspired by his distress over the depoliticization of the individual, which he feared would lead to the decay of both individual and social relationships. Reindeer Werk, the name for a couple of young London performers, were no less concerned by similar feelings: their demonstrations of what they called *Behaviour Land*, at Butler's Wharf in London in 1977, were not unlike the work of Rainer in Vienna, in that they recreated the gestures of social outcasts – the insane, the alcoholic, the bum.

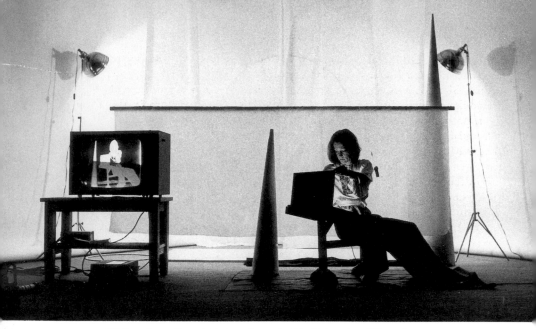

The choice of ritualistic prototypes led to very different kinds of performances. While the Viennese actions fitted the expressionistic and psychological interests so long considered a Viennese characteristic, the work of some American performers reflected much less well-known sensibilities, those of the American Indians. Joan Jonas's work referred back to the religious ceremonies of the Zuñi and Hopi tribes of the Pacific coast, the area where she grew up. Those ancient rites took place at the foot of hills on which the tribe lived and were conducted by the shamans of the tribe.

In Jonas's New York work *Delay Delay* (1972), the audience was similarly situated at a distance above the performance. From the top of a five-storey loft building, they watched thirteen performers dispersed throughout the empty city lots, which were marked with large signs indicating the numbers of paces away from the loft building. The performers clapped wooden blocks, the echoes of which provided the only physical connection between audience and performers. Jonas incorporated the expansive sense of outdoors, so characteristic of Indian ceremonies, in indoor works using
134 mirrors and video to provide the illusion of deep space. *Funnel* (1974) was viewed simultaneously in reality and in a monitored image. Curtains divided the room into three distinct spatial characters, each containing props – a large paper funnel, two swinging parallel bars and a hoop. Other indoor works such as the earlier *Organic Honey's Visual Telepathy* (1972) retained the mystic

166

quality of the outdoor pieces through the use of masks, head-dresses of peacock feathers, and ornaments and costume.

Tina Girouard's performances were also built around costumes and ceremonies inspired by the Mardi Gras festivities (she was born in the American south), and Hopi Indian rites. Combining elements from these ceremonial precedents, Girouard presented *Pinwheel* (1977) at the New Orleans Museum of Art. In this work, several performers marked out a square on the floor of the main entrance of the museum, using the fabric to separate the square into four sections representing animal, vegetable, mineral and other so-called 'personae'. Slowly fabrics and various props were ceremoniously added by the performers, transforming the existing pattern into what the artist considered to be 'a series of archetypal world images'. Girouard intended that the ritualized actions would place the actors in a context 'symbolic of the universe' in the spirit of Indian ceremonies, and by so doing create precedents for modern-day versions.

Living sculpture

Much performance work originating in a conceptual framework was humourless, despite the often paradoxical intentions of the artist. It was in England that the first signs of humour and satire emerged.

In 1969, Gilbert and George were students at St Martin's School of Art in London. Along with other young artists such as Richard Long, Hamish Fulton and John Hilliard, these St Martin's students were eventually to become the focus for English conceptual art. Gilbert and George personified the idea of art; they themselves became art, by declaring themselves 'living sculpture'. Their first 'singing sculpture' *Underneath the Arches*, presented in 135 1969, consisted of the two artists – faces painted gold, wearing ordinary suits, one carrying a walking stick and the other a glove – moving in a mechanical, puppet-like fashion on a small table for about six minutes to the accompaniment of the Flanagan and Allen song of the same name.

Like Manzoni, the inherent irony of focusing the artwork on their own persons and turning themselves into the art object was at the same time a serious means of manipulating or commenting upon traditional ideas about art. In their written dedication to *Underneath the Arches* ('The most intelligent fascinating serious and beautiful art piece you have ever seen') they outlined 'The Laws of Sculptors': '1. Always be smartly dressed, well groomed relaxed friendly polite and in complete control. 2. Make the world to believe in you and to pay heavily for this privilege. 3. Never worry assess discuss or criticise but remain quiet respectful and calm. 4. The Lord chisels still, so don't leave your bench for long.' For Gilbert and George there was thus no separation whatsoever between their activities as sculptors and their activities

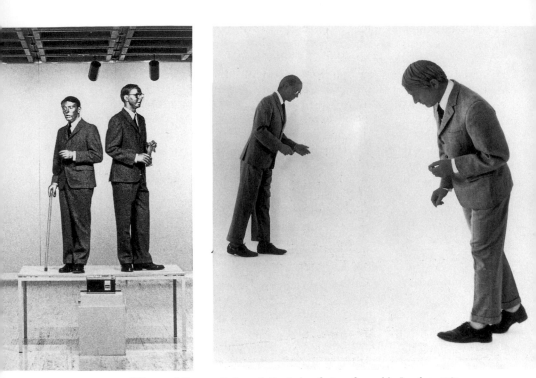

135 Gilbert and George, *Underneath the Arches*, first performed in London, 1969

136 Gilbert and George, *The Red Sculpture*, first performed in Tokyo, 1975

in real life. The stream of poems and statements, such as 'To be with art is all we ask', emphasized this point: printed on parchment-like paper and always carrying their official insignia – a monogram resembling the royal one over their logo 'Art for All' – these statements provide a key to the intentions of their single sculpture which they performed for several years, virtually unchanged, in England, and in America in 1971.

Another early work, *The Meal* (14 May 1969), had similarly embodied their concern to eliminate the separation between life and art. The invitations which had been sent out to a thousand people read: 'Isabella Beeton and Doreen Mariott will cook a meal for the two sculptors, Gilbert and George, and their guest, Mr David Hockney, the painter. Richard West will be their waiter. They will dine in Hellicars' beautiful music room at "Ripley", Sunridge Avenue, Bromley, Kent. One hundred numbered and signed iridescent souvenir tickets are now available at three guineas each. We do hope you are able to be present at this important art occasion.' Richard West

was Lord Snowdon's butler, and Isabella Beeton reportedly a distant relative of the Victorian gastronome, Mrs Beeton, whose sumptuous recipes were used. An elaborate meal was served to the final number of thirty guests, who ate sedately for a period of one hour and twenty minutes. David Hockney, commending Gilbert and George for being 'marvellous surrealists, terribly good', added: 'I think what they are doing is an extension of the idea that anyone can be an artist, that what they say or do can be art. Conceptual art is ahead of its time, widening horizons.'

Subsequent works were similarly based on everyday activities: *Drinking Sculpture* took them through London East End pubs, and picnics on quiet river banks became the subject for their large pastoral drawings and 136 photographic pieces, exhibited in between their slowly developed living sculpture. Their work *The Red Sculpture* (1975), first presented in Tokyo, lasted ninety minutes and was perhaps their most 'abstract', and their last, performance work. Faces and hands painted a brilliant red, the two figures moved into slowly paced poses in intricate relation to command-like statements which were taped and played on a tape recorder.

The seductive appeal of oneself becoming an art object, which resulted in numerous offshoots of living sculpture, was partly the result of the glamour of the rock world of the sixties; the New York singer Lou Reed, and the English group Roxy Music, for example, were creating stunning tableaux both on and off stage. The relationship between the two was highlighted in an exhibition called 'Transformer' (1974) at the Kunstmuseum, Lucerne, including works by the artists Urs Lüthi, Katharina Sieverding and Luciano Castelli. 'Transformer art' also referred to the notion of androgyny resulting from the feminists' suggestion that traditional female and male roles could – at least in fashion – be equalized. So Lüthi, a short, roundish Zurich artist, impersonated his tall, thin, beautiful girlfriend Manon, with the aid of heavy make-up and sucked-in cheeks, in a series of posed performances in which she and he, by all appearances, were interchangeable. Ambivalence was, he said, the most signficant creative aspect of his works, as seen in *Self-Portrait* (1973). Similarly, the Düsseldorf artists Sieverding and Klaus Mettig hoped, in *Motor-Kamera* (1973), to arrive at an 'interchange of identification' by acting out a series of domestic situations for which they were dressed and made up to look uncannily alike. In Lucerne, Castelli created exotic environments such as *Performance Solarium* (1975), in which he lay surrounded by paraphernalia from a transvestite's wardrobe, make-up box and photo album.

Another offshoot of living sculpture was less narcissistic: some artists explored the formal qualities of poses and gestures in a series of *tableaux vivants*. In Italy, Jannis Kounellis presented works which combined animate and inanimate sculpture: *Table* (1973) consisted of a table strewn with 137 fragments from an ancient Roman Apollo sculpture next to which sat a man,

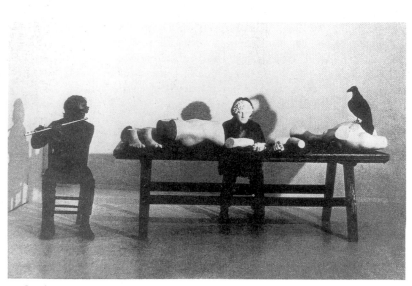

137 Jannis Kounellis, *Table*, 1973

an Apollo mask held to his face. According to Kounellis, this and several other untitled 'frozen performances' – some of which included live horses – were a means of illustrating metaphorically the complexity of ideas and sensations represented in art throughout art history. He considered the Parthenon frieze as such a 'frozen performance'. Each sculpture or painting in the history of art, he said, contained 'the story of the loneliness of a single soul' and his tableaux attempted to analyse the nature of that 'singular vision'. The

138 Roman artist Luigi Ontani portrayed such 'visions' in a series of performances in which he personified figures from classical paintings; they included *San Sebastian* (1973) (after Guido Reni) and *Après J.L. David* (1974). Some of his 'reincarnations' were based on historical figures: on his first visit to New York, in 1974, he travelled in a costume recreated from drawings of Christopher Columbus.

139 Scott Burton's *Pair Behavior Tableaux* (1976) for two male performers, at the Guggenheim Museum in New York, was an hour-long performance composed of approximately eighty static poses held for a number of seconds each. Each pose demonstrated Burton's so-called body-language vocabulary – 'role establishment', 'appeasement', 'disengagement' etc. – and was followed by a blackout; viewed from a distance of twenty yards, the figures were deceptively sculpture-like. Also in 1976, at The Clocktower in New York, an American-based artist by the name of Colette lay naked in a

140 luxurious twenty-by-twenty-foot environment of crushed silk in *Real Dream*, a 'sleep tableau' lasting several hours.

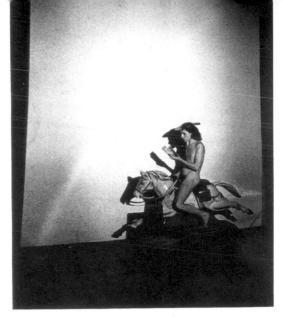

138 Luigi Ontani, *Don Quixote*, 1974

139 Scott Burton, *Pair Behavior Tableaux*, 1976. Tableau no. 47 from a five-part performance composed of eighty silent *tableaux vivants*. First performed at the Solomon R. Guggenheim Museum, New York, 24 February–4 April 1976

140 Colette, *Real Dream*, first performed at the Clocktower, New York, December 1975

Autobiography

Scrutiny of appearances and gestures, as well as the analytical investigation of the fine edge between an artist's art and his or her life, became the content of a large body of work loosely referred to as 'autobiographical'. Thus, several artists recreated episodes from their own life, manipulating and transforming the material into a series of performances through film, video, sound and soliloquy. The New York artist Laurie Anderson used 'autobiography' to mean the time right up to the actual presentation of the performance, so that a work often included a description of its own making. In a forty-five-minute piece entitled *For Instants*, presented at a Whitney Museum performance festival in 1976, she explained the original intentions of the work while at the same time presenting the final results. She told the audience how she had hoped to present a film of boats sailing on the Hudson River, and went on to describe the difficulties she had encountered in the process of filming. The recording of the soundtrack was similarly dealt with as Anderson pointed out the inevitable shortcomings of using autobiographical material. There was no longer one past but two: 'there's what happened and there's what I said and wrote about what happened' – making blurred the distinction between performance and reality. Typically, she turned this difficulty into a song: 'Art and illusion, illusion and art/are you really here or is it only art?/Am I really here or is it only art?'

Following *For Instants*, Anderson's work became more musically oriented and, with Bob Bialecki, she constructed an assortment of musical instruments for subsequent performances. On one occasion, she replaced the horse-hair of her violin bow with a recording tape, playing pre-recorded sentences on an audio head mounted in the body of the violin. Each pass of the bow corresponded to one word of the sentence on the tape. Sometimes, however, the sentence remained intentionally incomplete so that for example, Lenin's famous quote 'Ethics is the aesthetics of the future' became, *Ethics is the Aesthetics of the Few (ture)* (as Anderson entitled her 1976 work). Then she experimented with the ways in which recorded words sounded in reverse, so that 'Lao-Tzu', aurally reversed, became 'Who are you?' These aural palindromes were presented at the Kitchen Center for Video and Music as part of her *Songs for Lines/Songs for Waves* (1977).

Like Anderson's, Julia Heyward's performances contained considerable material from her own childhood, but while Anderson was Chicago-born, Heyward grew up in the southern states, the daughter of a Presbyterian minister. Traces of that background lingered in the style and content of her performances as well as in her attitude to performance itself. On the one hand, she adopted the southern minister's characteristic sing-song rhythm in her monologues and on the other, she described attending a performance as

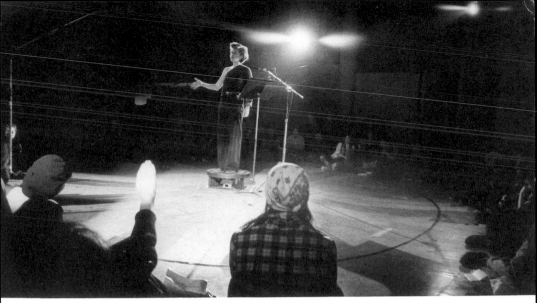

141 Julia Heyward, *Shake! Daddy! Shake!*, Judson
Church, 8 January 1976. 'This piece isolated a
body-part, an arm, and gave its history by
describing its function and its eventual doom. Its
function was shaking hands, as part of a man who
was a public servant (minister). Eventually the
arms gets a nervous disease . . .'

142 Laurie Anderson, *For Instants*, 1976,
performed on a 'viophonograph' turntable on
violin, with a needle mounted mid-bow. The
record is of her own voice. In the performance
Anderson accompanies her 'viophonograph'
playing with her own singing. The performance
also includes film sequences and spoken sections

143 Adrian Piper, *Some Reflected Surfaces*,
presented at the Whitney Museum, February 1976

'equivalent to going to church — at both one gets riled up, moved, replenished'.

Although her early New York performances, such as *It's a Sun! or Fame by Association* (1975) at the Kitchen and *Shake! Daddy! Shake!* (1976) at the Judson Memorial Church, both referred back to her life and relationships in the south, Heyward soon tired of the limits of autobiography. *God Heads* (1976), at the Whitney Museum, was a reaction against that genre and at the same time against all conventions and the institutions that reinforced them — the state, the family, the art museum. By separating the audience into 'boys' on the left and 'girls' on the right, she ironically emphasized the social roles of men and women. Then she showed film clips of Mount Rushmore (symbol of the state) and decapitated dolls (the death of family life). Pacing up and down the aisle formed by her segregated audience, Heyward threw her voice — like a ventriloquist — criticising the art museum: 'God talks now . . . this girl is dead . . . god talks through her . . . god sez no dollars for artists, no art shows.' In *This is my Blue Period* (1977), at the Artists Space, she examined the effects of television and its power to 'collectivize the subconscious — round the clock — in your own home', with equal irony. The work, she said, used 'sound displacement', 'subliminal visual and audience techniques' as well as 'language and body gesture' in order 'to manipulate the audience emotionally and cerebrally'.

This fascination for performance as a means to increase the audience's awareness of their positions as victims of manipulation — whether by the media or the performers themselves — also ran through Adrian Piper's *Some Reflected Surfaces*, presented in 1976 at the Whitney Museum. Dressed in black clothes, with white face, false moustache and dark glasses, Piper danced in a single spotlight to the song 'Respect' as her taped voice told the story of how she had worked as a disco-dancer in a downtown bar. Then a man's voice sharply criticised her movements, which she altered according to his instructions. Finally the light went out and the small dancing figure was seen briefly on a nearby video screen, as if implying that she was finally acceptable for public broadcast.

Autobiographical performances were easy to follow and the fact that artists revealed intimate information about themselves set up a particular empathy between performer and audience. This type of presentation thus became a popular one, even though the autobiographical content was not necessarily genuine; in fact, many artists strongly objected to being called autobiographical performers, but nevertheless continued to rely on the willingness of the audience to empathize with their intentions. Coinciding with the powerful Women's Movement throughout Europe and the United States, it allowed many women performers to deal with issues that had been relatively little explored by their male counterparts. For example, the

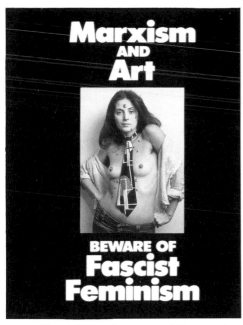

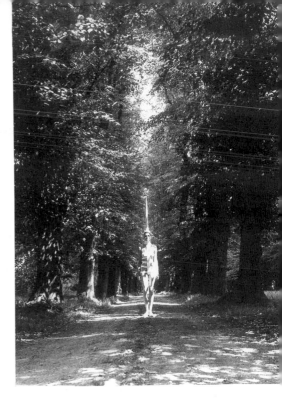

144 Hannah Wilke, *Super-t-art* and 'Beware of Fascist Feminism', 1974

145 Rebecca Horn, *Unicorn*, 1971

German artist Ulrike Rosenbach, dressed in white leotard, dramatically shot arrows at a madonna–and–child target in a work entitled *Don't Believe that I am an Amazon*, in front of a large audience at the Paris Biennale of 1975. This symbolic attack on Christianity's traditional suppression of women and essentially patriarchal outlook was foreshadowed by Hannah Wilke's presentation of herself as a female Christ in *Super-t-art* (1974), as part of Jean Dupuy's *Soup and Tart* group show at the Kitchen. Wilke's uninhibited display of her beautiful body related to a poster she made at the same time, entitled 'Beware of Fascist Feminism', which warned of the dangers of a 144 certain kind of feminist puritanism that militated against women themselves, their sensuality and the pleasure of their own bodies.

Earlier still, another German artist, Rebecca Horn, had devised a series of 'models of interaction rituals' – instruments specially made to fit the body which when worn generated that sensuality. *Cornucopia-Seance for Two Breasts* (1970) was a horn–shaped object made of felt that was tied to a woman's chest, connecting breasts and mouth. The costume for *Unicorn* 145 (1971) was a series of white straps laced across a naked female figure who wore the horn of the unicorn on her head. Dressed in this way, the figure walked through a park in the early morning as though defying the viewer to

175

ignore its beautiful presence. *Mechanical Body Fan* (1974), constructed for male or female bodies, extended the lines of the body into two large semicircles of fabric, radiating and defining an individual's body space. Slow rotation of the separate fans revealed and hid different parts of the body with each turn, while rapid rotation created a transparent circle of light.

The issues dealt with in many of these performances were often grouped together as feminist art by critics seeking an easy way to categorize the material, and even to undermine the serious intentions of the work. However, the social revolution demanded by feminism had as much to do with men as it did with women and certain performances were constructed in this light. Martha Wilson and Jackie Apple's *Transformance: Claudia* (1973) was as much a general comment on power and money as it was on the role of women in the hierarchy created by power and money. It began with an expensive lunch for a small party at the elegant and exclusive Palm Court Restaurant at the Plaza Hotel in New York, followed by a tour of downtown Soho galleries. They then improvised dialogue and behaviour which 'typified the role-model of the "powerful woman" as she has been culturally stereotyped by fashion magazines, TV and movies'. The work, the artists said, raised questions about the conflict between stereotypes and reality: 'Can a woman be feminine and powerful at the same time? or is the powerful woman desirable?'

This question of power was looked at from an entirely different viewpoint in *Prostitution Notes* (1975), executed by the Californian artist Suzanne Lacey in Los Angeles. Commissioned by Jim Woods of Studio Watts Workshop, and consisting of extensive data on prostitution, recorded over a four-month period and presented on ten large city maps, the work was intended to 'increase the awareness and understanding of those in the life of prostitution'. The data, Lacey said, 'reflected an underlying attitude of society towards women, as well as a common experience of treatment by that society'.

While some artists created performances which raised the level of public consciousness, others dealt with private fantasies and dreams. Susan Russell's *Magnolia* (1976), at the Artists Space in New York, was a thirty-minute visual story of the dreams of a southern belle, one section of which showed Russell sitting against a background film of wind-blown grass fields, her ostrich-feather shawl blown by an electric fan. The London artist Susan Hiller's *Dream Ceremonies* and *Dream Mapping* (both 1974) were created through actual dream seminars, conducted with a group of twelve friends in the open fields, surrounding a country farmhouse. The group dreamt together each night over a period of several days, discussing and illustrating their dreams on waking each morning. The Californian artist Eleanor Antin illustrated her own dreams in the form of various performances where, with the aid of costumes and make-up, she became one of the characters of her fantasies. *The*

Ballerina and the Bum (1974), *The Adventures of a Nurse* (1974) and *The King* (1975) (which celebrated the birth of her male self through the application, hair by hair, of a false beard) were each a means, she said, of extending the limits of her own personality.

Impersonation, autobiographical and dream material, the re-enactment of past gestures – all opened performance to a wide variety of interpretation. The Parisian artist Christian Boltansky, dressed in an old suit, presented cameos from his childhood in a series of works such as *My Mother Sewed*, in which he himself sewed in front of an intentionally childish painting of the fireplace of his family home. In London, Marc Chaimowicz appeared with a gold painted face in a reconstruction of his own room in *Table Tableaux* (1974) at the Garage. The fifteen-minute performance was, he said, a rendering of female sensitivity – 'delicacy, mystery, sensuousness, sensitivity, and above all humility'.

Life style: that's entertainment!

The intimate and confessional nature of much so-called autobiographical performance had broken the reign of cerebral and didactic issues associated with conceptually oriented performance. Those younger artists who refused to separate the world of art from their own cultural period – from the world of rock music, extravagant Hollywood movies (and the life styles they suggested), television soap opera or cabaret – produced a wide variety of works which were, above all, decidedly entertaining.

According to the London-based Scottish artist Bruce McLean, the key to entertainment was style and the key to style was the perfect pose. So in 1972 he formed a group (with Paul Richards and Ron Carra) called Nice Style, The World's First Pose Band. The preliminary preparation for their work was presented the same year in the form of 999 proposals for pose pieces, in a self-proclaimed retrospective at the Tate Gallery. Works such as *Waiter, Waiter There's a Sculpture in my Soup, Piece, Fools Rush in and Make the New Art, Piece* or *Taking a Line for a Walk, Piece*, published in a black book and displayed as a carpet of books on the floor, hinted at the kind of satirical humour that the Pose Band would employ. No. 383 of McLean's proposals, *He Who Laughs Last Makes the Best Sculpture*, left no doubts as to the intentions of the new group.

After a year of preparation and preview performances at various locations in London, the Pose Band presented a lecture on 'Contemporary Pose' (1973) at the Royal College of Art Gallery in London. Delivered by a stylishly dressed lecturer with a very obvious stammer, it was illustrated by members of the group variously dressed in silver space-suits (inflated with a hair dryer), exotic drag and a distinctive double-breasted raincoat. The 'perfect poses'

that the lecturer discussed at length were demonstrated with the aid of specially constructed 'stance moulds' or 'physical modifiers' (articles of clothing with built-in poses) and giant-size measuring instruments which ensured the accuracy of an elbow angle or a tilted head. The unobtrusive raincoat worn by one of the group was in fact an iconographic clue for any student of pose: it referred to the group's undisputed hero, Victor Mature. McLean half-seriously explained that Mature, 'a self-confessed bad actor with 150 films to prove it', considered himself as the product of one style: 'nothing else existed on the actual film except style'. In fact, he said, Mature had about fifteen gestures from the twitch of an eyebrow to the movement of a shoulder while his prime instrument of style was his ever-present raincoat. *Crease Crisis* (1973) was a performance film made in homage to Mature's raincoat.

Throughout 1973 and 1974 the group continued its 'research' into pose, presenting the results in hilarious performances in London; each had an appropriately zany title: *The Pose that Took us to the Top, Deep Freeze* (1973) took place in a banquet suite at the Hanover Grand, off Regent Street; *Seen from the Side* (1973) was a forty-minute film dealing 'with the problems of bad style, superficiality and acquisitiveness in a society that holds pose to be very important'; and *High up on a Baroque Palazzo* (1974) was a comedy on 'entrance and exit poses'. By 1975 Nice Style had disbanded, but McLean's own subsequent performances continued to be characterized by his inimitable humour and outrageous poses. Moreover, the tongue-in-cheek aspect of his work, like all satire, had its serious side: what was satirized was always art.

146 Nice Style, The World's First Pose Band, *High Up on a Baroque Palazzo,* presented at the Garage, London, 1974

147 Poster for General Idea's *Going Thru the Motions*, 1975

148 Venetian Blind costume (designed by General Idea) performing at Lake Louise ski slopes, Alberta, 1977

Similarly, the group General Idea (Jorge Zontal, A.A. Bronson and Felix Partz), founded in Toronto in 1968, parodied the overly serious nature of the art world. Their intentions, they said, were to be 'rich – glamorous – and artists' so they founded a magazine, *File*, described by a critic as 'Canadian Dada all wrapped up in a glossy exact-size replica of *Life*', in which artists were presented in the style of Hollywood stars. In one issue they declared that all their performances would in fact be rehearsals for a *Miss General Idea Pageant* to take place in 1984. *Audience Training* (1975) consisted of the audience 'going through the motions' of applause, laughter and cheers when signalled by the group to do so, and *Going Thru The Motions* became the title 147 of a performance rehearsal at the Art Gallery of Ontario in 1975, where they previewed models of the proposed building that would house the future pageant in *Six Venetian Blinds*: six women in cone-shaped costumes suggesting the new building, who paraded down a ramp to the sounds of a live rock band. Then the models toured department stores, city sites and ski 148 slopes, 'trying out the new building on the sky-line'.

179

149 Pat Oleszko, *Coat of Arms* (twenty-six arms), 1976 150 Vincent Trasov as Mr Peanut, Vancouver, 1974

Other artists also did costume performances: Vincent Trasov walked the
150 streets of Vancouver in 1974 as Mr Peanut in a peanut shell, monocle, white
gloves and top hat, campaigning for the office of Mayor; in the same city, Dr
Brute, also known as Eric Metcalfe, appeared in costumes made of leopard
spots from his prized collection called *Leopard Realty* (1974); the San
Franciscan artist Paul Cotton performed as a bunny with his pink powdered
genitals protruding from the fluffy costume at Documenta (1972); and the
New York artist Pat Oleszko appeared in a performance programme, 'Line-
149 Up', at the Museum of Modern Art (1976) in her *Coat of Arms* – a coat of
twenty-six arms.

Performance artists drew on all aspects of spectacle and entertainment for
the structure of their works. Some turned to cabaret and variety theatre
techniques as a means to convey their ideas, in much the same way that the
Dadaists and Futurists had done before: *Ralston Farina Doing a Painting
Demonstration with Campbell's Chicken Noodle/Tomato Soup* (1977) was one of
Farina's many magic shows in which he used 'art' as his props, and where the
intention, he said, was an investigation of 'time and timing'. Similarly, Stuart
Sherman's *Fourth Spectacle*, at the Whitney Museum (1976), was presented in

the manner of a travelling showman: pillows, doorknobs, safari hats, guitars, and shovels were produced by him from cardboard boxes and he then proceeded to demonstrate the 'personality' of each object through gestures and sound produced on a nearby cassette recorder.

By the mid-seventies, a considerable number of performers had entered the realm of entertainment, making artists' performance increasingly popular with large numbers of people. Festivals and group shows were organized, some spanning several days. *The Performance Show* (1975), in Southampton, England, brought together many British artists, among them Rose English, Sally Potter and Clare Weston, while in New York Jean Dupuy arranged several evenings of performances with as many as thirty artists billed for each programme. One such event was *Three Nights on a Revolving Stage* (1976) at the Judson Memorial Church; another was *Grommets* (1977), for which twenty artists were secluded in two tiers of canvas booths constructed in Dupuy's own Broadway loft. Visitors looked through metal eyelets (grommets), climbing ladders to reach the upper booths to see works by artists such as Charlemagne Palestine, Olga Adorno, Pooh Kaye, Alison Knowles and Dupuy himself, scaled down to fit the 'penny-peep-show' conditions. Moreover, to cater for the new demand, galleries like the Kitchen Centre for Video and Music and Artists Space in New York, De Appel in Amsterdam, and Acme in London, became specifically committed to presenting performances. Booking agents adjusted themselves to the increasing number of performances, and interest in the history of the medium grew: reconstructions of Futurist, Dada, Constructivist and Bauhaus performances were presented in New York, as well as reconstructions of more recent works, such as a full evening of Fluxus events.

The punk aesthetic

The official acknowledgment of museums and galleries only spurred many younger artists on to finding less sedate venues for their work. Historically, performers had always been free from any dependence on establishment recognition for their activities and had, moreover, purposefully acted against the stagnation and academicism associated with that establishment. In the mid-seventies it was again rock music that suggested an outlet. By then rock had undergone an interesting transition from the highly sophisticated music of the sixties and early seventies to music that was intentionally and aggressively amateur. Punk rock in its early stages – around 1975 in England and shortly after in the United States – was invented by very young, untrained and inexperienced 'musicians', who played the songs of their sixties' heroes with utter disregard for the conventional qualities of rhythm, pitch or musical coherence. Soon punk rockers were writing their own

vicious lyrics (which, in England, were often the expression of unemployed working-class youths) and devising equally outrageous methods of presentation: the new aesthetic, as demonstrated by the Sex Pistols or The Clash, was characterized by torn trousers, wild uncombed hair and ornaments of safety-pins, razor blades and body tattoos.

In London, Cosey Fanni Tutti and Genesis P. Orridge alternated between art performances, as COUM Transmissions, and punk performances, as Throbbing Gristle. It was as COUM that they caused a scandal in London in 1976; their exhibition 'Prostitution' at the Institute of Contemporary Arts, consisting of documentation from Cosey's activities as a model for a pornographic magazine, sparked off a row in the press and in Parliament. Despite the warning on the invitation card that no one under the age of eighteen would be admitted, the press was outraged, accusing the Arts Council (who partially sponsor the ICA) of wasting public money. Subsequently COUM were unofficially banned from exhibiting in galleries in England, an achievement equalled by the Sex Pistols the following year, when their records were blacklisted by radio stations.

The precedent of art students turning 'musicians' had been set before this by stars like John Lennon, Bryan Ferry and Brian Eno, and by groups like The Moodies, with their satirical take-off of fifties' moody-blues, and The Kipper Kids, with their sadistic imitation of 'boy scouts', naked from the waist down and drinking whisky, who made regular appearances at such places as the Royal College of Art Gallery and the Garage, in London. In New York, the punk rock club CBGB's was frequented by a young generation of artists who soon founded their own bands and joined the new wave. Alan Suicide (also known as Alan Vega), an artist in neon and electronics, and jazz musician Martin Rev played their 'echo music' at CBGB's, often billed on the same programme as The Erasers, another group of artists turned punk in 1977.

The transition from art to anti-art punk was, for many artists, not absolute, in that they still considered much of their work as artists' performance. The punk aesthetic did, however, have an effect on the work of many performers: Diego Cortez habitually performed in his outfit of leather jacket, slicked back hair and dark sunglasses, while Robin Winters threw marijuana joints at the audience as a preliminary gesture to his *Best Hired Man in the State* (1976), ending the half-hour performance with a mock-suicide. The mood of many of these works was disruptive and cynical; in many ways it came closest to some Futurist performances, in that it rejected establishment values and ideas, claiming art of the future as something completely integrated into life.

This generation of artists in their late twenties, who began performing publicly in 1976 or 1977, clearly had a view of reality and art that was already

SEXUAL TRANSGRESSIONS NO. 5

PROSTITUTION

151 COUM Transmissions, 'Prostitution', at the ICA, London, 1976

quite different from the work of artists only a few years older. Their new style of performance, while reflecting the punk aesthetic, with its anarchistic and overtly sadistic and erotic attitudes, was, at the same time, a sophisticated blend of recent performance precedents with their own life styles and sensibilities. Jill Kroesen's *Preview for Lou and Walter* (1977) at the Artists Space was structured with people, characters and emotions orchestrated in the same way that a composer manipulates timbre and pitch. Despite these formal considerations, the content of the work was decidedly punk-like: it was a tale of a community of hick farmers whose frustration at being prevented from fornicating with the local sheep was relieved by tap dancing. As the 'Share-If' and the 'If Be I' characters tapped out their routine, the androgynous lovers Lou and Walter sang songs such as 'Pederast Dream' or 'Celebrations of S & M', filling in the story line: 'Oh Walter I'm just a little Lou/Oh Walter I'm so in love with you. . . . Oh Walter clench your fist won't you come inside/Oh Walter won't you lacerate my hide.'

Some of the younger generation artists also started using performance in conjunction with film making, painting and sculpture. In New York, Jack Goldstein, a maker of films and unusual records such as 'Murder' and 'Burning Forest', presented a work entitled *Two Fencers* (1978), in which two

152 Robert Longo, *Sound Distance of a Good Man*, 1978

ghostly figures fenced in the dark, their white bodies illuminated by a fluorescent light, to his record of the same name. Robert Longo translated the mood of his 'solid photography' – painted reliefs made from drawings deriving from movie stills – into a performance triptych, *Sound Distance of a Good Man*. A seven-minute work set against a wall and presented on stepped platforms, it brought together three statuesque images recalling Longo's wall reliefs: two muscular wrestlers clinched under a spotlight on a slowly revolving disc on the viewers' left, and a white-clad female figure sang an extract from an opera on the right, while a film of a man's head (bearing an uncanny resemblance to the film extract from which one of the painted reliefs was made) against a statue of a lion, held the centre 'panel'.

The performance fringe

During the seventies, while a considerable number of younger artists went straight from art school into performance as their chosen medium, an increasing number of playwrights and musicians in the United States also worked directly in the performance context, just as the dancers and musicians who dominated the sixties – Terry Riley, Phil Glass, Steve Reich, Alvin Lucier and Charlemagne Palestine, for example – had done. Young performers using music as the main element of their work, such as the

184

'classically' oriented Connie Beckley, or 'New Wave' groups such as Peter Gordon and his Love of Life Orchestra, The Theoretical Girls or the Gynecologists, also appeared at performance art venues like the Kitchen and Artists Space.

Meanwhile, in another area, the grand spectacles of Robert Wilson and Richard Foreman showed how far some of the current ideas in performance could be taken when presented on a larger scale. Wilson's twelve-hour *The Life and Times of Sigmund Freud* (1969), *The Life and Times of Joseph Stalin* (1972), *A Letter for Queen Victoria* (1974) and *Einstein on the Beach* (1976) drew 154,155 largely on artists and dancers for the cast (his work in theatre and dance having been enriched by his background in art and architecture), resulting in mammoth works – real Wagnerian *Gesamtkunstwerke*. Foreman's Ontological-Hysteric Theater (given in his own downtown Broadway loft) reflected performance art preoccupations as well as the avant-garde theatre.

While performances were usually one-off, brief events, minimally rehearsed and lasting from about ten to fifty minutes, the ambitious works of Wilson and Foreman went through several months of rehearsal, ran from at least two hours to as long as twelve, in the case of Wilson, and had repeat performances over several months. Such works represented a development of American experimental theatre from The Living Theatre and The Bread and Puppet Theatre and showed the influences of Artaud and Brecht (in the productions of Foreman) or Wagner's music dramas (in those of Wilson), having also assimilated ideas from Cage, Cunningham, new dance, and performance art. The work of what is called here the performance fringe was a synthesis of these streams.

Termed 'The Theatre of Images' by the New York critic Bonnie Marranca, the performance fringe was non-literary: a theatre dominated by visual images. The absence of straightforward narrative and dialogue, plot, character and setting as a 'realistic' place, emphasized the 'stage picture'. Spoken words focused on the manner of presentation by the performers and on the perception of the audience *at the same time*. In *Pandering to the Massses: A Misrepresentation* (1975), Foreman's taped voice spoke directly to the audience making sure that each section was 'correctly' interpreted as it occurred. Similarly, in his *Book of Splendors: Part Two (Book of Levers) Action* 153 *at a Distance* (1976), the action was performed and interpreted simultaneously. As the leading lady, Rhoda (Kate Manheim), moved from sequence to sequence, her taped voice asked questions the author would no doubt ask himself while writing: 'Why do I surprise myself when I write, and not when I speak?' 'How many new ideas can you put at one time into your head?', to which she would reply: 'It isn't new ideas, but new places to put ideas.'

This *place* was Foreman's unusual theatre. In his preface to *Pandering to the Masses*, he wrote: 'The play evolved over its two months of rehearsal in such

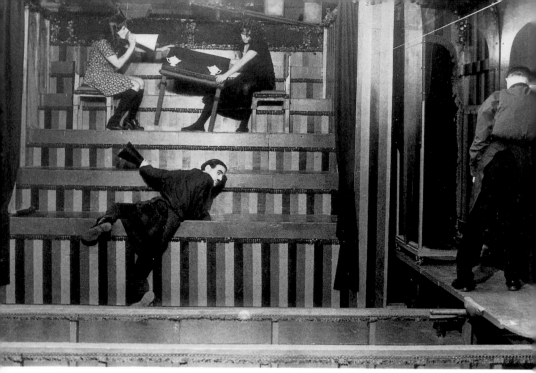

153 Richard Foreman, *Book of Splendors: Part Two (Book of Levers) Action at a Distance*, 1976

a way that certain features grew out of the rather unusual performance space of the Ontological-Hysteric Theater's loft'. This consisted of a narrow room, the stage and audience area both being only fourteen feet wide. The stage itself was seventy-five feet deep, the first twenty feet being at floor level, the next thirty feet running at a steep rake, finally levelling off at about a six-foot height for the remaining depth. Sliding walls entered from the side of the stage, bringing about a series of rapid alterations to the space. This specially constructed space determined the pictorial aspect of the work: objects and actors appeared in a series of stylized tableaux, compelling the audience to view each movement within the picture-frame of the stage.

These visual tableaux were accompanied by 'aural tableaux': sound blasting from surrounding stereo speakers. Foreman's overlaying of taped voices and sound with the action attempted to penetrate the consciousness of the audience – the voices that filled the space were the author thinking aloud, as it were. These clues to the intentions behind the work – presented within the work – were meant to trigger off similar unconscious questioning in the audience. In this way, the Theatre of Images gave considerable importance to the *psychology* of making art.

Robert Wilson used the personal psychology of an autistic teenager, Christopher Knowles, as material in his productions. Having collaborated with Knowles over many years, Wilson seemed to associate his extraordinary fantasy world and use of language with preconsciousness and innocence. Moreover, Knowles's language was remarkably close to the 'words–in–freedom' so admired by the Futurists, and suggested a style of dialogue to Wilson. So instead of regarding Knowles' autism as an obstacle to expression in a normal world, Wilson used the phenomenology of autism as aesthetic material.

The texts of Wilson's productions were written in collaboration with the company, including misspellings, incorrect grammar and punctuation as a means to disregard the conventional use and meaning of words. The spoken sections were intentionally irrational, or conversely, as 'rational' as any unconscious thought. So, for example, a passage from *A Letter for Queen* 154 *Victoria* read:

1. MANDA SHE LOVE A GOOD JOKE YOU KNOW. SHE A LAWYER TOO
2. LET'S WASH SOME DISHES
1. WHAT DO YOU DO MY DEAR?
2. OH SHE'S A SOCIAL WORKER
1. NICE TRY GRACE
2. MANDA THERE ARE NO ACCIDENTS

(Act 1, Section 2)

154 **Robert Wilson.** *A Letter for Queen Victoria,* 1974

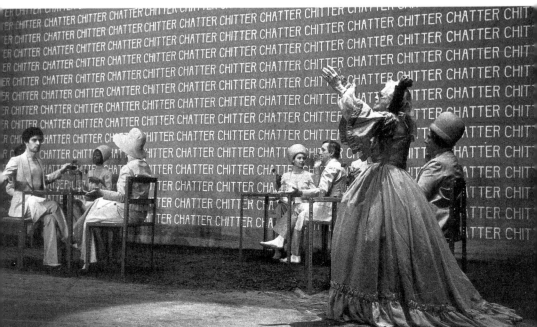

Performers were referred to by numbers rather than names, and objects often appeared (water tank, rock, lettuce, crocodile) which seemingly had no relationship to the action on the stage. The works had no beginning or end in the conventional sense, but were a series of oneiric or free association declamations, dances, tableaux and sound, each of which might have its own brief theme, but which did not necessarily relate to the next. Each section served as an image, as a medium through which the playwright expressed a particular sensibility whose starting point might or might not be evident to the audience. For example, in his preface to *Queen Victoria*, Wilson noted that the work emerged 'from something that I saw and something that somebody said'. He described the sources for the thematic material as well as for the visuals, explaining that his first decision to base the 'architecture' of the stage on diagonals was confirmed in two random circumstances. First he had seen a photograph of Cindy Lubar, 'wearing a piece of muslin draped in a triangular shape with a hole cut out for her head. It looked like an envelope.' Wilson saw this as a set of diagonals, imposed on a rectangle. Then somebody mentioned a shirt-collar in conversation, which he realised had the same shape as an envelope. The stage was accordingly divided into diagonal sections and the actors performed along those diagonals in the first act. The title and opening lines of the production came from a copy of a letter actually sent to Queen Victoria ('I liked it because it was nineteenth century language'): 'Albeit in no way possessed of the honour of an introduction, and indeed infinitely removed from the deserving of it, yea, singularly unfit for exposure to the brilliance of your sun . . .'

Einstein on the Beach, first presented in July 1976 at the Festival d'Avignon and then at the Venice Biennale and on an extensive European tour (but not in England), was finally given at the Metropolitan Opera House in New York. It derived from conversations and images which had been brewing in Wilson's mind for some time and expressed his fascination with the effect of Einstein's relativity theories on the contemporary world. A spectacle of extraordinary proportions, the five-hour production brought together the musician Philip Glass and his company, the dancers Lucinda Childs and Andrew deGroat (who choreographed the work), Sheryl Sutton and many others, all of whom worked with Wilson from the scripting stage. Elaborate sets depicted a surrealist castle, a courtroom, a railway station, and a beach, with towers, an enormous beam of light that hung over the centre stage at one point, and a science fiction 'factory' with flickering lights and computer symbols. They were all designed by Wilson himself. Glass's extraordinary music, which was partly electronic, contributed to the overriding continuity of the work, while one of Childs's dance sequences, where she paced stiffly up and down the same diagonal for over half an hour, mesmerized the audience.

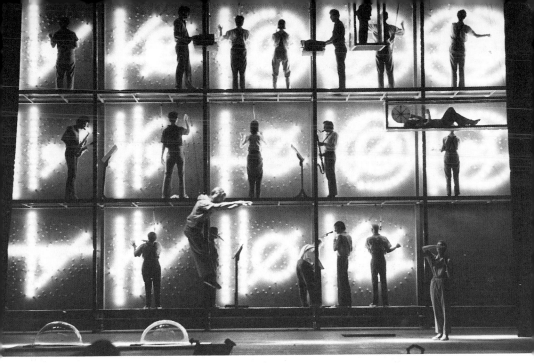

155 The final setting of Wilson's *Einstein on the Beach*, 1976

Both works were described by Wilson as operas, and his 'unification of the arts' in these productions represented a modern counterpart to Wagner's aspirations. They brought together the talents of some of the most inventive art performers, also using the more 'traditional' media of theatre, film, painting and sculpture. His 1977 work *I Was Sitting on my Patio This Guy Appeared I Thought I Was Hallucinating* is a more compact and spare one, eschewing the extravagance of the earlier 'operas'. Nevertheless, the performance fringe, while hovering between artists' performance and avant-garde theatre, was the product of both.

At the same time, the extremely elaborate and large-scale requirements of enterprises such as Wilson's made his work appear far more traditional than most performance art. Indeed, if its scale was symptomatic of the increased importance of performance by the end of the seventies, this overtly theatrical aspect also indicated a new direction for the eighties. Not only did Wilson himself direct theatrical works using pre-existing texts, as in his opera with composer Gavin Bryars of Euripide's *Medea* (1981), or in Heiner Muller's *Hamlet Machine* (1986), but the text itself began to play a significant but still somewhat abstruse role in his new productions. Wilson stated that his intentions were to reach a broader audience, to create works 'on the scale of large popular theater'.

The media generation

By 1979, the move of performance towards popular culture was reflected in the art world in general, so that by the beginning of the new decade the proverbial swing of the pendulum was complete; in other words, the anti-establishment idealism of the sixties and early seventies had been categorically rejected. A quite different mood of pragmatism, entrepreneurship and professionalism, utterly foreign to the history of the avant garde, began to make itself apparent. Interestingly enough, the generation that created this about-turn mostly comprised students of conceptual artists who understood their mentors' analysis of consumerism and the media but broke conceptual art's cardinal rule, of concept over product, by turning from performance and conceptual art to painting. The new paintings were often quite traditional – many were figurative and/or expressionistic in content – even though they were sometimes also filled with media imagery. Responding to this accessible and bold work, a few gallery owners and their newly affluent clients, as well as the occasional public relations team, insinuated a new, very young generation of artists into the art market; within a few years, by 1982, some artists were transformed from struggling unknowns into wealthy art stars. Thus the eighties art world, in New York in particular, was criticized for its disproportionate attention to 'hype' and the commercial business of art.

The artist-as-celebrity of the eighties came close to replacing the rock star of the seventies, although the artist's mystique as cultural messenger suggested a more establishment role than the rock star had played. Indeed, this return to the bourgeois fold had as much to do with an overwhelmingly conservative political era as it did with the coming of age of the media generation. Raised on twenty-four-hour television and a cultural diet of B movies and 'rock 'n roll', performance artists in the 1980s interpreted the old cry to break down barriers between life and art to be a matter of breaking down barriers between art and the media, also expressed as a conflict between high and low art. One major work that made a landmark crossing of these 156 borders was Laurie Anderson's *United States*, an eight-hour opus of song, narrative and sleights of hand and eye, presented at the Brooklyn Academy of Music in 1982 (it was actually an amalgam of short visual and musical stories created over six years). *United States* was a flattened landscape that the media evolution had left behind: projected hand-drawn pictures, blown-up photographs taken from TV screens and truncated film formed operatic-size backdrops to songs about life as a 'cloooosed circuit'. She sung and spoke a love song 'let $x = x$', through a vocalizer that made her voice sound like a robot's suggesting a melancholy splicing of emotions with technological know-how. 'O Superman', a song at the heart of the show, was an appeal for help against the manipulation of the controlling media culture; it was the cry of a generation exhausted by media artifice.

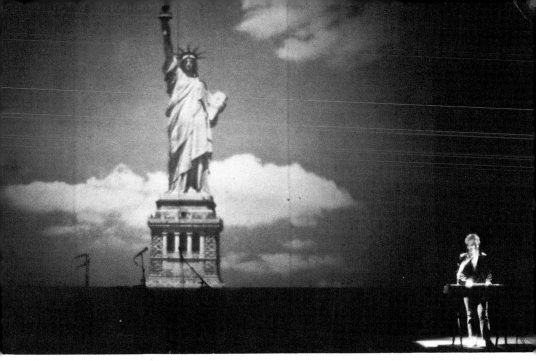

156 Laurie Anderson, *United States Parts 1 and 2*, at the Brooklyn Academy of Music, 1980

Anderson's endearing stage presence and her obsession with 'communication' were qualities that enabled her to reach the broadest possible audiences. Indeed, in 1981 she had signed up with Warner Brothers (USA) for a six-record contract so that, as far as the public was concerned, *United States* marked the beginning of the 'coming out' of performance into the mass culture. For although by the end of the seventies performance had been accepted as a medium in its own right by the institutional heirarchy of the art world, in the early eighties it moved into the commercial world.

Two other artists in New York set precedents for this transfer: Eric Bogosian and Michael Smith both began as comic acts at the end of the seventies in Lower Manhattan's late-night clubs, and both within five years successfully appeared on the 'other side' while retaining the always paradoxical title of performance artist. In addition, their early achievement encouraged the many disco clubs that opened over the next five years to feature performance as nightly entertainment and thus they spawned a new genre: artists' cabaret.

Eric Bogosian, a trained actor performing in the art context, began in the tradition of solo performers, taking Lenny Bruce, Brother Theodore and Laurie Anderson as his models. He created a series of characters that stepped out of radio, TV and cabaret scripts of the fifties; beginning in 1979 with

'Ricky Paul' – a belligerent, macho entertainer with a twisted, old-fashioned dirty humour – he added new portraits that by the mid-eighties comprised a picture gallery of American male types: angry, often violent or hopelessly subdued. Presented in powerful solo performances with titles such as *Men Inside* (1981) or *Drinking in America* (1985/6), they were a cumulative diatribe against an uncaring society. As much concerned with form as with content, Bogosian's portraiture took the best from performance, its imagistic focus and appropriations from the media which were fashionable at the time, and matched them with the finesse and confidence of the highly skilled actor. His approach was to 'frame' each character, emphasizing the clichés and conventions of manipulative acting techniques, while at the same time setting up stark, isolated 'pictures' that reflected the similar concerns of his fine-art peers. This combination, as with Anderson, attracted attention beyond a downtown New York following so that by 1982 Bogosian, as both writer and actor, had acquired producers, the following year a prestigious company of agents, and the year after that, film and TV contracts.

Michael Smith's transfer was not as complete as Bogosian's, but he was an early example of the performance artist/entertainer that, in many different forms, characterized the general direction of the art in the early eighties. With his stage persona Mike, Smith worked on the edge between performance and television, making video tapes and performances that were a combination of both. In *Mike's House* (1982), presented at the Whitney Museum, a TV studio was constructed – complete with actor's dressing room and kitchenette – the centre of which was a 'living room'. Rather than perform in person, Smith appeared in a half-hour tape on the 'living room' TV; *It Starts at Home* showed Mike on the telephone to his obnoxious 'producer' Bob (actually Bogosian's voice), discussing the possibility of a major TV comedy show.

157 *Opposite*: Ann Magnusson, *Christmas Special*, performed at The Kitchen Center, New York, 1981

158 Eric Bogosian in an early cabaret performance as 'Ricky Paul' at the short-lived Snafu Club, New York, August 1980

159 Karen Finlay strains against urban domesticity in *Constant State of Desire*, a solo theatrical performance at The Kitchen Center, New York, 1986

160 Tom Murrin in his *Full-Moon Goddess*, a fast-paced act of less than ten minutes, using 'found-on-the-street' material for his costume; performed at PS122, New York, 1983

This picture of a performance artist dreaming of becoming a celebrity in the media world, perfectly captured the ambivalence of the performance artist: how to make the crossover without losing the integrity and the protection – to explore new aesthetic territory – of the art world. Not that being discovered by the media was the only goal of the new performance entertainers who featured nightly at downtown Manhattan's East Village clubs such as The Pyramid, 8 BC, The Limbo Lounge or the Wow Café, and the East Village's own 'institutional' showcase, PS 122 (the main presenters of artists' cabaret between 1980 and 1985). Rather, these artists chose to break new ground at a distance from the more established venues and performers. They made rough, quickly sketched works that explored the edges between television and real life, without suggesting that they were ready for either. Post-punk media scavengers and mass culture connoisseurs, they created their own version of art cabaret with some old-fashioned pizazz from favourite TV and vaudeville shows, touched here and there with a little seediness that sufficed for parody.

Despite the odds of working in settings where there were few guarantees of an attentive audience, and the fact that the clubs were trying to make profits, which put pressure on the artists to actually succeed in their mission to attract general audiences, many artists made riveting work. John Kelly created mini dramatizations of the artist Egon Schiele's angst-ridden biography; Karen Finlay defied the passivity of her audiences with threatening themes of sexual excess and deprivation; and Anne Magnusson appeared as various TV soap-opera stars. Others, like The Alien Comic (Tom Murrin) and Ethyl Eichelberger, came from years of experience in experimental theatre to use the raw, energetic venues for their new work. Murrin's comic was a fast-paced story-teller of East Village sagas, while Eichelberger took the drag act beyond its preoccupation with transvestism into the realm of romance and satire with his collection of hysterical, historical divas from Nefertiti and Clytemnestra to Elizabeth 1, Carlotta of Mexico and Catherine the Great. Indeed, for many the particularities of club performance provided useful limits: the result was work that was unusually sharp in its focus and lucid in its execution.

John Jesurun, a film maker, sculptor, and former TV production assistant, benefited from just such a setting; he thrived on the 'real circumstances' (a commercial club) and on the 'real' audience that were, like himself, members of the media generation. His *Chang in a Void Moon* (June 1982–83) was a 'living film serial', presented in weekly episodes at The Pyramid Club, which used staging techniques adapted from movies: camera pans, flashbacks or jumpcuts. Jesurun did not simply take out pictures from the media or hold up fine art to the cultural mainstream. Rather, he stepped right inside film and television, opposing the realities of celluloid and flesh and blood or, as Jesurun

159
157

160

194

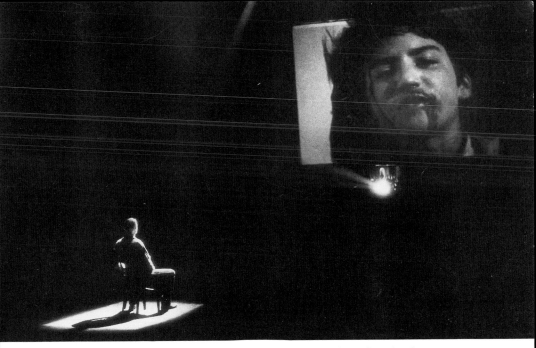

161 John Jesurun's high-tech theatre disturbs the boundaries between the media and real life. In *Deep Sleep*, performed at La Mamma, New York, in 1986, a young boy is imprisoned in film, never to return to the flesh

put it, 'the juxtaposition of truth-telling and lie-telling'. In *Deep Sleep* (1985), 161 for example, four characters began on stage while two appeared larger than life on screens suspended at either end of the performance space. One by one, each was drawn onto the film, like genies through the lip of a bottle, until a solitary figure remained to tend and maintain the projector. In *White Water* (1986) live actors and 'talking heads', on twenty-four closed-circuit monitors surrounding the audience, engaged in a ninety-minute verbal battle over illusion and reality. Timed like the 'tick-tock' of a metronome so that live and recorded dialogue inter-wove perfectly, Jesurun's 'video theatre' was an important indicator of the time; for its high-tech drama was as much an example of the prevailing media mentality as of the new theatricality of performance.

Towards theatre

By the mid-eighties, the overwhelming acceptance of performance as fashionable and fun 'avant-garde entertainment' (the mass circulation *People Magazine* called it *the* art form of the eighties) was largely due to the turn of performance towards the media and towards spectacle from about 1979 onwards. More accessible, the new work showed attention to décor –

195

costumes, sets and lighting – and to more traditional and familiar vehicles such as cabaret, vaudeville, theatre and opera. On large or small scales – in an opera house such as the Brooklyn Academy of Music or on an intimate, 'open stage' such as London's Riverside Studios – dramatization of effects was an important part of the whole. It is interesting that performance came to fill the gap between entertainment and theatre and in certain instances actually revitalized theatre and opera.

Indeed, the return to traditional fine arts on the one hand, and the exploitation of traditional theatre craft on the other allowed performance artists to borrow from both to create a new hybrid. The 'new theatre' gained the licence to include all media, to use dance or sound to round out an idea, or splice a film in the middle of a text, as in Squat Theater's *Dreamland Burns* (1986). Conversely, 'new performance' was given the licence to acquire polish, structure and narrative, as in James Neu's *Café Vienna* (1984) which, in addition to its unusually layered stage (peeled back, wedge by wedge as the action progressed), had a fully-fledged script as its most unusual aspect. Other works, including Spalding Grey's autobiographical tours of landscapes from his past, such as *Swimming to Cambodia* (1984), and his and Elizabeth Le Comte's *Trilogy* (1973–), initially presented at The Performing Garage (an experimental theatre), were later seen as often on the performance as on the theatre circuit.

162 Squat Theater's *Dreamland Burns*, 1986, written by Stephan Balint, began with a twenty-minute film depicting a young girl's move into her first apartment, and ended with urban redemption in a 'thriller movie' setting

163 Jan Fabre, *The Power of Theatrical Madness*, 1986, a highly stylized melodrama of eighties romance and sexual violence against backdrop-slide projections of Mannerist paintings

In Belgium, Jan Fabre's highly theatrical performances, such as *This Is Theatre As It Was To Be Expected And Foreseen* (1983) or *The Power of Theatrical Madness* (1986), mixed overtly expressionistic acting with violence, both physical and metaphysical, as well as imagery drawn from artists like Kounellis and Marcel Broodthaers. Highly staged, action-packed, stressful and often repugnant – in one scene in *Theatrical Madness* frogs jumping about the stage were covered with white shirts and then apparently stamped on by the actors, leaving blood-stained linen on stage – Fabre's work was a hybrid of visual cut-outs from performance and climactic portrayals of psychological states culled from literature and theatre.

In Italy, several young artists in their early and mid-twenties had grown up on Fellini, American film and television imports, and frequent appearances of Robert Wilson (whose work was seen far more regularly and completely in Europe than in his native United States), as well as rumour and the infrequent appearances of Laurie Anderson. These new artists were the enthusiastic creators of a genre dubbed Nuova Spettacolarita by the press, or Media Theatre by its proponents. In Rome and Naples where the two most active groups were based (La Gaia Scienza and Falso Movimento), the spectacles of the cities themselves formed the backdrop to their early work. Falso Movimento, formed in 1977, first created short events and installations that were concerned with language and film and which were in line with a

seventies aesthetic. By 1980, they too had swung emphatically towards theatre, using the proscenium stage as a wide panorama for their 'metropolitan landscapes', with media references of all sorts. Intent on 'turning the stage itself into a screen', *Tango Glaciale* (1982), lasting an hour, used several different styles within a single theatrical space (representing the different levels and parts of a house, swimming pool and garden included). From classical Greek references to a mock-romantic sequence in which Gene Kelly's sailor from *On the Town* played next to Robert de Niro's saxophonist from *New York, New York*, their work was intended to establish contemporary archetypical imagery within the large frame of the stage. *Otello* (1984), a work with the composer Peter Gordon, had as its starting point Giuseppe Verdi's opera rather than Shakespeare's text. But the performance resembled neither. Only Gordon's score elaborated on its historical precedent, taking the folk elements of the earlier composer to splice his melodies with large acoustic effects and electronic collages in a dazzling concoction of old and new sounds. The changing imagery was as filmic as ever: this time, *Casablanca*, Fassbinder's *Querelle* and Fellini's *Amacord* were mined for evocative pictures.

La Gaia Scienza, equally enthusiastic in its collaborations and in its eclectic references to film, architecture, dance and recent performance art, was more choreographically oriented than Falso Movimento. Mime and mechanistic, puppet-like movement, trompe l'œuil costumes, outsized props and orchestrated lighting design, as well as sets that turned themselves inside out, created the basis for their visual theatre. *Cuori Strappati* ('Torn Hearts', 1984), an hour-long work, with music by Winston Tong and Bruce Geduldi, was a theatrical play on film strips and silent-movie slapstick.

Likewise, major European centres witnessed a burgeoning of performance-theatre. Artists responded to the thoroughly open-ended medium of performance, and took courage from what was then an acceptable introduction of theatrical elements which made it possible to reach a wider audience. In Poland, Akademia Ruchu, its seven members influenced by the seminal political and expressionistic work of Tadeuz Kantor in the 1970s, also produced theatrical performances. Understandably less touched by the media than their contemporaries in other countries, Akademia Ruchu nevertheless displayed a sense of European film history, matching ideas and motion. In the West, they appeared at the Almeida Theatre, London, in October 1986 with two pieces, *Sleep* and *Carthage*. In Spain, on the other hand, La Fura dels Baus has blossomed in the recently liberated political setting. Comprising twelve actors, including painters, musicians, professional and inexperienced performers, it has produced works such as *Suz o suz* (1986) and *Accions* (1986) which explore daring and provocative bacchanalian scenes of violence, death and the after-life, reminiscent of great

164

164 Falso Movimento, *Otello*, first performed at the Castel S. Elmo in Naples, 1982. It was a 'mediatheatre' tribute to the opera by Giuseppe Verdi, which turned the stage into a screen, with photographs, film and sets within sets

seventeenth-century Spanish paintings in their dramatic landscapes and religious intensity, and with faint traces of Surrealist film images such as those of Buñuel's. Arianne Minuschkin and Théâtre Soleil in France, so provocative in the 1970s, have been re-inspired by performance in the 1980s, and the group Epigonen in Belgium have made an equally dynamic impact.

Thus, the division between traditional theatre and performance became blurred, to the extent that even theatre critics began to cover performance, though until 1979 they had almost totally ignored it, leaving its reviewing to fine arts or avant-garde music critics. Nevertheless, they were forced to acknowledge that the material and its applications had emerged from performance art and that the playwright/performer was indeed trained as an artist. For there was no comparable movement in current theatre to which the energy of the new work could be attributed. Likewise, there had been no revolution within opera to suggest that the impetus for the many new operas, with their bold visual architecture and intricate new music, had come from a source other than performance's recent history.

For it was Robert Wilson and Philip Glass's *Einstein on the Beach* (1976) that 155 by the eighties had inspired several new operas and large-scale *Gesamtkunstwerke*, beginning with Glass's own *Satyagraha* (1982) and *Akhnaten* (1984), both directed and staged by the Stuttgart Opera House's dynamic director Achim Freyer. The latter two and *Einstein* were presented by the same director as a trilogy in 1987. Bob Telson and Lee Breuer's revival of Greek tragedy, in *Gospel at Colonus* (1984), was interpreted as a song-filled, 167

hand-clapping, glorious gospel meeting; the controversial story of Malcolm X was told in dramatic song by the new-music composer Anthony Davis in his production of *X* (1986). In a quite different vein, Richard Foreman created his own quizzical musical about the eighties, *Birth of a Poet* (1985), in a collaboration with the writer Kathy Acker, the painter David Salle and the composer Peter Gordon. It owed as much to Picabia's *Relâche* – bright lights blinded the audience and performers drove round stage in small golf carts – as it did to the sixties musical *Hair*: protagonists in bell-bottom trousers, long hair and head-bands sang of sex and art, but with the cynicism of the eighties consumer, and in Acker's often obscene prose. *Birth of a Poet* was brilliantly packaged on a stage that changed its appearance approximately every five minutes and was a direct response to the enthusiasm of the eighties for collaborations, indeed for vehicles in which very popular, high-profile artists on the strength of their collaboration could create an exciting event.

While the term opera could not always be applied strictly to these visual-theatre musicals, their opulence was indeed operatic, and they did provide a context for unusual vocal material and renowned opera singers. Robert Wilson's *Great Day in the Morning* (1982), a collaboration with the celebrated American soprano Jessye Norman, was a staged presentation of Negro spirituals. Jessye Norman was set against a series of changing tableaux which were designed, Wilson explained, 'so that the visuals help us hear and the singing helps us see'. By contrast, *The Civil Wars: A tree is best measured when it is down* (1984), with Philip Glass and other composers and David Byrne of

165 A scene from Robert Wilson's *The Civil Wars: A tree is best measured when it's down*, 1984; the Rotterdam section

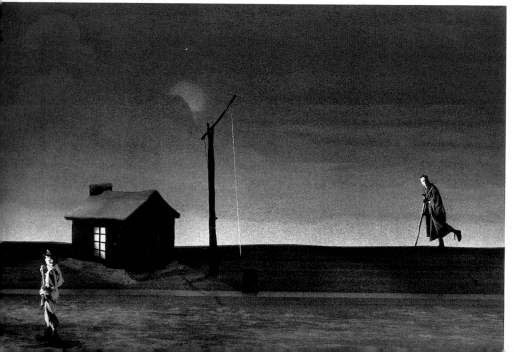

166 Richard Foreman's *The Birth of the Poet*, 1985, with its text verging on the obscene, its surrealistic imagery and the voluble audience indignation, suggested the spirit of Picabia's *Relâche*

167 Bob Telson and Lee Breuer's *Gospel at Colonus*, 1984, married classical theatre with the powerful form and song of American gospel

Talking Heads, was a grand opera; conceived as a twelve-hour spectacle whose separate parts were designed for and reflected the contributions of five nations (Holland, Germany, Japan, Italy and the United States), it was intended for the Olympic Arts Festival in Los Angeles. Although it has never been performed all together, its individual parts presented a monumental picture-book of images from the American Civil War, blended, for example, with contemporaneous photographs of Japanese Samurai warriors. It was a slow-moving visual history-board peopled with men and women the height of buildings, historical characters such as General Lee, Henry IV, Karl Marx and Mata Hari, and animals from the ark – elephant, giraffe, zebra and tiger. Wilson wanted his 'history of the world' to reach a large, popular audience. 'It's meant to be the way rock concerts are', Wilson remarked, recalling his first attendance at a rock concert. 'They are the great opera of our time.'

Dance Theatre

It is not surprising that dance paralleled these developments by moving away from the intellectual underpinnings of the seventies' experiments to work that was both far more traditional and entertaining. With a renewed interest in highly trained bodies, beautiful costumes, lighting and backdrops, as well as in narrative, the new choreographers took what they had learned from the preceding generation and blended those lessons in 'accumulation', natural movement and choreography of geometric patterning with classical dance techniques and recognizable movements appropriated from a broad spectrum of dance. From the seventies, they also retained the practice of working closely with artists and musicians, which meant having elaborately painted sets designed by 'media generation' artists, and rhythmically charged music that was a blend of punk, pop and serial music.

Karole Armitage, trained by Cunningham and Balanchine, typified this extrovert mood. With her long limbs and perfectly tuned body, she joined the musician and composer Rhys Chatham and his 'out of tune guitars' to create a dance piece that captured the sensibility of the moment. *Drastic Classicism* (1980) – a collaboration which included Charles Atlas who was responsible for the décor – was a concoction of punk/new wave aesthetics, with its seedy glamour, pop sophistication and its colour chart of blacks, purples and splashes of phosphorescent green and orange. It was also a balance of classical and anarchistic approaches to both dance and music: dancers and musicians literally clashed on stage, the dancers ricocheting off the musicians who could barely hold their ground though at the same time they beat out a wall of sound and forced the dancers to create 'louder' movements (a mix of Cunningham and Balanchine's) to match the increasing intensity of the music. Similarly, Molissa Fenley pulled dance from its minimal aesthetics

168 Karole Armitage, *Drastic Classicism*, 1980, with Rhys Chatham

169 Molissa Fenley's combination of high speed and choreography based on the shape of the body is seen here in *Hemispheres*, 1983

directly into the eighties with impossibly fast, non-stop motion designed for bodies trained like hers – equally gymnast and dancer – in works such as *Energizer* (1980), a whirlwind discourse on the placement of arms, heads and hands. In *Hemispheres* (1983), she appropriated from an image-bank of dance 169 movements that suggested an Egyptian hieroglyph or a frieze of Greek warriors; palms were turned up as in Indian classical dance, or an elbow was crooked as in a Balinese curtsey, while a hip movement might recall a popular samba. Overlayed with music specially composed by Anthony Davis, Fenley's *Hemispheres* (referring to the brain), set out to be a reconciliation of opposites: present and past, analytical and intuitive, classical as well as modern. The sheer physicality of the work made it both demanding for the dance specialist and delightful for a larger audience.

For Bill T. Jones and Arnie Zane, another way to reach the general audience was by breaking yet one more seventies taboo, that of partnering. The cornerstone of classical dance, they sought to give the *pas de deux* new form, and their own partnership provided the key: tall, with a bone structure chiselled like an African wood sculpture, Jones stood a foot above Zane, who in both personality and shape suggested a Buster Keatonish character out of

170 Bill T. Jones and Arnie Zane's *Secret Pastures*, 1984, with Jones as the creature created by the mad professor (Zane), was indicative of a return to narrative and décor in dance of the 1980s

vaudeville. Jones was a highly trained and lyrical dancer and Zane a photographer who turned dancer when he was 25. Their combined choreography was one of movement design and elaborate theatrical effects, while the relationship that their partnering suggested gave their early
170 material an intimate autobiographical character. Works like *Secret Pastures* (1984), however, transcended the personal: it had a company of fourteen dancers; a narrative involving a mad professor and his monkeys on a beach strewn with palm trees, created by the media artist Keith Haring; a zany, circus-like score by Peter Gordon and highly styled clothing by the designer Willi Smith. With these accoutrements it crossed the High–Low bridge linking avant-garde diversity with accessible American modern dance, such as that of Jerome Robbins or Twyla Tharpe. For these choreographers, 'informing popular culture' was an important goal, 'not pop culture informing us', they argued, and *Secret Pastures* laid vivacious claim to being an example of avant-garde pop.

Many dancers, on the other hand, continued to work with the more esoteric guidelines established by the preceding generation, even though they too added costuming, lighting and dramatic themes to their creations. Ishmael Houston Jones used improvization as a key choreographic motif in works such as *Cowboys' Dreams and Ladders* (1984), which he created with the artist Fred Holland; Jane Comfort in *TV Love* (1985) used her signature repetitions, and her fascination for language as the rhythmic undercurrent to her dance, in a parody of TV chat shows. Blondell Cummings in *The Art of War/9 Situations* (1984) mixed silence and sound, gestures, video and pre-

recorded texts in semi-autobiographical, intimate dances that illuminated aspects of black culture and feminism, while referring to a book of the same title written in the 6th century BC. Tim Miller re-created vignettes from his youth, such as *Buddy Systems* (1986), where dance was used to punctuate or defuse emotional states or to link one body gesture to another. Stephanie Skura, by contrast, covered all dance territory in parodies of its recent history: *Survey of Styles* (1985) was almost a quizz show, with movements mimicked from seventies and eighties choreographers as the subjects of her guessing game.

The ultimate dance theatre was that of Pina Bausch and her Tanztheater Wuppertal. Taking the permissive vocabulary of the seventies as her yardstick – from classical ballet to natural movements and repetitions – Bausch devised adventures in visual theatre on the scale of Robert Wilson's. These she mixed with the kind of ecstatic expressionism associated with northern European drama (with German precedents such as Bertoldt Brecht, Mary Wigman and Kurt Joos), thus introducing dramatic and compelling theatre that was also dramatic and visceral dance. Just short of being actual narratives (although words were often shouted by one dancer or another), Bausch's dance dramas explored in minute detail the dynamics between women and men – ecstatic, combative and eternally interdependent – in various body languages determined by the strikingly individual members of her company. The women – long-haired, powerful and exotic, and in many different shapes and sizes – and the men – just as varied in bulk and appearances – made movements that were repetitive, obsessive and

171 Pina Bausch's *Kontakthof*, 1978, had men and women in line formation as part of a repetitive choreography that was an elaborate essay of everyday self-conscious gestures

fastidious. They were played out over long hours as behavioural discourses between the two sexes. Walking, dancing, falling, strutting or just sitting, women and men held and shoved, caressed and tortured one another in extraordinary settings. In *Auf dem Gebirge hat man ein Geschrei gehört* ('On the mountain a cry was heard', 1984), the stage was inches thick in dirt. In *Arien* 171 (1979), it was inches deep in water. In *Kontakthof* (1978), a high-ceilinged dance hall was the setting for mesmerizing choreography constructed from closely observed gestures of self-conscious men and women; straighten tie/straighten bra strap, pull down jacket/check petticoat, touch eyebrow/adjust lock of hair, and so on, until the cycle of movements, endlessly and rhythmically repeated, first by the women, then by the men, and together in various combinations, created its own dazzling momentum.

With a ritualistic intensity that recalled European body art of the sixties, and with symbolism ascribed to materials like earth and water, Bausch's dance theatre was the antithesis of the media-conscious work emanating from the USA. Slow, penetrating, almost funereal, in browns, blacks, creams and greys, her dances eschewed easy accessibility and instant pleasures. Equally timeless and tirelessly physical was the Japanese dance theatre Butoh, an almost untranslatable term that 'black dance or step' approximates. It was a dance form of slow-motion movements and exaggerated gestures, sometimes juxtaposed with incongruously shocking music or performed in utter silence. Austere and mysterious, the Butoh performers' Zen-like goal

172 The Japanese Butoh group, Sankai Juku, in *Kinkan Shonen*, on their visit to New York in 1984

was to achieve spiritual enlightenment through rigorous physical training. They were often naked, skins dusted with white or ashen clay, and the resulting impression given by these still, contorted figures was that they were part fetuses, part bound mummies, thus symbolizing Butoh's chosen subject of the space between birth and death. Intricately tied to ancient Japanese traditions – both priestly, as in the dances of Bugaku, and magically theatrical, as in Noh – exponents such as Min Tanaka, Sankai Juku, and Kazuo Ono in Japan, or Eiko and Komo and Poppo and the Gogo Boys in New York, have in common their fascination with the body as an instrument of transcendental metamorphosis. A work by Sankai Juku called *Jomon Sho* ('Homage to Pre-History – Ceremony for Two Rainbows and Two Grand Circles', 1984), is a seven-part, randomly arranged cycle of life's cataclysmic events. Members of the group first appear as four amorphous balls lowered 172 from the theatre's ceiling and eventually unravel into fully grown men hanging upside down from a rope, which suggests both umbilical cord and noose. Gracious and grotesque – another section, *To Ji* ('Incurable Illness'), has the performers propelling themselves across the stage, limbless in finned sacks – these ritualistic and solemn performances related to a large body of iconic work, both Eastern and Western, that in its powerful physical presence attempted to reveal spiritual elements in the visual landscape.

Live Art

Attempts to commercialize cabaret-style performance were made during the early 1980s by the large television and film companies, particularly in New York but no less in Sydney and Montreal. However, in England performance defiantly retained its manifesto of being live art by fine artists. There, several artists elaborated on Gilbert and George's powerful 'living sculpture' theme, even though their motives were based on a quite different, eighties concern: the role of painting in late twentieth-century art. *The Living Paintings* (1986), 173 a series of works by Stephen Taylor Woodrow, were developed through Woodrow's commitment to live art as the only effective contemporary medium. Hence, living (as opposed to dead) painting comprised three figures attached to a wall; painted in solid grey or black, from hair to shoes and socks, and looking more like a sculptural frieze on a large public building than an actual painting, their startling stillness throughout a six- or eight-hour presentation was broken from time to time, as when one male figure bent at the waist to touch the head of a passer-by. Monumental and yet painterly – the folds of their coats were so thick with paint that they cast shadows like those in a trompe l'œuil painting – these figurative 'paintings' were entirely in keeping with the fine-art preoccupation of the time for isolated, iconic pictures. Raymond O'Daly's *The Conversion of Post Modernism* was equally 2

monumental and poised, and similarly stark in its emphasis on the formalism of painting (in his case, on line drawing as the underlying skeleton of painting). Its eight-hour presentation was intended to emphasize the 'stillness of painting and drawing' and to give a sense of a painting 'always being there, on the wall'. As part of the same Living Art Festival at the Riverside Studios, London, in the summer of 1986 where Woodrow's figures appeared, O'Daly's tableau comprised two white-clad figures, 'outlined' in black, who were draped round a styrofoam horse, the positioning of which was based on Caravaggio's *The Conversion of Saint Paul*. In addition, O'Daly's title, also after Caravaggio, was an ironic reference to what he considered to be the para-religious conversions by artists and critics alike to the currently fashionable school of post modernism.

Equally disdainful of the symbiotic relationship between painting and commerce, and of the direction of performance away from art towards theatre and cabaret, was Miranda Payne, a third participant in the Living Art Festival. Payne's main intention was to highlight the process of making a painting; putting herself on a wall in a gallery was an emphatic way of bringing attention back to performance in the art context, while protesting against the object-for-sale attitude that had superseded the experimentation of the seventies. *Saint Gargoyle* (1986), whose title was inspired by looking up at saintly figures perched high on pillars in a church, was an hour-long 'demonstration' of a painting. Beginning with a blank wall, a cardboard box in hand, she proceeded to hang the tools of her trade (scissors, knives, a hammer) on hooks and to unravel a photograph of a painting that, once pinned to the wall, she then 'entered'. Perched on a mounted pedestal, she enacted the paradoxical and often absurd role of the figure in the painting.

Active painters and action paintings, these works were explicit in their exploration of paintings as live, visual objects hanging on a wall, and implicit

174

173 Stephen Taylor Woodrow's *The Living Paintings* were hung on a wall, over the heads of visitors to the 'Living Art' festival, Riverside Studios, London, August, 1986

174 Miranda Payne hangs from a wall in her work *Saint Gargoyle*, performed at the 'Living Art' festival, Riverside Studios, London, August 1986

in their analysis of the overwhelming return to painting. Thus, artists insisted on returning performances to the art context, away from its more theatrical and pop departures. In England and elsewhere, however, many artists ignored both tendencies and continued to make diverse works based on those of the seventies (Anne Bean and Paul Burwell with their Bow Gamelan (music made of found objects and sounds, like firecrackers), or Sylvia Ziranek with her stylish solos on the art of speaking English, or Anne Wilson and Marty St James with their duet on the couple's life).

The apparent adoption of performance by the popular media in the eighties led many to question whether performance could retain its anarchic ways, and still function as a catalyst to shape new ideas in fine art. For performance had reached a peak of acceptance, with major annual festivals, specialist magazines and art-school curricula that charted its course. In 1986, a rather crass Hollywood movie even featured a 'performance artist' and her Hollywood-style performances (she lit small fires, in a large loft, while moaning and writhing), as the underlying theme of a not very interesting art-world thriller. Moreover, performance's recent history was shaped by the fact that numerous artists worked exclusively in performance, unlike previous periods when it was typical for artists to use performance as an experimental stepping-stone to mature work in painting or sculpture. They built up a body of work over twenty-five years or more, and made new productions that did indeed show the evolution of their thinking over such a lengthy period. Thus it became possible and desirable for these recent 'masters' of performance to actually present retrospectives, of masterpieces and minor works alike, for serious art-historical review. Correspondingly, the new discipline of performance history, even though limited to a handful of art history graduates and their unorthodox teachers, suggested that new work must from then on be viewed in the academic light of recent revelations about performance history – a scrutiny it had thus far escaped. There were some who felt that performance could never again be as innocent as the utopian manifestos of the Futurists or the dare-devil provocations of the Surrealists, that in fact there was 'no new thing under the sun.'

But performance has one overriding and peculiar character, which is that it still can be anything at all: for the artist, it represents the possibility of working without rules and guidelines. Its history is like a series of waves; it has come and gone, sometimes seeming to be rather obscure or dormant while different issues have been the focus of the art world. When it has returned it has looked very different from its previous manifestation. Thus performance still has its customary role; for the extraordinary range of material in this long, complex and fascinating history demonstrates that it continues to defy easy definition, and that it will always be a means to break through any limits or conventions imposed on art activity.

Select Bibliography

Chapter 1: Futurism

APOLLONIO, Umbro, ed. *Futurist Manifestos*. London and New York, 1973

CARRIERI, Raffaele. *Futurism*. Milan, 1963

CLOUGH, Rosa Trillo. *Futurism – the Story of a Modern Art Movement. A New Appraisal*. New York, 1961

CRAIG, Gordon. 'Futurismo and the Theatre', *The Mask* (Florence), Jan. 1914, pp. 194–200

Futurism and the Arts, A Bibliography 1959–73. Compiled by Jean Pierre Andreoli-de-Villers. Toronto, 1975

Futurismo 1909–1919. Exhibition catalogue. Royal Academy of Arts, London, 1972–3

KIRBY, E.T. *Total Theatre*. New York, 1969

KIRBY, Michael. *Futurist Performance*. New York, 1971

Lacerba (Florence), Pubd 1913–15

LISTA, Giovanni. *Théâtre futuriste italien*. Lausanne, 1976

MARINETTI, Filippo Tommaso. *Selected Writings*. Ed. R.W. Flint. New York, 1971

MARINETTI, Filippo Tommaso. *Teatro F.T. Marinetti*. Ed. Giovanni Calendoli (3 vols). Rome, 1960

MARTIN, Marianne W. *Futurist Art and Theory, 1909–1915*. Oxford, 1968

RISCHBIETER, Henning. *Art and the Stage in the Twentieth Century*. Greenwich, Conn., 1969

RUSSOLO, Luigi. *The Art of Noise*. New York, 1967

TAYLOR, Joshua C. *Futurism*. New York, 1961

Chapter 2: Russian Futurism and Constructivism

Art in Revolution: Soviet Art and Design Since 1917. Exhibition catalogue. Arts Council/Hayward Gallery, London 1971

BANHAM, Reyner. *Theory and Design in the First Machine Age*. London, 1960

BANN, Stephen, ed. *The Tradition of Constructivism*. London, 1974

BARR, Alfred H. Jr. 'The "LEF" and Soviet Art', *Transition* (New York), no. 14, Fall 1928, pp. 267–70

BOWLT, John E. *Russian Art 1875–1975*. London, New York, 1976

BOWLT, John E. 'Russian Art in the 1920s', *Soviet Studies* (Glasgow), vol. 22, no. 4, April 1971, pp. 574–94

BOWLT, John E. *Russian Art of the Avant-Garde. Theory and Criticism 1902–1934*. New York, 1976

CARTER, Huntly. *The New Spirit in the Russian Theatre, 1917–1928*. London, New York and Paris, 1929

CARTER, Huntly. *The New Theatre and Cinema of Soviet Russia, 1917–1923*. London, 1924

Diaghilev and Russian Stage Designers: a Loan Exhibition of Stage and Costume Designs from the Collection of Mr and Mrs N. Lobanov-Rostovsky. Introduction by John E. Bowlt, Washington, DC, 1972

The Drama Review. Fall 1971 (T-52) and March 1973 (T-57)

DREIER, Katherine. *Burliuk*. New York, 1944

FÜLÖP-MILLER, René. *The Mind and Face of Bolshevism*. London and New York, 1927

GIBIAN, George, and TJALSMA, H.W., eds. *Russian Modernism. Culture and the Avant-Garde 1900–1930*. Cornell, 1976

GORDON, Mel. 'Foregger and the Mastfor'. Unpubd MS. Ed. in *The Drama Review*, March 1975 (T-65)

GRAY, Camilla. 'The Genesis of Socialist Realism', *Soviet Survey* (London), no. 27, Jan.-March 1959, pp. 32–9

GRAY, Camilla. *The Great Experiment. Russian Art 1863–1922*. London and New York, 1962. Reissued as *The Russian Experiment in Art 1863–1922*. London and New York, 1970

GREGOR, Josef, and FÜLÖP-MILLER, René. *The Russian Theatre*. Philadelphia, 1929. Ger. orig. Zurich, 1928

HIGGENS, Andrew. 'Art and Politics in the Russian Revolution', *Studio International* (London), vol. clxxx, no. 927, Nov. 1970, pp. 164–7; no. 929, Dec. 1970, pp. 224–7

HOOVER, Marjorie L. *Meyerhold. The Art of Conscious Theatre*. Amherst, 1974

LEYDA, Jay. *Kino: A History of the Russian and Soviet Film*. London and New York, 1960

MARKOV, Vladimir. *Russian Futurism: A History*. Berkeley, Calif., 1968

MEYERHOLD, V. *Meyerhold on Theatre*. Ed. E. Brown. London and New York, 1969

SAYLER, O.M. *The Russian Theatre Under the Revolution*. New York and London, 1922

SHKLOVSKY, Viktor. *Mayakovsky and his Circle*. New York, 1971

Chapters 3 and 4: Dada and Surrealism

APOLLINAIRE, Guillaume. *Apollinaire on Art. Essays and Reviews 1902–1918*. Ed. L.C. Breunig. New York, 1972

BALAKIAN, Anna. *André Breton*. London and New York, 1971

BALAKIAN, Anna. *Literary Origins of Surrealism*. New York, 1947

BALL, Hugo. *Flight Out of Time. A Dada Diary*. New York, 1974

BARR, Alfred H. Jr. *Cubism and Abstract Art*. New York, 1936

BARR, Alfred H. Jr. *Fantastic Art, Dada, Surrealism*. New York, 1936

BENEDIKT, Michael and WELLWARTH, George E. *Modern French Theatre. The Avant-Garde, Dada and Surrealism*. New York, 1966

BRETON, André. *Manifestoes of Surrealism*. Ann Arbor, 1969. Fr. orig. Paris, 1946

BRETON, André. *Surrealism and Painting*. New York, 1972. Fr. orig. Paris, 1928

Dada and Surrealism Reviewed. Exhibition catalogue. Arts Council/Hayward Gallery, London, 1978

HENNINGS, Emmy. 'Das Cabaret Voltaire und die Galerie Dada', in P. Schifferli, ed.: *Die Geburt des Dada*. Zurich, 1957

HUELSENBECK, Richard. *Memoirs of a Dada Drummer*. New York, 1974

JEAN, Marcel. *History of Surrealist Painting*. London, 1962. Fr. orig. Paris, 1959

LIPPARD, Lucy. *Dada on Art*. Englewood Cliffs, NJ, 1971

MATTHEWS, John H. *Theatre in Dada and Surrealism*. Syracuse, NY, 1974

MELZER, Annabelle Henkin. *Latest Rage the Big Drum: Dada and Surrealist Performance*. Ann Arbor, 1981

Minotaure (Paris), 1933–9

MOTHERWELL, Robert, ed. *The Dada Painters and Poets*. New York, 1951

NADEAU, Maurice. *The History of Surrealism*. New York, 1965. Fr. orig. Paris, 1946–8

POGGIOLI, Renato. *Theory of the Avant-Garde*. Cambridge, 1968

RAYMOND, Marcel. *From Baudelaire to Surrealism*. New York, 1950

La Révolution Surréaliste (Paris), 1924–9

RICHTER, Hans. *Dada. Art and Anti-Art*. London, 1965. Ger. orig. Cologne, 1964

RISCHBIETER, Henning. *Art and the Stage in the Twentieth Century*. Greenwich, Conn., 1969

RUBIN, William S. *Dada and Surrealist Art*. New York, 1969

RUBIN, William S. *Dada, Surrealism, and Their Heritage*. New York, 1968

SANDROW, Nahma. *Surrealism. Theatre, Arts, Ideas*. New York, 1972

SHATTUCK, Roger. *The Banquet Years*. New York, 1955

STEINKE, Gerhardt Edward. *The Life and Work of Hugo Ball.* The Hague, 1967
Le Surréalisme au Service de la Révolution (Paris), 1930–33
WILLETT, John. *Expressionism.* London and New York, 1970

Chapter 5: Bauhaus

Bauhaus 50 Years. Exhibition catalogue. Royal Academy of Arts, London, 1968
CHENEY, Sheldon. *Modern Art and the Theatre.* London, 1921
DUNCAN, Isadora. *The Art of the Dance.* New York, 1928
FUERST, Walter R., and HUME, Samuel J. *XXth Century Stage Decoration.* London, 1928
GOLDBERG, RoseLee. 'Oskar Schlemmer's Performance Art', *Artforum* (New York), Sept. 1977
GROHMANN, Will. 'Der Maler Oskar Schlemmer', *Das Neue Frankfurt,* vol. ii, April 1928, pp. 58–62
GROPIUS, Walter, ed. *The Theatre of the Bauhaus.* Middletown, Conn., 1960. Ger. orig. (ed. O. Schlemmer) Munich, 1925
HILDEBRANDT, Hans. *Oskar Schlemmer.* Munich, 1952
HIRSCHFELD-MACK, Ludwig. *Farbenlichtspiele.* Weimar, 1925
LABAN, Rudolf von. *Die Welt des Tänzers.* Stuttgart, 1920
Oskar Schlemmer und die Abstrakte Bühne. Exhibition catalogue. Kunstgewerbemuseum, Zurich, 1961
PÖRTNER, Paul. *Experiment Theatre.* Zurich, 1960
SCHLEMMER, Oskar. *Man.* Cambridge, Mass., 1971. Ger. orig. Berlin, 1969
SCHLEMMER, Tut, ed. *The Letters and Diaries of Oskar Schlemmer.* Middletown, Conn., 1972. Ger. orig. Munich, 1958
WINGLER, Hans M. *Bauhaus.* London and Cambridge, Mass., 1969. Ger. orig. Bramsche, 1962

Chapters 6 and 7: Living Art c. 1933 to the present

ADRIAN, Götz, KONNERTZ, Winfried, and THOMAS, Karin. *Joseph Beuys.* Cologne, 1973
Avalanche Magazine (New York), nos. 1–6, 1972–4
BATTCOCK, Gregory, ed. *The New Art.* New York, 1966
BATTCOCK, Gregory, and NICKAS, Robert, eds. *The Art of Performance: A Critical Anthology.* New York, 1984

BENAMOU, Michael, and CARAMMELLO, Charles, eds. *Performance in Post Modern Culture.* Madison, Wisc., 1977
BRECHT, George, and FILIOU, Robert. *Games at the Cedilla, or the Cedilla Takes Off.* New York, 1967
BRECHT, Stephan. *The Theater of Visions: Robert Wilson.* Frankfurt, 1979
BRONSON, A.A., and GALE, Peggy, eds. *Performance by Artists.* Toronto, 1979
CAGE, John. *Notations.* New York, 1969
CAGE, John. *Silence.* Middletown, Conn., 1963
CAGE, John. *A Year from Monday.* Middletown, Conn., 1963
CELANT, Germano. *Record as Artwork 1959–1973.* London, 1973
CUNNINGHAM, Merce. *Changes: Notes on Choreography.* New York, 1969
DUBERMAN, Martin. *Black Mountain. An Exploration in Community.* New York, 1972
FORTI, Simone. *Handbook in Motion.* Halifax, Nova Scotia, 1975
HANSEN, Al. *A Primer of Happenings & Time–Space Art.* New York, 1968
HANSEN, Peter S. *An Introduction to Twentieth Century Music.* Boston, 2/1961
HENRI, Adrian. *Environments and Happenings.* London, 1974
HIGGINS, Dick. *Postface.* New York, 1964
High Performance (Los Angeles), 1979–
JOHNSON, Ellen H. *Claes Oldenburg.* Harmondsworth and Baltimore, Md, 1971
JOHNSON, Ellen H. *Modern Art and the Object.* London and New York, 1976
KAPROW, Allan. *Assemblage, Environments & Happenings.* New York, 1966
KERTESS, Klaus, 'Ghandi in choral perspective (Satyagraha)', *Artforum* (New York), Oct. 1980, pp. 48–55
KIRBY, E.T. *Total Theatre.* New York, 1969
KIRBY, Michael. *The Art of Time.* New York, 1969
KIRBY, Michael. *Happenings.* New York, 1965
KIRBY, Michael, and SCHECHNER, Richard. 'An Interview', *Tulane Drama Review,* vol. x, no. 2, Winter 1965
KOSTELANETZ, Richard. *John Cage.* New York, 1970
KOSTELANETZ, Richard. *The Theatre of Mixed Means.* New York, 1968

KULTERMANN, Udo. *Art-Events and Happenings.* London and New York, 1971
KUSPIT, Donald. 'Dan Graham: Prometheus Mediabound', *Artforum* (New York), Feb. 1984
LIPPARD, Lucy. *Six Years. The Dematerialization of the Art Object from 1966–1972.* New York, 1973
LOEFFLER, Carl E., and TONG, Darlene, eds. *Performance Anthology: A Source book for a Decade of California Performance Art.* San Francisco, 1980
MCEVILLEY, Tom. 'Art in the Dark', *Artforum* (New York), June 1983, pp. 62–71
MARRANCA, Bonnie, ed. *The Theatre of Images.* New York, 1977
MEYER, Ursula. 'How to Explain Pictures to a Dead Hare', *Art News,* Jan. 1970
NITSCH, Hermann. *Orgien, Mysterien, Theater. Orgies, Mysteries, Theatre* (Ger. and Eng.). Darmstadt, 1969
OLDENBURG, Claes. *Raw Notes.* Halifax, Nova Scotia, 1973
OLDENBURG, Claes. *Store Days.* New York, 1967
OPEN LETTER. Essays on Performance and Cultural Politicization. (Toronto), Summer-Fall 1983, nos. 5–6
PEINE, Otto, and MACK, Heinz. *Zero.* Cambridge, Mass., 1973, Ger. orig. 1959
Performance Magazine (London), June 1979–
RAINER, Yvonne. *Work 1961–1973.* Halifax, Nova Scotia, and New York, 1974
RATCLIFFE, Carter. *Gilbert and George: The Complete Pictures 1971–1985.* New York and London, 1986
REISE, Barbara. 'Presenting Gilbert and George, the Living Sculptures', *Art News,* Nov. 1971
ROSE, Barbara. *American Art Since 1900.* London and New York, 1967
ROTH, Moira, ed. *The Amazing Decade: Women and Performance Art 1970–1980.* Los Angeles, 1982
SCHNEEMANN, Carolee. *More than Meat Joy: Complete Performance Works and Selected Writings.* New York, 1979
SOHM, H. *Happening & Fluxus.* Cologne, 1970
Studio International. Vol. clxxix, no. 922, May 1970; vol. cxci, no. 979, Jan.–Feb. 1976; vol. cxcii, no. 982, July–Aug. 1976; vol. cxcii, no. 984, Nov.–Dec. 1976
TOMKINS, Calvin. *The Bride and the Bachelors.* London and New York, 1965
WALTHER, Franz Erhard. *Arbeiten 1969–1976.* Exhibition catalogue, São Paolo, 1977

Index

213

Sources of Illustrations

Photo copyright Claudio Abate *138*; Photo Tom Carravaglia *170*; Photo © 1985 Paula Court *117*, © 1984 *152*, *1981 157, 158*, © *1984 168*, © *1983 169*; Photo copyright Dance Museum, Stockholm *75*; Photo Olf Dziadek *2, 173, 174*; Photo copyright © Johan Elbers *154, 1987 171*; Photo Gianni Fiorito *164*; Courtesy General Idea *147*; Photo courtesy Gilbert and George *135, 136*; Photo copyright © Al Giese *118*; Photo Hervé Gloaguen, courtesy Merce Cunningham *113*; Courtesy Dan Graham *130*; Solomon R. Guggenheim Museum, New York, Photo Robert E. Mates, courtesy Scott Burton *139*; Photo Martha Holmes *110*; Photo copyright Rebecca Horn *145*; Photo Scott Hyde *109*; Photo copyright © 1986 Jean Kallina *165, 166*; Kiesler Archive, Collection Mrs Frederick Kiesler *100*; Giovanni Lista: *Futurisme*,

L'Age d'Homme, Lausanne 1973 *9*; Photo Nicholas Logsdail, courtesy Dan Graham *129*; Photo Robert Longo *152*; Photo Wolfgang Lux *128*; Photo © 1986 Dona McAdams *159, 160;* Photo Babette Mangolte *114, 134, 153, 155* (courtesy Trisha Brown *131, 132*); Photo Lizbeth Marano, courtesy Julia Heyward *141*; Collection Mattioli, Milan *7*; Musée d'Art et d'Histoire, Saint-Denis *71;* Museo Depero, Rovereto *18, 19*; Photo Hans Namuth *118*; Photo National Film Archive, London *116*; New York Graphic Society Ltd, Greenwich, Connecticut *46*; Courtesy Hermann Nitsch *133;* Photo Elizabeth Novick, courtesy Robert Rauschenberg *112*; Courtesy Pat Oleszko *149*; Courtesy Luigi Ontani *138*; Courtesy Dennis Oppenheim *126*; Photo Nicholas Peckham *115*; Photo Gerda Petterich, courtesy Merce Cun-

ningham *106*; Photo Kerri Pickett *162*; Collection Massimo Prampolini, Rome, Photo Guidotti-Grimoldi *17*; Private collection, Rome *15, 16, 20*; Photo Eric Shaal, Life Magazine © 1978 Time Inc. *105*; Photo © 1984 Beatriz Schiller *167*; Oskar Schlemmer Archiv, Staatsgalerie, Stuttgart, courtesy Tut Schlemmer *1, 87, 90, 98*; Photo © 1984 Patrick T. Sellitto *163*; Photo Harry Shunk *119, 121*; Photo Warren Silverman *143*; Photo © archives SNARK (archives Marker) *72*; Collection Sprovieri, Rome *14*; Photo Bob Strazicich, courtesy Image Bank *150*; Theatrical Museum, Leningrad *28*; Photo Caroline Tisdall *124;* Photo © 1984 Jack Vartoogian *174*; Courtesy Wolf Vostell *111*; Photo courtesy John Weber Gallery, New York *125*; Photo Kirk Winslow *161*; Photo Les Wollam, *144*